"There is no

excellent beauty

that hath not

some strangenesse

in the

proportion."

SIR WALTER RALEIGH,
HOLDER OF
THE ROYAL PATENT
TO FOUND THE
VIRGINIA COLONY

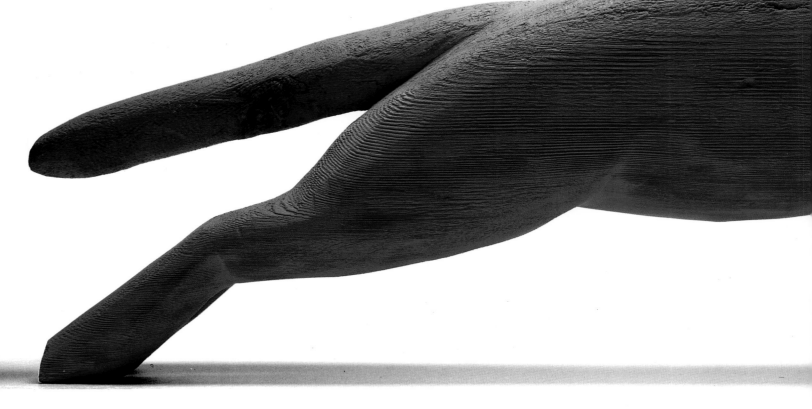

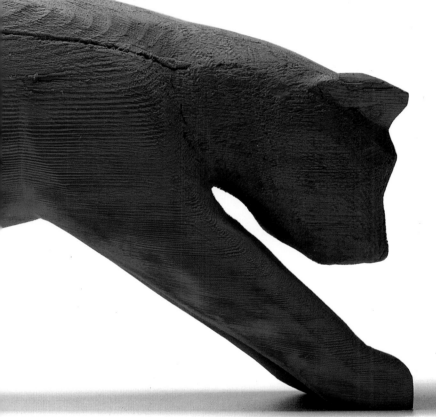

LACHIA

ARTISTS OF
THE SOUTHERN
MOUNTAINS

BY
RAMONA
LAMPELL
&
MILLARD
LAMPELL
WITH
DAVID LARKIN

PHOTOGRAPHS
BY
MICHAEL FREEMAN
AND
PAUL ROCHELEAU

A
David Larkin
Book

STEWART,
TABORI
&
CHANG
NEW YORK

Text copyright © 1989 Millard and Ramona Lampell
Photographs copyright © 1989 Paul Rocheleau
Photographs copyright © 1989 Michael Freeman

Published in 1989 by
Stewart, Tabori & Chang, Inc.
740 Broadway, New York, New York 10003

Library of Congress Cataloging-in-Publication Data

Lampell, Ramona.
 O, Appalachia : artists of the southern mountains / by Ramona
Lampell & Millard Lampell with David Larkin ; photographed by
Michael Freeman and Paul Rocheleau.
 p. cm.
 ISBN 1-55670-098-9
1. Folk art—Appalachian Region, Southern—History—20th century.
2. Folk artists—Appalachian Region, Southern—Biography.
I. Lampell, Millard, 1919–. II. Larkin, David. III. Freeman,
Michael, 1945–. IV. Rocheleau, Paul. V. Title.
NK811.L36 1989
709.2′275—dc20
[B] 89-11344
 CIP

Distributed in the U.S. by Workman Publishing,
708 Broadway, New York, New York 10003
Distributed in Canada by Canadian Manda Group,
P.O. Box 920 Station U, Toronto, Ontario M8Z 5P9
Distributed in all other territories by
Little, Brown and Company, International Division,
34 Beacon Street, Boston, Massachusetts 02108

Printed in Japan

10 9 8 7 6 5 4 3 2 1

PHOTO CREDITS

Paul Rocheleau: pages 5, 6, 11, 13 top, 14–15 top and
bottom, 16, 17, 19, 22, 24 bottom, 29, 31, 34–35, 38, 39,
42–43, 44, 45, 46–47, 49, 53, 54, 55 top and bottom, 57,
58, 59, 60, 61, 62 left, middle, and right, 63 left and right,
65, 66, 66–67, 68–69, 70, 71, 72 left and right, 73,
74–75, 76–77, 78 top left, bottom left, and top right, 80,
81, 82 top and bottom, 83, 84, 85, 86, 93, 96 left and
right, 97, 98, 99, 104, 107, 108–109, 115, 120–121, 122,
123, 124, 125, 126–127, 129, 130–131, 131 top, 132–133,
134, 135, 136, 137 top and bottom, 138, 139, 142, 143,
144–145, 146, 147, 148, 149, 151, 152, 153, 154–155, 156,
157, 158, 159, 160, 161, 162–163, 164, 165, 166–167,
168–169, 170, 171, 172, 173, 176, 177, 178, 179, 180–181,
188–189, 190, 191, 192 both, 193, 194, 195, 196–197,
198–199, 200, 201 top and bottom, 202 left and right, 203
top left, top right, and bottom right, 204–205, 206–207,
218–219, 220, 221, 222 left and right, 223, 224–225, 225,
226, 227, 228, 229, 230 left and bottom, 231, 232–233,
234, 235, 249 top and bottom, 250 top and bottom, 254,
255, 256, jacket, backflap

Michael Freeman: pages 2–3, 8–9, 10, 12, 13 bottom, 18,
20, 21, 22–23, 24 top, 25, 26–27, 27 top, 28, 30, 32 top
and bottom, 33, 36, 37, 40, 41, 50, 51, 52, 56, 64, 87, 92,
94, 100–101, 102, 103, 105, 106 left and right, 108, 113,
114, 116, 117, 128, 174–175, 182, 183, 184–185, 186–187
top and bottom, 208 top and bottom, 209, 210, 211,
212–213, 214–215, 216–217, 236–237, 239 top and
bottom, 242 left, 242–243, 243 bottom, 244–245,
246–247, 251, 252, 253 and back jacket.

Jonathan Wallen: pages 76, 90, 91, 95, 140–141

Elaine Garfinckle: pages 110–111, 118–119

Ray Bradley: pages 240, 241

Ramona Lampell: page 48

Tom McColley: page 79

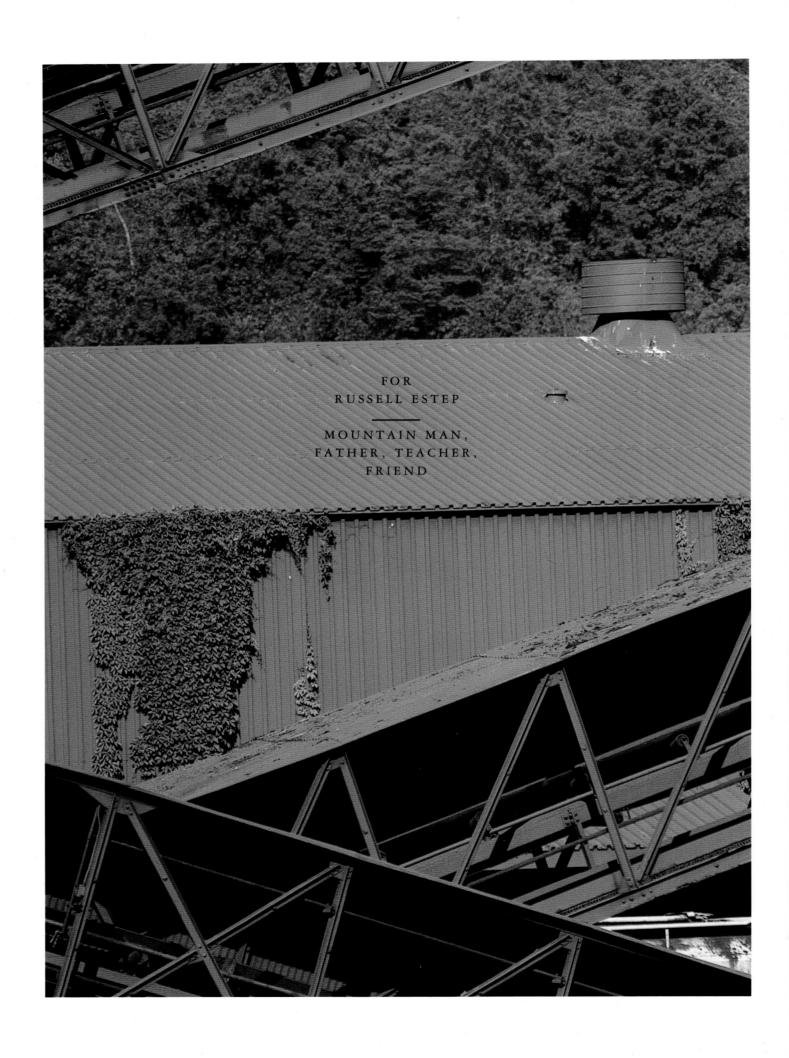

FOR
RUSSELL ESTEP

———

MOUNTAIN MAN,
FATHER, TEACHER,
FRIEND

CONTENTS

INTRODUCTION

THE SOUTHERN Appalachians spill down the Blue Ridge of Virginia, across the entire state of West Virginia, the coal fields of Kentucky and Tennessee, the highlands of North Carolina, Georgia, and Alabama. The mountains have a breathtaking beauty, as though giant waves of the Atlantic had crashed inland and frozen into ridges and peaks. The names of Appalachia's rivers sing with the lilt of a banjo tune: the French Broad, the Hiwassee, the Monongahela, the Congaree.

It is a region little known to outsiders. All too many Americans have drawn their image of Appalachia from television and cartoon strips. Mountaineers are portrayed as shiftless and ignorant, living in ramshackle cabins, working corn-whiskey stills. Poverty is shown, but never its reason. There is no mention of the sturdy human relationships in the hills, nor the enduring values that mountain people cherish: homeplace and close-knit kin.

Appalachian culture is not even acknowledged to exist. Yet three declarations of independence were issued like defiant battle cries from the mountains before Thomas Jefferson wrote the one we know. Mountaineers preserved old English ballads and shaped a native poetry in folk tales and songs. They published the nation's first abolitionist newspaper as far back as a century and a half ago.

In a country that every year boasts more and more asphalt, steel, and concrete, the Appalachians look much as they did in the distant past. True, there are the scars of poverty, derelict cars sitting on cinder blocks, littered creeks, rusted junk spilled down ravines. Pickup trucks have replaced horses and mules, television dishes sprout among the dogwoods and poplars, but the mountains still offer three rare commodities: beauty, peace, and solitude.

In Appalachia, speech is laconic, but hands are

Facing page: Clefford Goad: *Plough Horse*

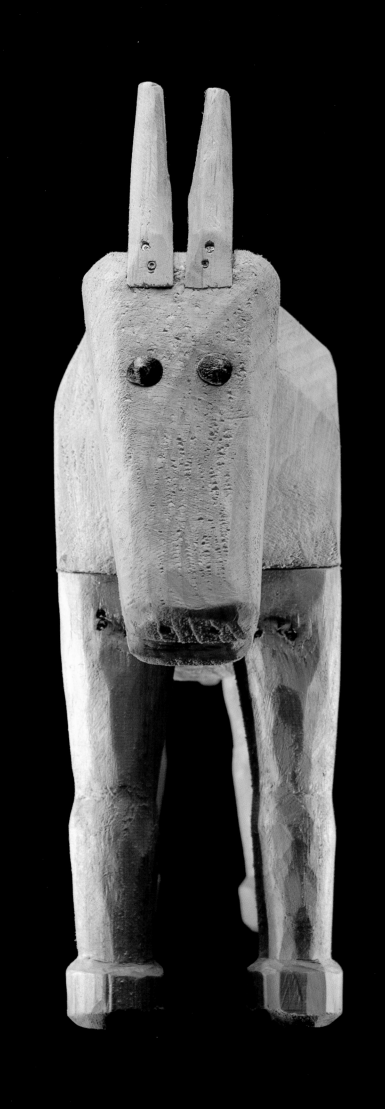

eloquent. Skilled at repairing, mountain people are frugal. They save scraps and pieces, old wood, old nails. They make use of what lies at hand. Isolation and a lack of ready cash drove past generations to make what they needed: quilts, baskets, axe handles, crockery. But what drives their descendants to produce an outpouring of art unique as a thumbprint, native as a split-rail fence?

The mountains nurture visionaries. And visions are the seeds of art.

Hanshew Hollow, West Virginia, where Ramona and I live, is a green fold in the mountains. Almost everyone in the hollow is kin to my wife, a slew of uncles, aunts, nieces, nephews, cousins, and their children, grandchildren, and great-grandchildren. Mountain families tend to stay rooted where they were born.

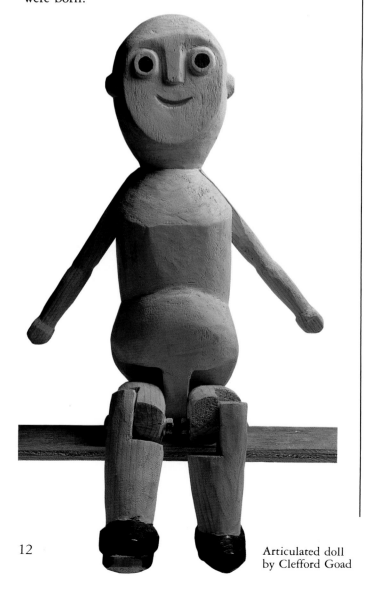

Articulated doll
by Clefford Goad

Our home sits on a ridge. From our windows we can see massed regiments of mountains, twenty shades of green deepening to blue, fading to lilac as they march away.

I was born in a soot-stained, New Jersey mill town, but early on Appalachia began weaving itself into my life. At fifteen, I started hitchhiking, and Appalachia was where I kept ending up.

Mountain humor appealed to me. On a sign outside a church in Kentucky that proclaimed, "Jesus Is Coming, Perhaps Tomorrow," I remember, some mountaineer had scrawled, "I ain't ready."

I remember the tenant farmer in North Carolina who invited me to share supper, drawling, "We got a'plenty. We got a thousand things to eat . . .," spitting, adding offhand, "Every one of 'em's peas."

I remember taking a sip of the coffee I'd paid a nickel for at a country store in Tennessee. When I pursed my lips and murmured that it was kind of strong, the gaunt mountain woman who ran the place admonished, "There ain't no such a thing as strong coffee, son. There's only weak people." It was the kind of poker-faced wit I was later to find in the works of self-taught mountain artists like Cher Shaffer, Charley Kinney, and Clefford Goad.

The mountains drew me. I went to college in West Virginia. My roommate was a coal miner's son. At his home, I had my first encounter with Appalachian music. He played the guitar, his daddy played the banjo, and his coltish sister played the mandolin. I listened, enthralled, to their high-pitched harmony on the haunting lament, "Darlin' Corey," learned the rattling, breakneck verses of "Sourwood Mountain," and joined in as they bawled:

Whet up your axe and whistle up your dog,
We're off to the woods to catch groundhog,
Grounddd . . . hog!

They were free and easy with the songs that had sprung from their lives. When they forgot a line, they made up one to take its place. They added new verses and didn't hesitate to improvise a lick or a whole original melody.

From mountain musicians, I learned something that in years to come would help me understand self-taught mountain artists. Starting out, painting and sculpture are just something they try because they feel a need to make a statement that words cannot express. There are no rules to intimidate them. There is no one to tell them how it should be done. As far as they are concerned, there is nothing special one needs to know before picking up a brush or a whittling knife. They have no thought that their works will find an audience, that others will value what they have made. They don't call themselves artists. They don't label what they create *Art*.

Ramona's interest in self-taught mountain artists began as a search for a way to present to the outside world a true picture of Appalachia, its special store of knowledge, its real wealth. At a local fair she came upon S. L. Jones displaying his carvings and was struck by the vigor of the sturdy figures, the larger than life heads with their unflinching gaze. In Jones's work she saw a hickory-hard honesty, a striking reflection of the mountain way of looking at the world.

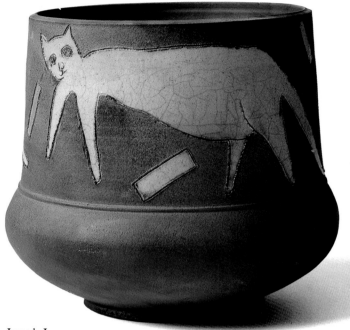

Joseph Lung:
raku pot, *Spirit Animals*

She began to haunt small fairs. Mostly they showed hobby work, gimcracks, toys and crafts, quilted potholders, and corn-shuck dolls. At one fair out of thirty, she might come upon something rare, a carving done with a bold vision that set it apart, a painting into which its creator had poured secret dreams and longings, a work inspired by deep faith and executed with original style. Artists were there to be found.

It helped that she was a native. She questioned family and friends, asked neighbors, followed up clues. Her search took her farther and farther afield. Now she travels all the southern Appalachian states, jouncing up red-dog roads, sloshing through hubcap-deep creeks, skidding through mud and snow to places like Pinnacle, Hurricane, Pink Lily, and Flowery Branch.

In the works of self-taught Appalachian artists, two themes dominate: nature and morality. Attuned to wild creatures and the quirks of nature, mountain people possess an abiding faith in the force that created them. "I will lift up mine eyes to the hills, From whence cometh my help." (Ps. 121: 1)

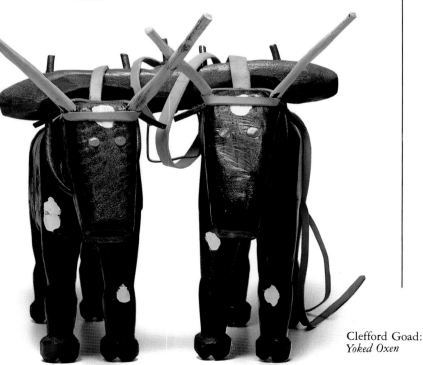

Clefford Goad:
Yoked Oxen

13

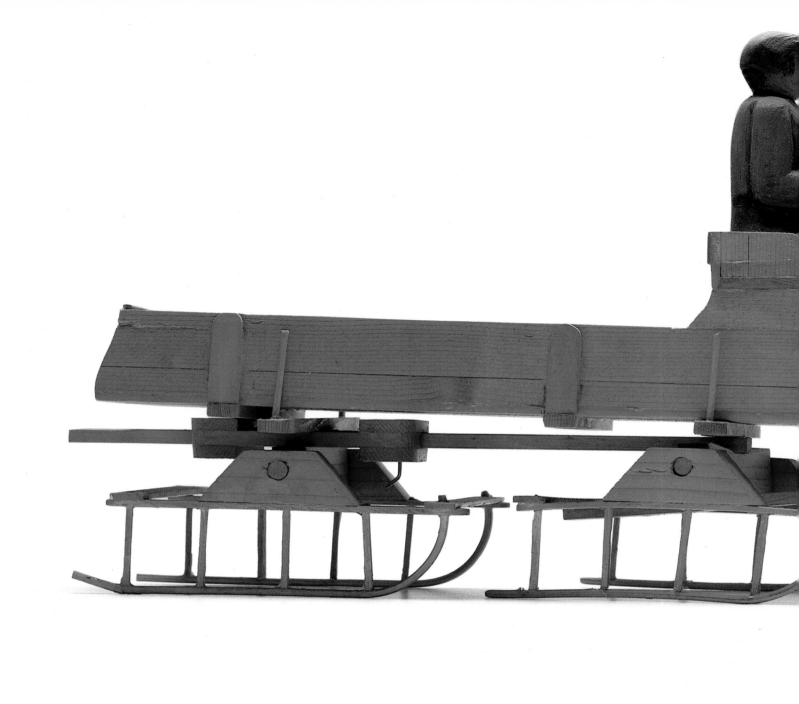
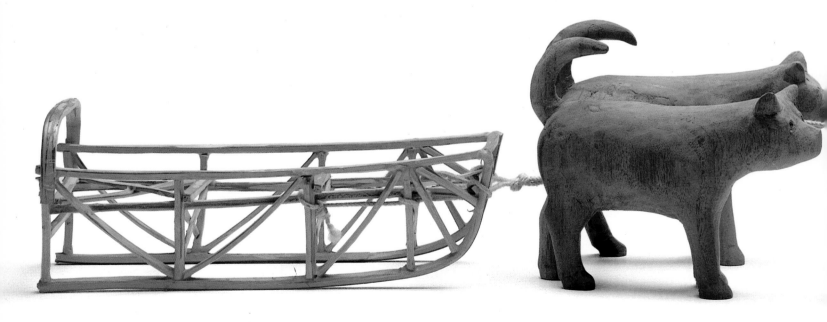

Robert Eicher: *Goin' to Town*

Carl Brown: *Huskies*

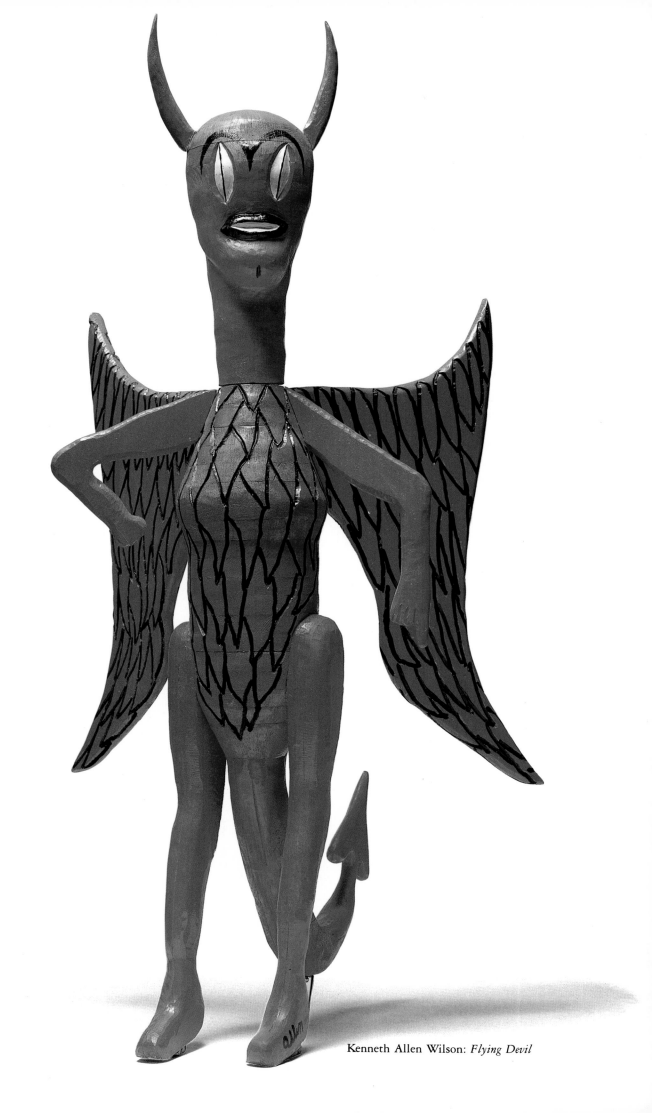

16 Kenneth Allen Wilson: *Flying Devil*

Erma Lewis, Jr.: *Devil*

It is significant that not one of the artists in this book lives in a city—except Cher Shaffer, and the country is where she grew up. The mountains offer solitude. Being alone in the mountains is different from being alone in the city. The woods are a magical place where you can't help being aware of the changing miracles of pattern, color, and shape. The woods fill you with wonder. Out of a sense of wonder comes the urge to create.

Artist after artist speaks of a love for the woods. It is where they go alone to ponder creation, good and evil, life and death. In their works, the devil appears again and again, dwarfing the angels. Biblical dramas of humans and creatures exercise a powerful attraction—Adam, Eve, and the snake, Jonah and the whale, Daniel in the lions' den.

It is natural that so much of the art presented here is carved wood. Every mountain man, and many a mountain woman, carries a pocketknife. The works of these self-taught artists spring directly out of their lives, revealing the world they knew as children: what they were taught, the Bible stories they read, the woods they roamed, the work they did, and the world they know now.

To fully understand Appalachian art, you must travel into the mountains, spend time with the artists, learn how they live, listen to them speak of their work. You must journey the back roads of Appalachia. This book is designed to take you there.

Craig Dudley: *Ice Cream Man*

18

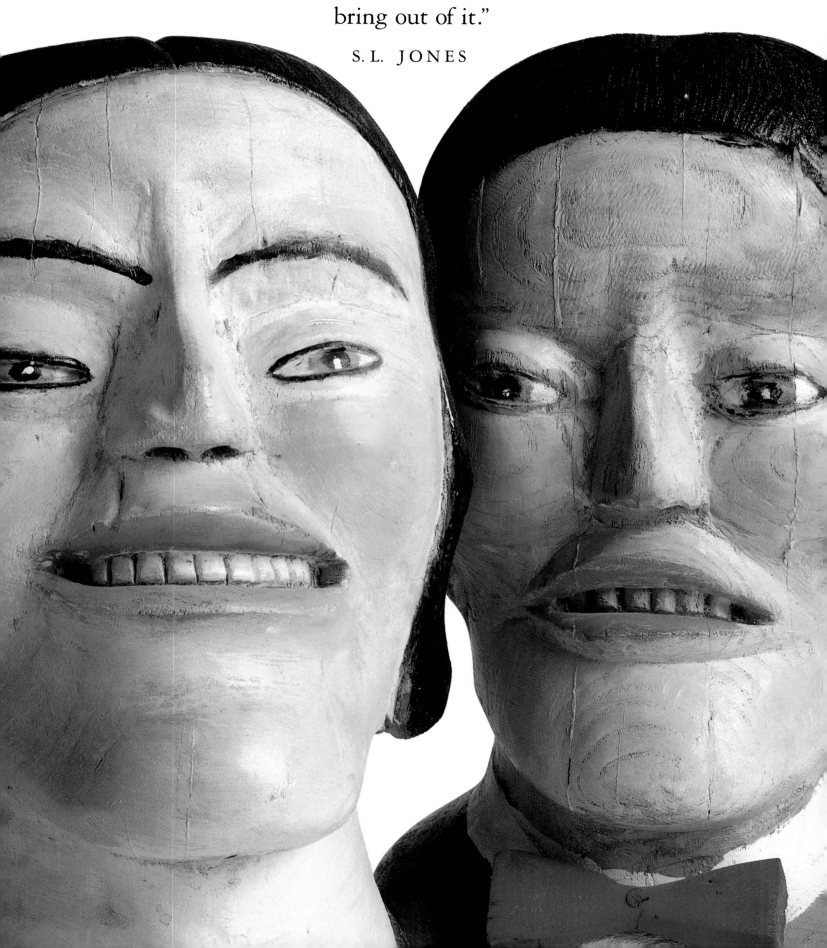

"I sit and study a piece of wood,
trying to see what I can
bring out of it."

S. L. JONES

S. L. JONES

THE RATTLESNAKE curves of a mountain road lead down to Hinton, West Virginia. A gritty railroad town, its days of glory are gone, the roundhouse rusted, the thunder of steam locomotives silenced by time. Beyond Hinton, a back road leads along the river, through the Greenbrier Valley, home territory of S. L. Jones.

Behind his modest home on Pine Hill is the workshop he built for himself, a single room heated by a wood stove. Like most mountaineers he hates being cooped up indoors. He has brought in light and space by painting across the back wall a mural of sheep on a hillside, a summer sky, and in the distance the Appalachians where he has lived all his life.

Ranged on a long table are his carvings, friends keeping him company. On the wall are his colored pencil drawings: sad-eyed horses, cagey pigs, and women with sensual mouths whose wise, faintly crooked smiles seem to say they know secrets the rest of us can only guess.

When the weather allows, even when there is a hard wind and a razor chill in the air, S. L. Jones works outside. Approaching ninety, he is still stout, meaning built solid, built to last. He used to go to the woods to get what he needed for his art. Now he must settle for accepting the heavy logs brought to him by his sons and friends. Disdaining any further help, he wrestles the logs onto a wheelbarrow and trundles them up the slope to a flat spot outside his workshop. When a log is seasoned, he roughs it out with a chain saw and sets to work with a worn set of chisels and a rasp with a homemade handle. They are the tools he uses to do most of his carving, saving his knife for the delicate details, the whorl of an ear, the arc of an eye.

An old-fashioned man, S. L. Jones faces the world with an erect, courteous formality, a stance he gives to the men and women he carves. They hold themselves ramrod straight, commanding attention by their strength. At first they seem, like their creator, to show little emotion. Yet somehow, they give an impression of a tumult of feelings locked inside. Look closely and see the intensity in the set of a jaw, the ghost of humor shadowing a mouth.

Shields Landon Jones was born and raised in the hills between Indian Mills and Red Sulphur Springs. One of thirteen children of a tenant farmer and part-time lumberjack, he started work as soon as he was big enough to lift a hoe, helping his father scratch a living out of the rocky slopes.

Preceding page: *Rose and Orville*

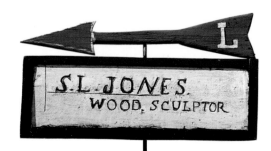

20

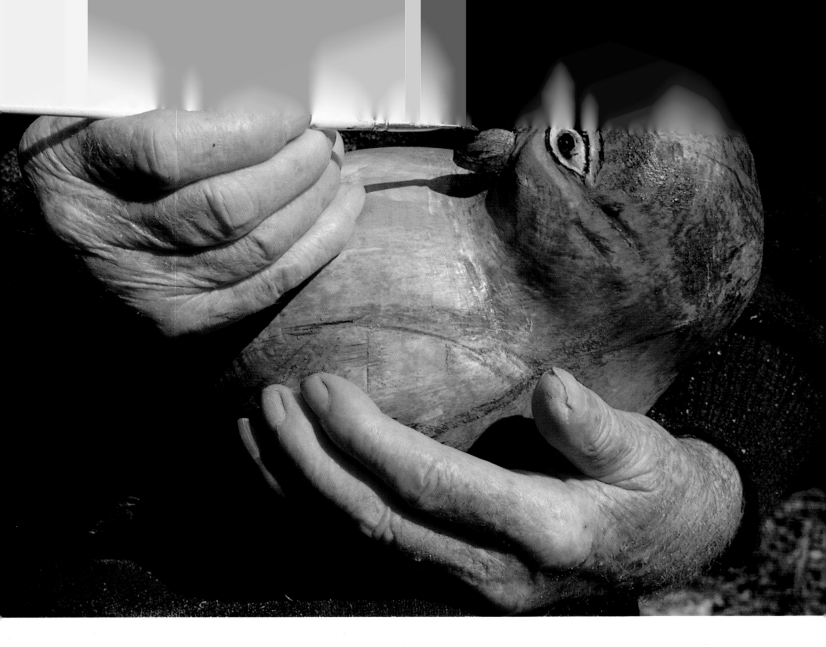

S. L. Jones had the love of the woods that is engraved in Appalachian children like the imprint of a fossil leaf in coal. Prowling with his dog, he had a hawk's eye for the plants that make healing teas and poultices: goldenseal, comfrey, slippery elm, and "sang," the ginseng roots that fetched a fancy price and were shipped all the way to China, where they were prized for adding zest to a man's virility.

Early on, S. L. Jones learned the mountain skills of hunting and trapping. "Days, whenever I could slip away, I'd be out after rabbits. And I liked to hunt in the dark, run a fox all night, hear an old hoot owl hollering. If another owl across the mountain answered him, that was a sign of bad weather coming on." He fashioned box traps to snare rabbits. Their hides brought fifteen cents, "a right smart of money

in them days." His first earnings went to buy a barlow knife. "Whittling was something I was pretty good at, something I did to pass the time. Waiting for my dog, Dan, to sniff out game, I'd find me a piece of buckeye, and carve a squirrel or a bird."

S. L. Jones liked to take care of his mother's chickens, doctor them when they got sick, operate to mend a broken wing. He dreamed of becoming a veterinarian, only "wasn't no way a poor man like my daddy could pay for the education." In the West Virginia mountains, a young man who wanted to escape the farm had two choices: the coal mines or the railroad. S. L. Jones quit school in the eighth grade, lied about his age, and got a job laying track for the Chesapeake & Ohio Railway Company.

"Many's the time I'd be called out at night in the dead of winter for a train wreck or a bridge washed away by a flood." He'd work in the freezing dark, sometimes up to his waist in icy water, right on through the next day, warming his hands over a fire when they turned blue.

S. L. Jones was married and had good-sized children by the time he became foreman of a construction crew. With fourteen men under him, he built depots and equipment sheds, poured roundhouse foundations, put up bridges and retaining walls. He spent forty-six years working for the C&O, and when he finally took his pension the children were grown and out on their own. Then his wife passed away.

To fill out his days and fight his loneliness, he began to create companions for himself. Turning to the art of his boyhood, he whittled small figures at first, a horse, a dog. Bit by bit, the figures grew larger, until he was making some of them three feet tall, carving kinfolk, long-ago neighbors, and railroad men with whom he had worked. He carved families and massive heads.

He had never studied sculpture or painting, never seen an art book, never been to a museum or gallery. He had never known an artist. With no concern for the niceties, he simply set out to create the friends he needed to keep up his spirits and warm his life.

Above: *Me and Susie*

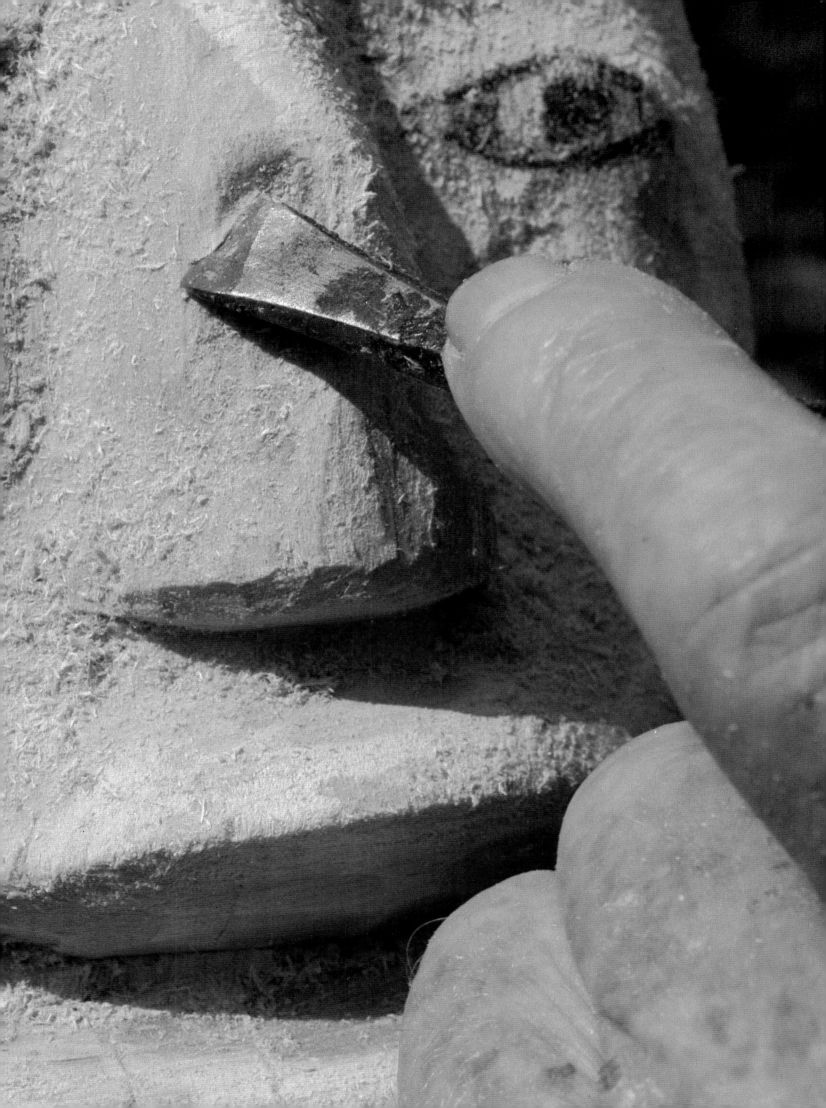

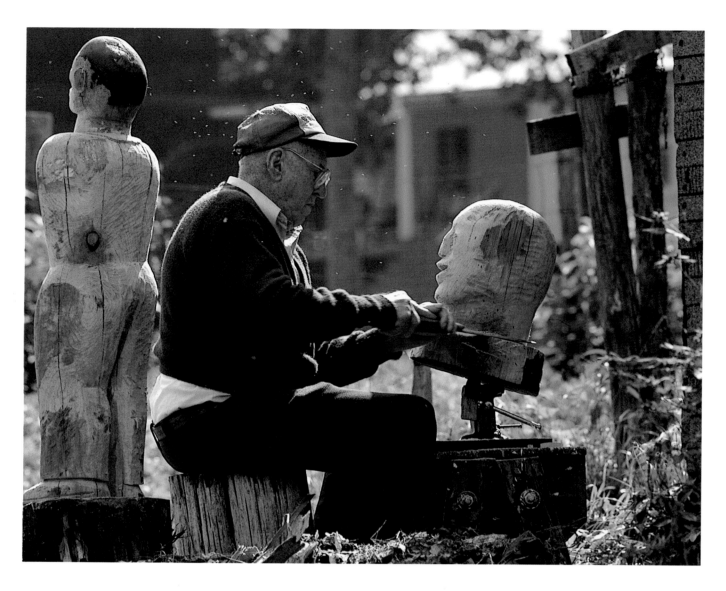

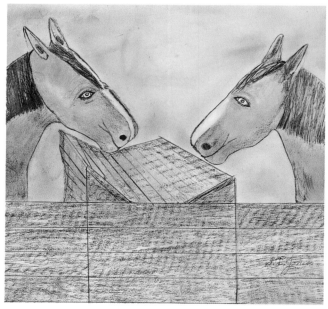

Morgan and Old Buck

It was natural for him to turn to wood for solace. Trees are the heart and soul of mountain life. Deep in the hollows, they provide boards, rafters, and beams for homes and barns, fuel for the cookstove, heat to keep out the winter cold. Most of the virgin growth has been timbered off, but trees continue to flourish in stunning variety, their names a poem. Red oak, white oak, maple, and sourwood. Sweet gum, black gum, cedar, and walnut. Redbud and linn, beech and wild cherry, dogwood and sycamore, tulip poplar, butternut, ash, hickory, and locust. From a long way off, S. L. Jones can identify every tree in the woods by shape, leaf, and bark. He knows which are hard and which are soft, which split cleanly, which invite the carver's blade.

Outside his workshop, at the edge of his garden with its neat rows of onions, corn, and tomatoes, a stack of firewood awaits the stove and seasoned logs await the artist's hand. S. L. Jones adds the finishing touches to a head, doing what he calls "dressing it up." *Uncle Everet* stands thigh-high to a tall man. Like a doting parent sending his child off to school for the first time, S. L. Jones wants *Uncle Everet* to look his best when he goes out into the world.

"I'm going to make a wonderful woman for him. When they get together, won't that be something? He won't know a lonely day in his life."

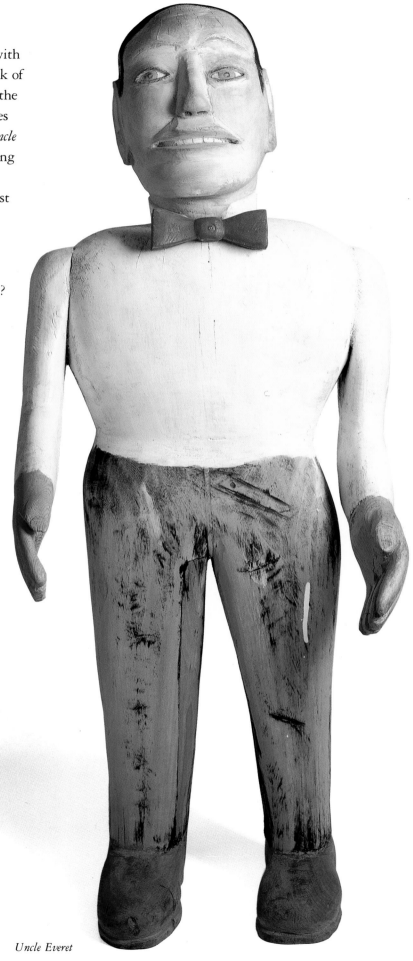

Uncle Everet

Memories of his boyhood have inspired a number of S. L. Jones's pieces. *Going To The Grist Mill* (below) is his recollection of his father driving the sled he used to haul grain over the snow. *The Sulky* (right) recalls trips to the dirt track in the next county, where trotting races were run.

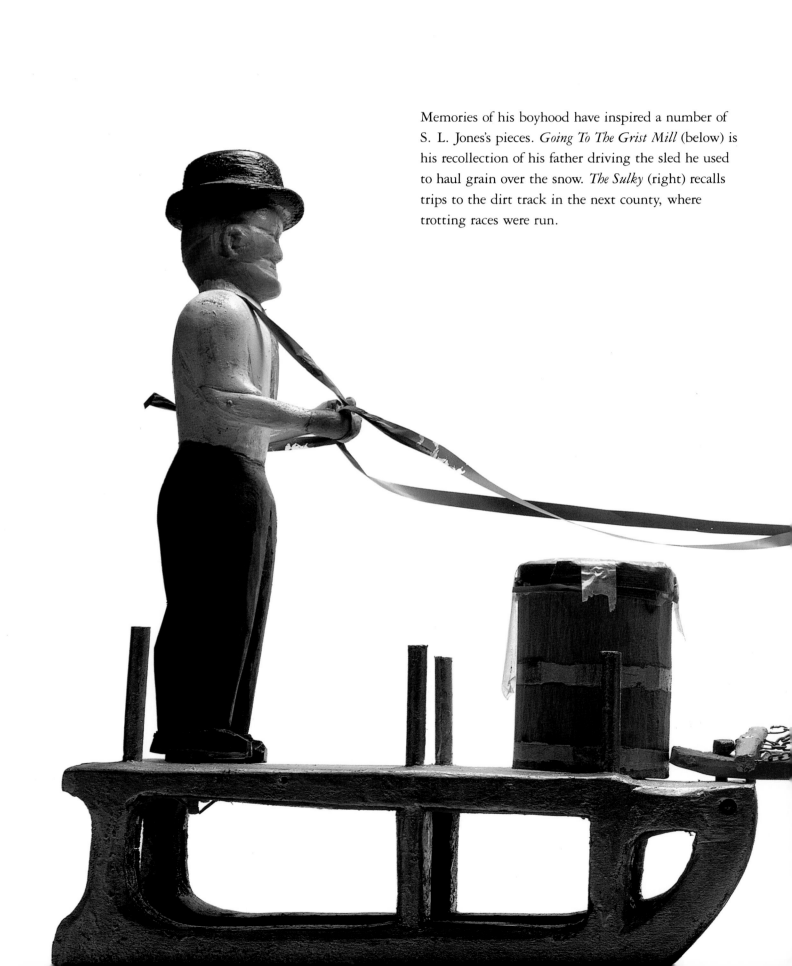

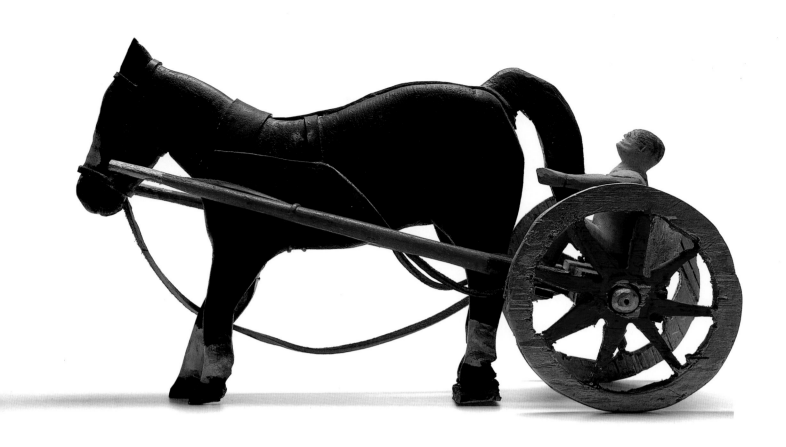

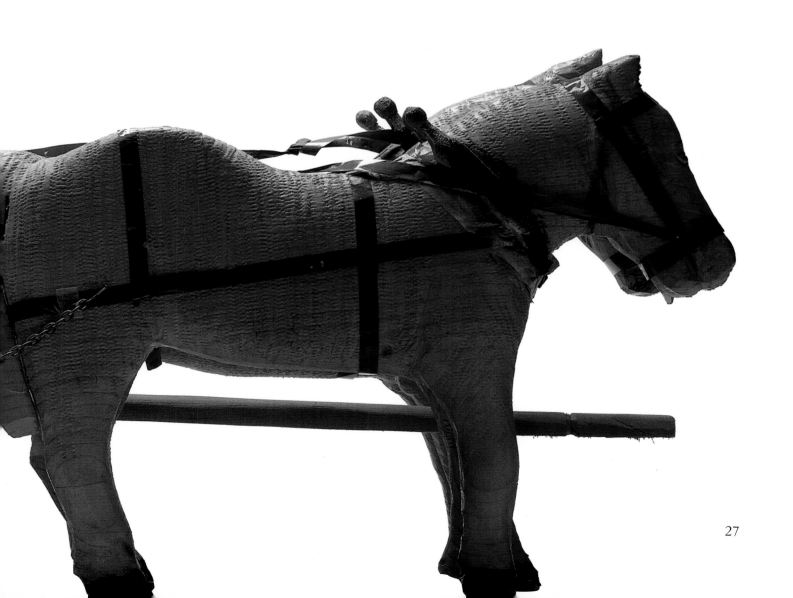

28

The walnut head, *John Henry* (facing page), is giant size, fitting and proper for the legendary gandy dancer who worked for the C&O railroad at the Big Bend Tunnel, a mile or so from where S. L. Jones lives. Song and story tell of the black, track-laying champion who challenged the newfangled machine the railroad brought in to replace the steel-driving crews:

John Henry said to his captain,
A man ain't nothing' but a man,
And before I'd let that steam-drill beat me down,
I'd die with my hammer in my hand.

John Henry won his race against the machine, but, as the ballad goes:

He worked so hard that he broke his poor heart,
And he laid down his hammer and he died.

The largest figure S. L. Jones has made is of himself (right). It stands close to five feet tall. Recalling his courting days, he has given the wooden S. L. a rakish boater carved out of poplar, a leather belt, and the awkward, cheerful, country innocence he had in those days.

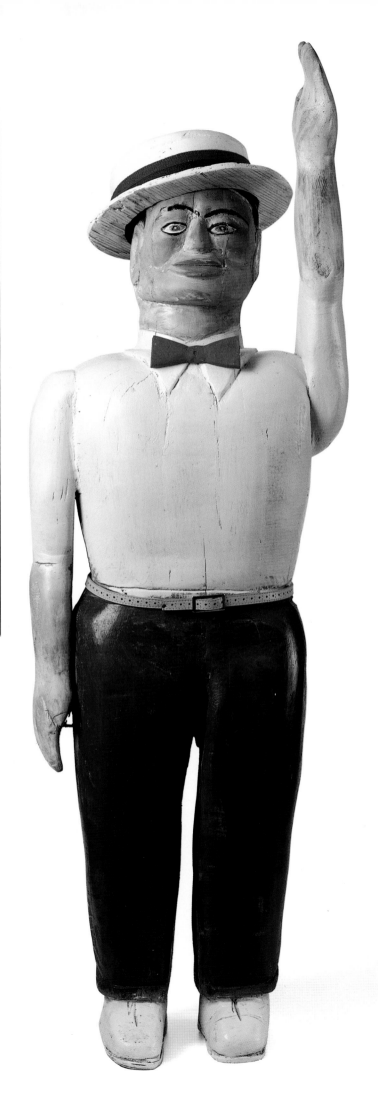

For all his spare speech and stolid manner, S. L. Jones enjoys drama. He displays his work as an impresario presents a performance, introducing each piece with a flourish, a beam of pride, and a little speech. When a letter arrives praising one of his figures, he beams and allows, "Yeah, that fiddler come out pretty good. If you listen close, you can hear him a'playing 'Cripple Creek.'"

The fiddler, *Slim Jones*, is not kin but a renowned country musician who, rumor said, got his talent from the devil. In exchange, he was bound to set people dancing with such wild abandon on Saturday nights that they were too exhausted on Sunday to go to church.

Not that S. L. Jones approves of the tricks of the devil. He is a deeply religious man. He just can't help admiring anyone who can fiddle up a storm. "My father was a real good banjo-picker, good dancer, good fiddler. Reckon I was about six when he killed him a big old gray squirrel and tanned its hide for the head of a five-string banjo he made. I'd study him a'playing it, and it wasn't too long, he come in from the fields and found me picking his favorite, 'Soldier's Joy.' So he made me a banjo of my own. But what I had my heart set on more than anything in God's world was a fiddle."

He traded a shotgun for one. And won his first fiddling contest when he was twelve. He still plays the gospel hymns, breakdowns, and ballads he did back then, the songs that for generations have echoed like bird songs in the mountain air.

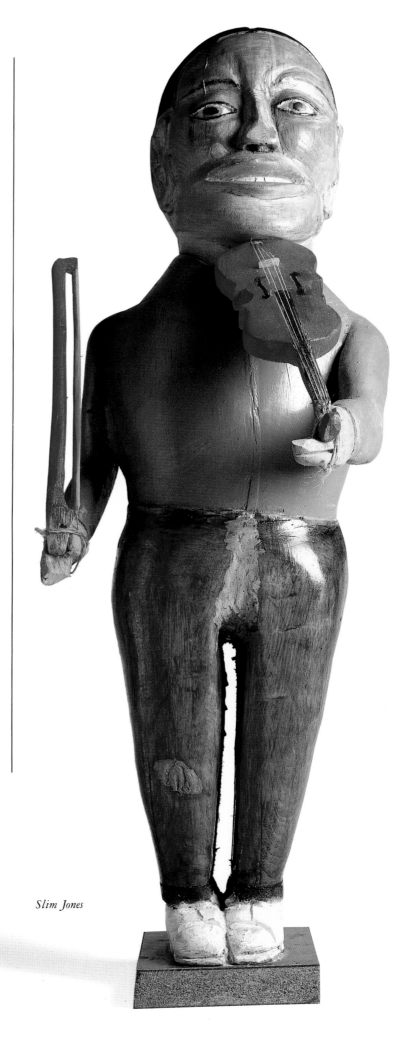

Slim Jones

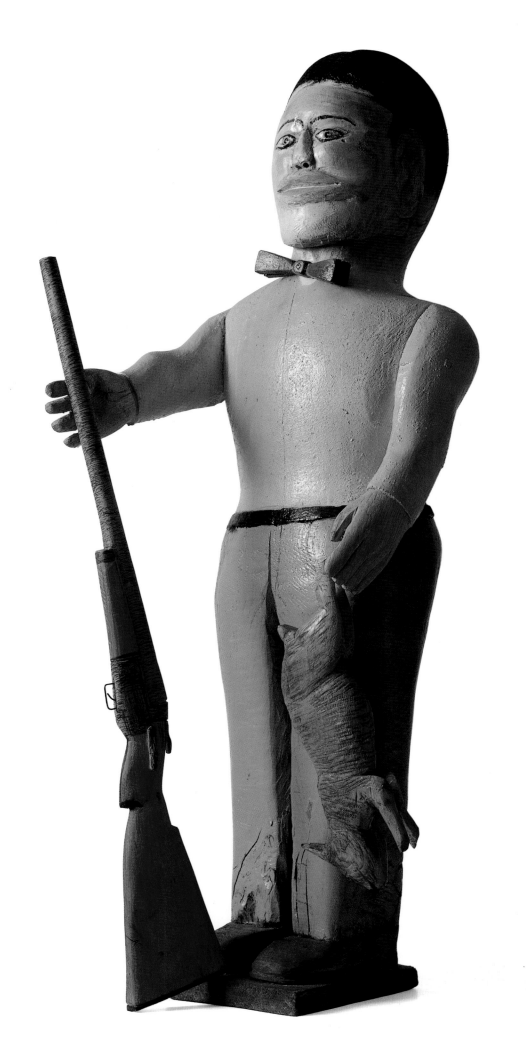

Uncle Adam's Supper

31

A man ain't nothin' but a man. Like John Henry, S. L. Jones loves a challenge. His carving and drawing keep him vibrantly alive. The stuff of legend is in this country boy with only a fragment of schooling, who put in years of mule labor on the railroad and emerged to create works of art.

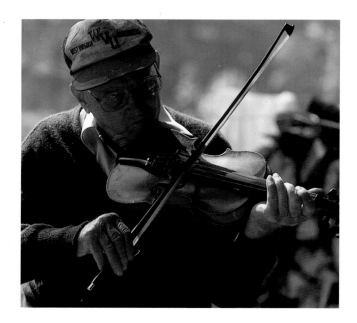

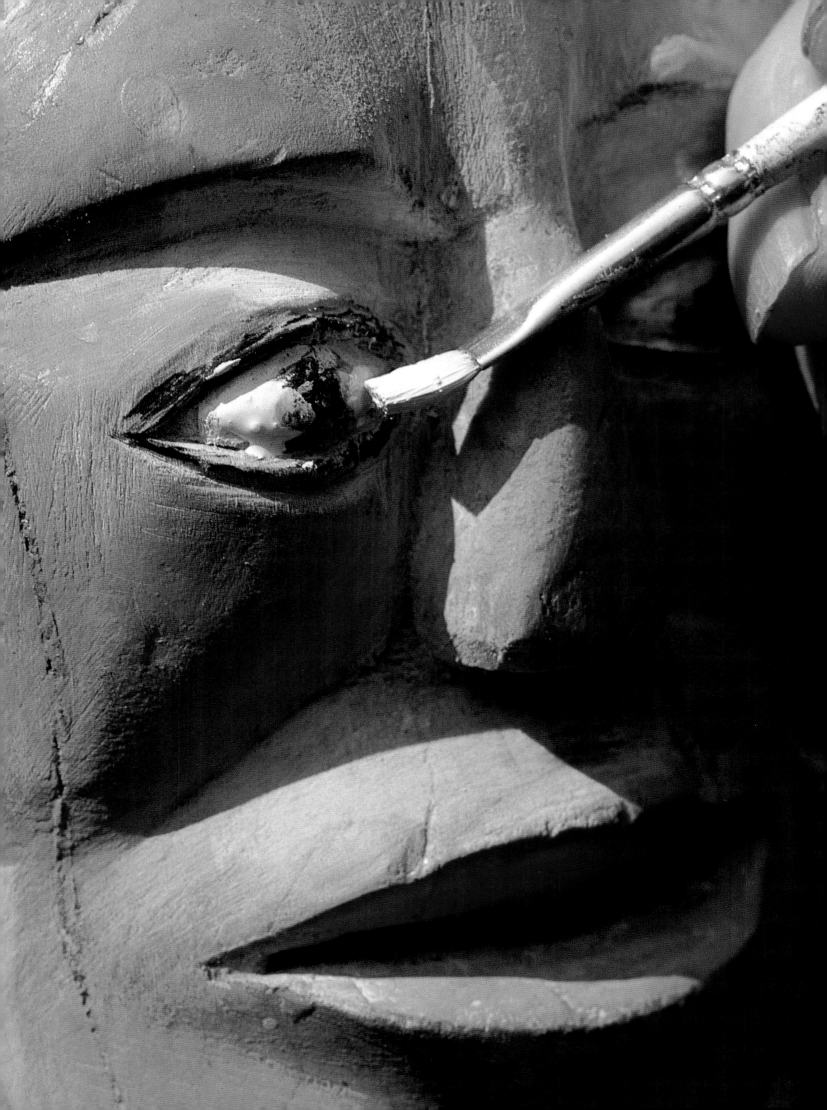

"Making things is something I got from my dad.
In the winter, when he couldn't farm,
he'd turn out axe handles, scythe handles, boat oars.
Carve them by hand. He'd make baskets to carry
to market, and some to sell to railroad men."

ELMER RICHMOND

ELMER RICHMOND

I USED TO HAVE the best coon dog in West Virginia." At the memory, Elmer Richmond shakes his head in admiration. "Coons are stubborn, but I never met one could beat Old Blue. Like to broke my heart when I lost him. We got after a coon one night, and Old Blue took out over the ridge and just kept going. I could hear him yelping, heading over another ridge, out and beyond. He kept going, kept going. Wasn't no way I could keep up with him. He just plumb vanished and never come back."

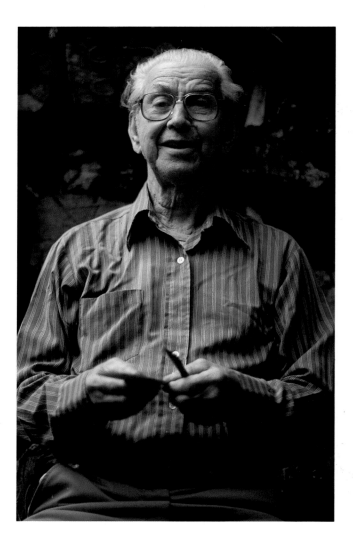

He gazes gloomily into the distance, mourning the loss. "The next year, I was sangin' over yonder in Glade Creek, and I come across Old Blue sitting under an oak tree, looking up. Just the skeleton of him. And an old coon up there in the branches, just the skeleton of him, looking down." For a split second, he watches a listener debate whether to believe the story. His laughter erupts, an explosive whoop.

A mischievous teller of tall tales, Elmer Richmond is a railroad man, beekeeper, walking encyclopedia of mountain lore, and builder of unique, cedar slat baskets.

"Making things is something I got from my dad. In the winter when he couldn't farm, he'd turn out axe handles, scythe handles, boat oars. Carve them by hand. He'd make baskets to carry produce to market, and some to sell to railroad men. Get called to work, they might be repairing track in the middle of nowhere for two, three days. They had to take food, and they'd use my dad's baskets to carry it. I came across one he made, must have been seventy-five years ago."

The broad New River sweeps through a gorge, its rapids churning white as it eddies past Elmer Richmond's home stretch of mountains. Railroad tracks run along the shore, passing the huge, closed, coal-washing plant where freight cars sit empty on the siding, and cutting through the heart of the little town where Elmer Richmond lives, now hardly more than a church and a few dozen houses. Once there was a general store with a café, but it's boarded up

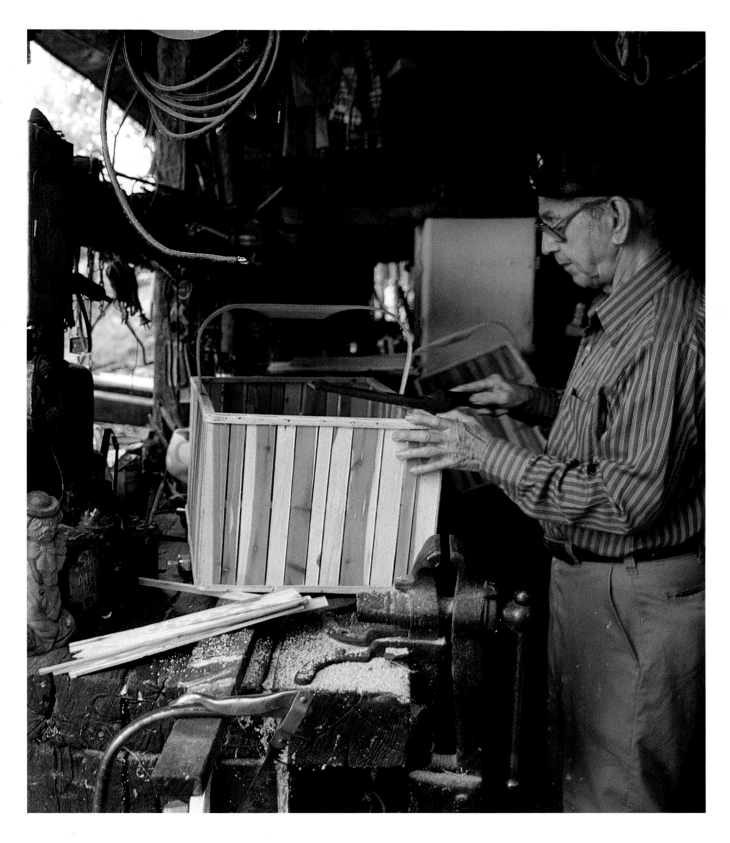

now. Wedged in the old store doorway is a seat from a car. Grizzled railroad men sit there, swapping stories of adventures that may or may not have ever happened. Elmer Richmond has no time to hang out there. He can't bear to sit and do nothing. He's prowling the hills, or tending his thirty-two stands of bees, or bottling honey, or tying up his tomatoes, or in his cluttered workshop, building a basket.

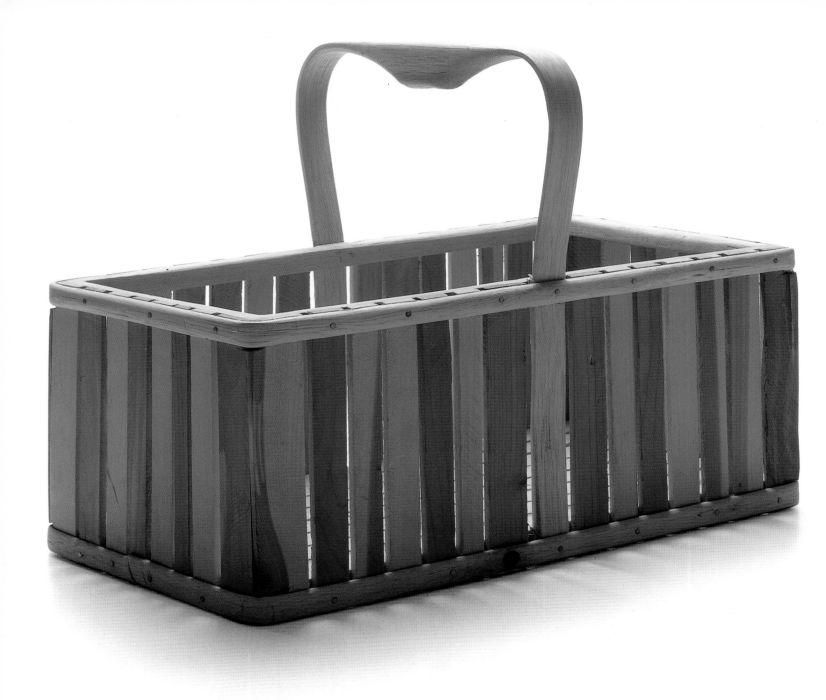

Above and facing page: cedar slat basket with carved
white oak handle

The true beginning of his baskets lies in the woods,
where he hunts for white oak and cedar trees.
Scouting the woods, sharp-eyed, loose-limbed,
tireless, he can easily walk twelve miles a day,
climbing the rocky trails like a mountain goat.
Getting white oak is easy, there's plenty of it. Cedar
is scarce. When he finds one, he goes hunting
permission to cut it down. Tangy scent fills the air as
he saws it into three-foot lengths, then splits them
into thin slabs with a froe, exposing the streaks of
magenta, rose, copper, ocher, and purple.

"I go about making a basket like building a house.
Start with the foundation, and then frame it. Carve
out the heart-shaped, white oak handle and set it in
there. Put on the cedar floor and walls. Tricky part is
putting the straps around the top and bottom,
bending them at the corners. There's one kind of
white oak bends easy, and another kind that'll
sometimes split on me. They've got the same bark
and leaves; out in the woods, I can't tell the
difference. Soaking it in water helps some, but there's
no way of telling if it's going to split till I get to
working it. Get her bent, nail the ends, dress her up,
and you got her."

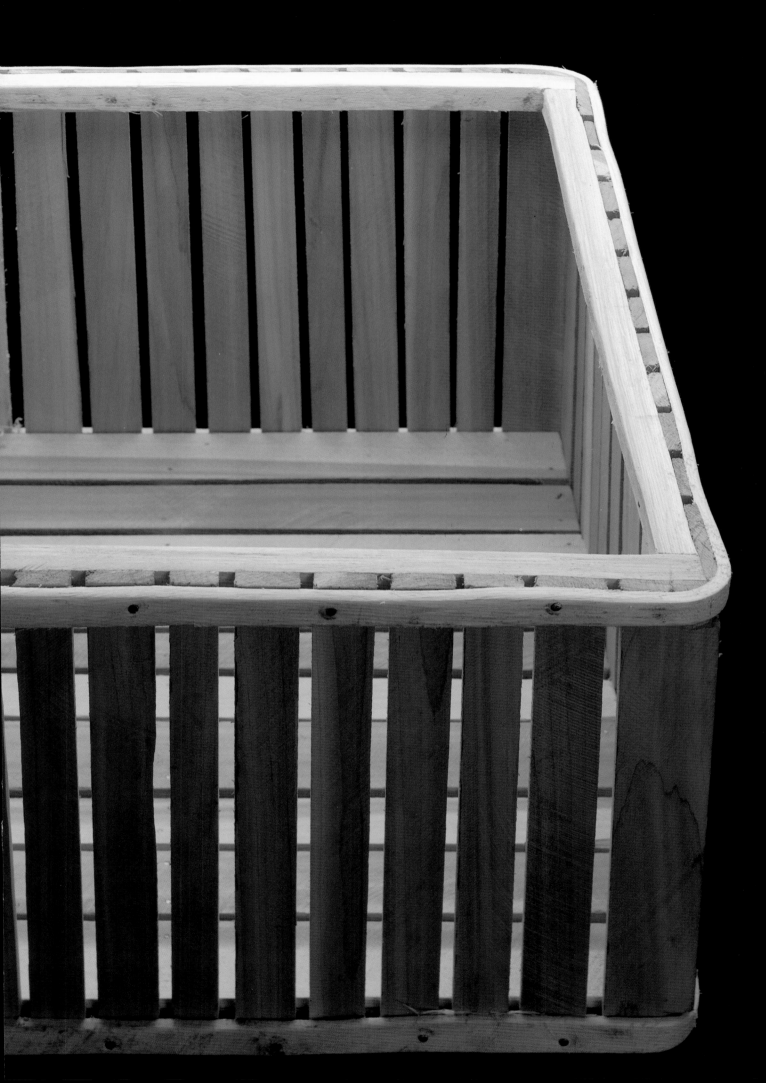

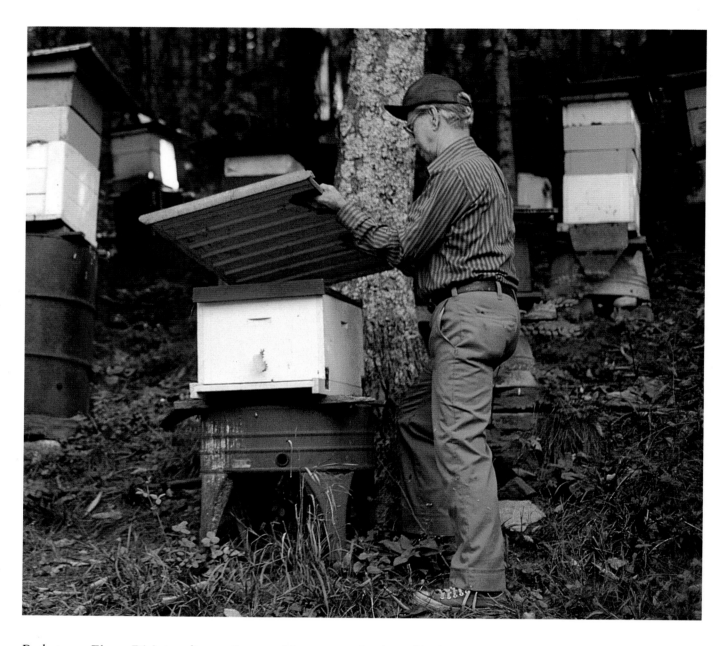

Baskets are Elmer Richmond's art. Bees are his obsession. "They live everywhere but the North and South Poles. How about that? Yes, sir." He leads a visitor up the slope alongside his home to the row of hives he has built in a grove of sourwood and linden. "I used to go with my father out in the woods of an evening to find a wild bee tree. Use smoke, you know, cut out a block and bust it open. We'd have a hive right close and be patient. Just give them time, and those wild bees, they'd go into it." He nods with satisfaction. "Then we'd have ourselves some honey for our buttermilk biscuits."

Smoothly, carefully, he removes a super, a wooden tray filled with honeycomb. "All the workers are female. They're the ones that run things." A trace of a grin touches his lips. "My wife says that ought to tell me something."

In the shed that serves as his storehouse, the quart jars gleam gold, umber, cinnamon, pale yellow. The almost transparent linn honey is his favorite. He shoves back his hat, his eyes glinting with admiration. "Oh, they're amazing little creatures. They've found fossil bees trapped in amber that lived about fifty million years ago."

Elmer Richmond was born on a farm in the hills looking down on the New River, an area where his kin have lived since the first buckskin backwoodsmen put up cabins in the wilderness, "the dark, bloody ground" that is now West Virginia. He treasures the things that connect him to the past, the hundreds of Cherokee arrowheads and spearheads he has uncovered while turning over the earth for planting.

He has his great-grandfather's long-barreled squirrel rifle. He's not sure how old it is. "It's a flintlock, and they used cap locks during the Civil War, so this gun comes before that. Just after the fighting ended, my great-grandad was killed by scalawags who rode through here. They wanted his horse, and he wouldn't surrender it. They stood him against a tree and shot him."

When Elmer Richmond was young, he worked alongside his father clearing the hillside, blasting out rock bars with dynamite, grubbing up stumps, digging out briers. "The most of our place was pretty steep going. It took West Virginia mules to work it, the kind with two short legs and two long ones."

The closest neighbor was miles away. It wasn't unusual to go for a month without seeing anyone but his immediate family. Every spring, he left school to help with the planting and didn't go back to the classroom until the fall harvest was finished. Other than school, the only places he went were church, the post office, and the little store on the mountain top.

"Only things we had to buy were salt and vinegar. We had honey and maple sugar for sweetening. There was a lot of wild game then, deer, rabbits and squirrels, turkey and pheasant. Squirrels are good eating. Tasty as anything in this world, if you know how to fix them."

From the turn of the century until the end of World War II, life up and down the New River swirled around the railroad. Coal trains, timber trains, rattling boxcars, flatcars, gondolas. Clacketing passenger trains, the whoosh and roar of the steam locomotive, the high, lonesome wail of its whistle.

Here she comes, look at her roll,
Ridin' those rails, eatin' that coal,
Like a hound dog waggin' its tail,
Charleston bound, bound, bound,
It's the fireball mail . . .

Elmer Richmond was born hearing train whistles. The little towns along the river swarmed with railroad men. Boarding houses were jammed. Saturday nights were raucous with whores, gamblers, dances, drunken fist fights. The main railroad yard with its machine sheds, roundhouse, and loading chutes was up the river in Hinton. It smelled of bitter coal smoke and echoed with the slam and squeal of coupling trains.

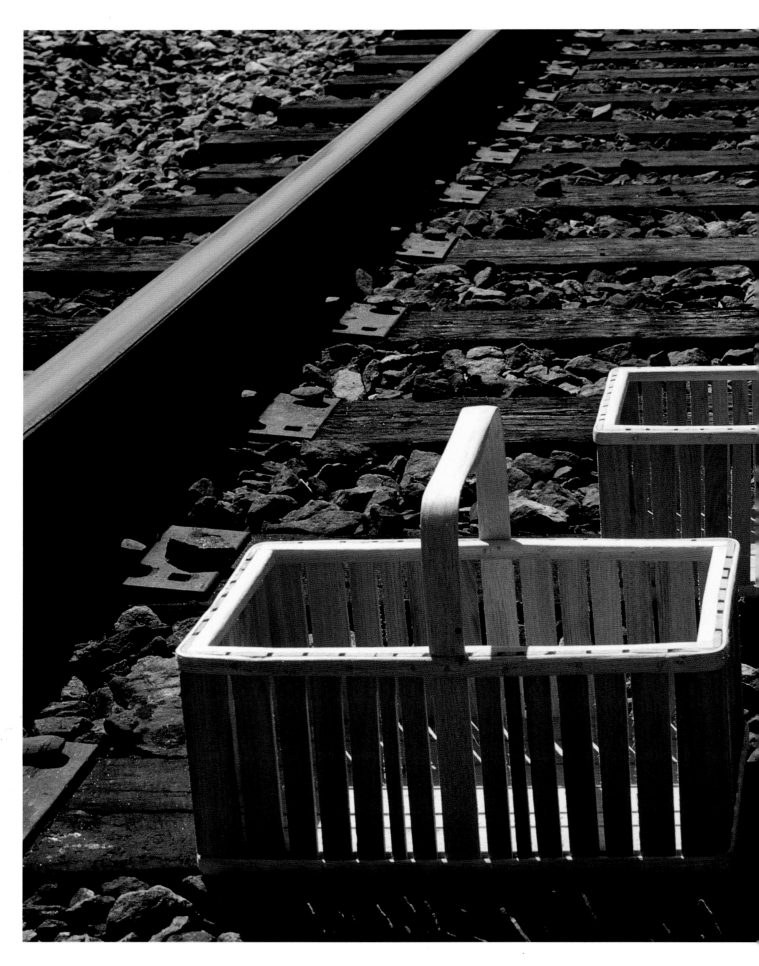

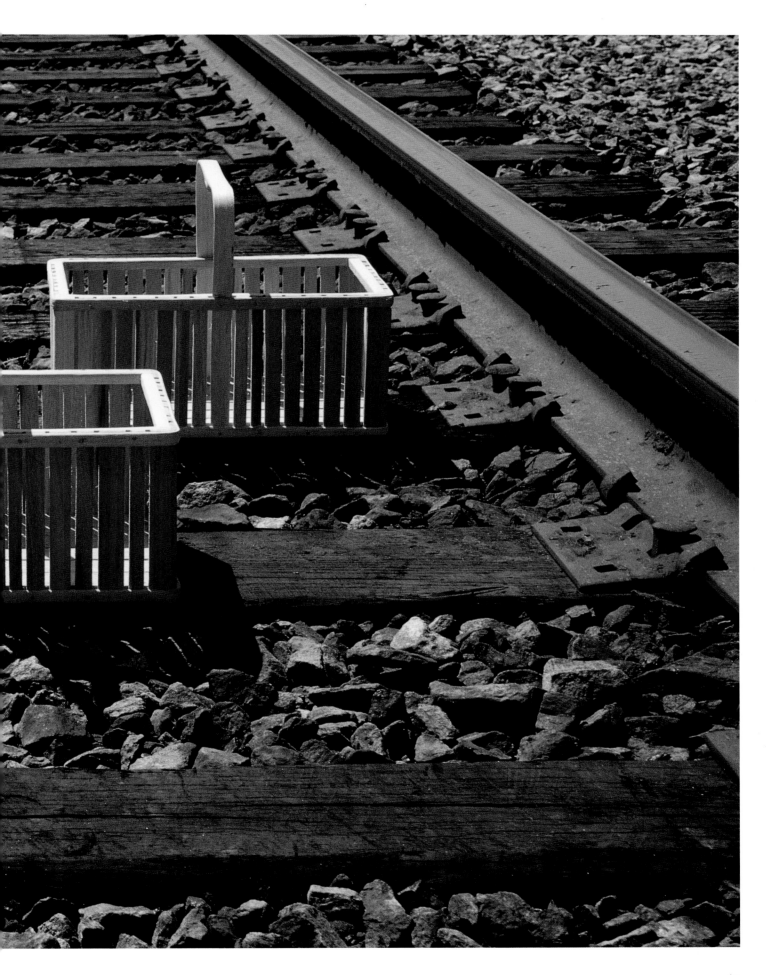

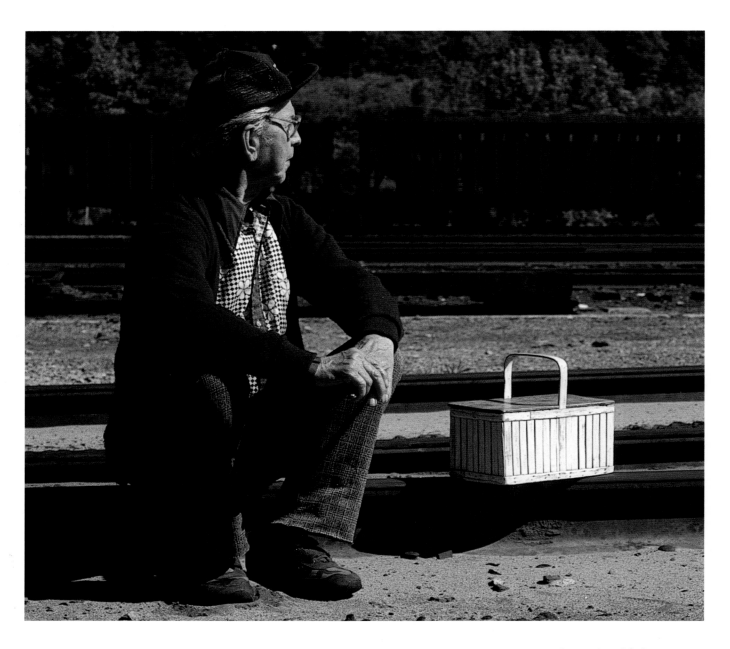

He started out as a gandy dancer, working section with a track-lining crew. It was rough work, dirty work, riding the track out to the job in an open motorcar, replacing rotten ties, shoveling rock ballast, straightening rails that had been skewed by thundering trains. He lived in boxcar houses, stumbling out at dawn to jam a heavy lining bar under crooked sections of track, heaving, grunting, straining—*Hey!, Hey!*—moving the rail, inching it, lining it up. That was the life Elmer Richmond led until he made foreman, after twenty backbreaking years.

Now and then, he visits the old train yard. It's pretty much deserted now, with only a few diesels passing

through. He isn't romantic about the old days.

"It wasn't anything to write home about. All filthied up, dirt in your eyes, breathing in smoke and cinders. Times there was a wreck, we'd be stranded in all kinds of weather."

After forty-three years on the railroad, Elmer Richmond retired. That's when he started making baskets. He turns them out in all sizes, some to hold a small flowering plant, some to carry a picnic lunch, some large enough to hold a day's firewood, and others large enough to carry a baby and serve as its crib.

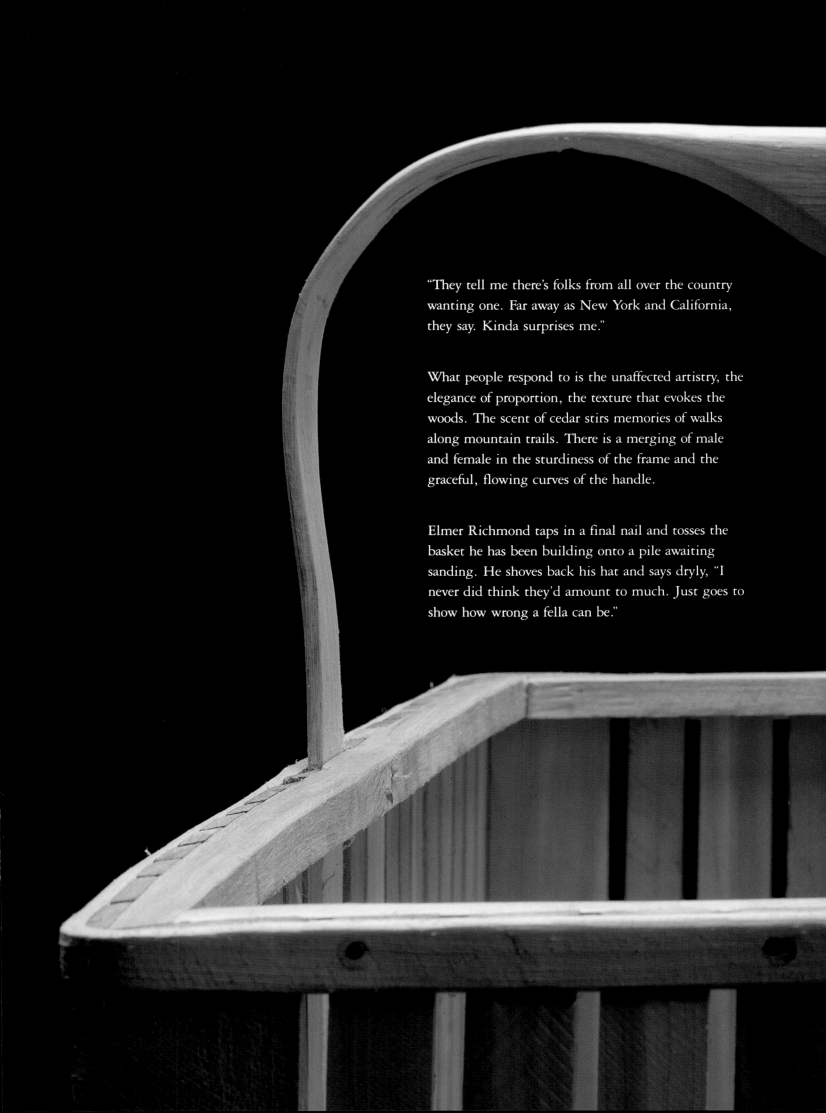

"They tell me there's folks from all over the country wanting one. Far away as New York and California, they say. Kinda surprises me."

What people respond to is the unaffected artistry, the elegance of proportion, the texture that evokes the woods. The scent of cedar stirs memories of walks along mountain trails. There is a merging of male and female in the sturdiness of the frame and the graceful, flowing curves of the handle.

Elmer Richmond taps in a final nail and tosses the basket he has been building onto a pile awaiting sanding. He shoves back his hat and says dryly, "I never did think they'd amount to much. Just goes to show how wrong a fella can be."

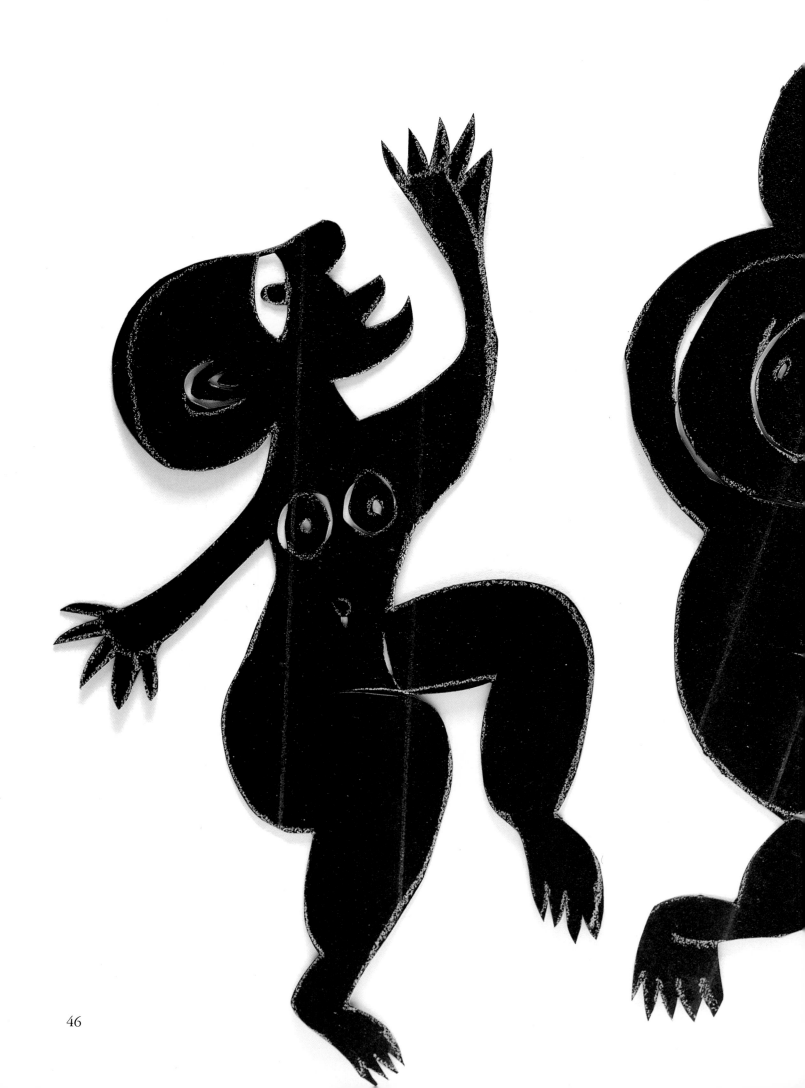

46

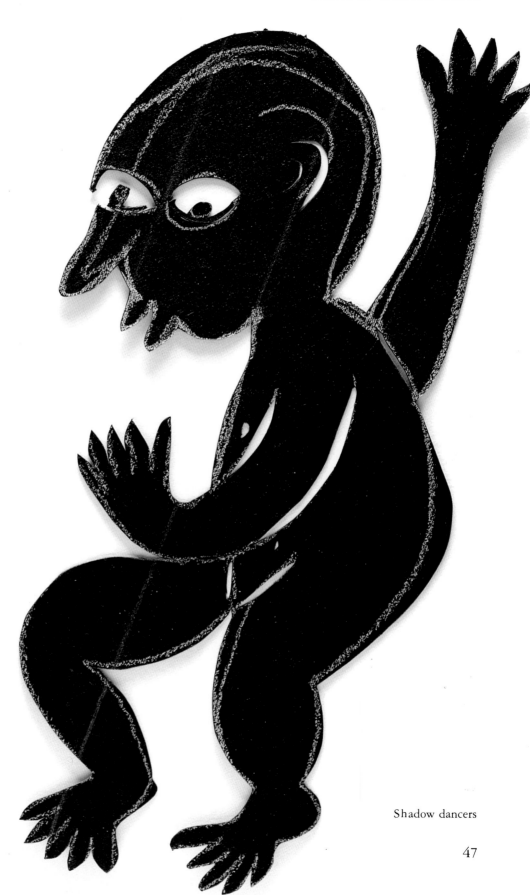

"When people ask me if I'm a trained artist, I have to laugh.
I'm not a trained anything. I'm barely civilized."

CHER SHAFFER

Shadow dancers

CHER SHAFFER

BROUGHT UP on a farm in Georgia, Cher Shaffer, now in her early forties, lives in the mountains of West Virginia. She is married to a man who represents farmers in sales of their crops, and she divides her days between the fires of creation and the demands of domesticity. There are times when she looks like a frazzled lady who got lost on her way to a PTA meeting and times when she has the unearthly beauty of one possessed. She has a laugh like the mating call of a woodchuck and a sweet absorption in her children. Her swiftly changing personality evokes the plaintive cry of Jean Cocteau: "Do not understand me too quickly."

She is a painter, wood carver, housewife, stone sculptor, and maker of haunting figures created from torn strips of cloth, wood, clay, human hair, seeds, shells, claws, fur, and feathers. She is a practical,

down-to-earth mother, a rebel, a mystic, a dreamer, a one-woman magic show. Now you see her, now you don't.

Cooking squash and chicken for supper, Cher Shaffer has an air of prosaic sanity. At the kitchen table, her youngest, five-year-old Raven, is undressing her Barbie doll. Off in his room, thirteen-year-old Gabriel is listening to the heavy metal din of Bon Jovi, his favorite rock group. Out in the yard, eight-year-old Scarlett and a friend are locked in earnest debate over which boy in their class is the most disgusting. This is hardly the scene in which one expects to meet an artist driven by wildness, one whose works range from buoyant innocence to the dark night of the soul.

Sliding the pan of squash into the oven, Cher Shaffer declares amiably, "I have a lot in common with a mermaid. What is a mermaid, anyway? Half fish, half woman, caught between two worlds."

The forms and styles of her pieces have a dazzling variety. She turns out acrylic paintings, chalk and ink drawings, paper cutouts, figures of fired clay, wood, and stone. Considering that the only times she can claim for her own are the hours at dawn before her children awaken and at night when they are sleeping, her outpouring of art is astonishing. She creates by instinct, in an almost unconscious state of furious passion, feeling herself to be the medium of some supernatural force whose power she accepts as perfectly normal, saying matter-of-factly, "Something out there is speaking through me."

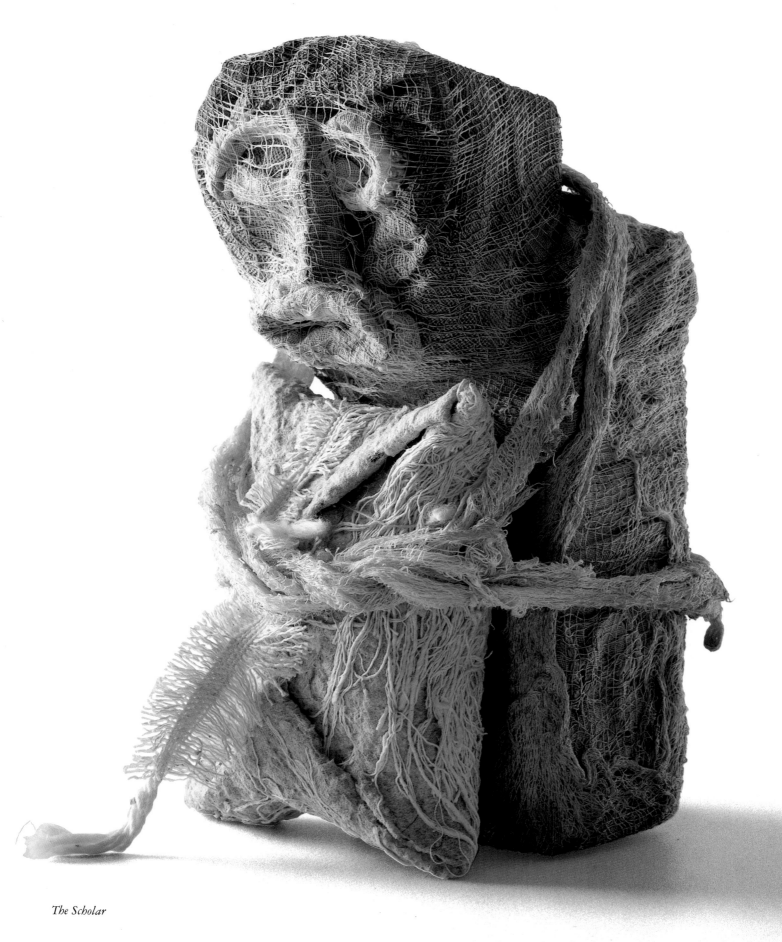

The Scholar

Starting on a new work, Cher Shaffer talks to it. She treats it as though it were an independent being with a life of its own and confides to it her innermost feelings. Amusement bubbling up, she says, "I know, I sound like an idiot." Her laugh, a bright bark, ends in a sigh. "Well, it's true. The things I'm working on speak to me. They help me unravel the mystery of what a piece is, or should be, or wants to be."

One corner of the basement family room is out of bounds to the children. It serves as her cramped studio. Like the lair of an alchemist, it is filled with objects whose uses are mysterious. A rusty railroad spike, a clutter of oddly shaped stones, bleached driftwood she has scavenged from the banks of the Ohio River, a blue and white speckled dishpan, scraps of leather and rags, old beads and bells she has rummaged out of boxes of junk in dusty thrift shops. Scribbled on the back of a grocery receipt pinned to the wall is an idea for a painting: "I Am the God of White Trash."

Sitting at her work table, dark hair framing her sensitive face, there is something touching about Cher Shaffer, something vulnerable, an uncertainty in her voice as she gropes to describe what it's like when she works:

"Things take shape in my mind. When they come, it's fast and furious, it's . . . a panic almost. I close myself up. I don't see anything, I don't hear anything, I become what I'm doing. And that's scary when you've got three kids running around, and it gets to the point where all of a sudden it's, oh god, where's the baby?"

Her art is deeply personal, springing from the joys and terrors of her Georgia childhood. A polite, obedient, observant girl, she was fascinated by the black sharecropper families who surrounded her. "I was a little fearful of them," she remembers. "I was told to be fearful. But I watched them. I watched them."

Dancing Rabbit

50

Helvetia, a West Virginia village founded by Swiss immigrants.

The lives of blacks seemed so much more vivid and colorful than her own. She watched them working in the fields, peered in their yards as she walked past, absorbed the games of their children, learned about their superstitions and customs. Lingering outside their church, she listened to the foot-stomping, hand-clapping spirituals that were so much more thrilling than white hymns. In them, she heard the searing images that, in the future, were to shape some of her work:

In that great gettin' up mornin',
You will see the coffins bustin',
You will see po' sinners weepin',
And you'll hear the hellhounds barkin',
With the rumblin' of the thunder,
And you'll see the moon a'bleedin',
See the blazin' stars a'fallin',
In that great gettin' up mornin',
Fare thee well, fare thee well!

In the dusty, suffocatingly hot summers of her childhood, Cher Shaffer went to Mississippi to visit kinfolks. At her grandmother's house, she had to sleep in a bedroom where someone had recently died. Recalling it, her voice tightens: "I was so fearful. I came to associate the night with death. Where my grandmother lived, they still had wakes. The body was laid out at home, and all the relatives and friends would troop in to look at it. I was forced to kiss a corpse once, when one of my aunts died. After that, when there was a wake, I stayed out in the yard, hid behind a tree, and tried to make myself invisible. It didn't always work. Some kind soul would find me and lead me in to say goodbye to poor what's-his-name." It would be a long time before art offered her a way to deal with darkness and death.

Cher Shaffer was twelve, getting into thirteen, and about to start high school when the family fortunes hit a bad stretch and her father decided to sell the farm and move to Atlanta. She panicked at the thought of entering a big city school where students were experimenting with dope and sex. Hidden beneath her obedience had always been a spark of defiance. That summer, it flared.

"I told my parents I couldn't go to school in Atlanta. My father said, 'What do you mean you can't? You have to.' I just flat-out refused. My dad couldn't believe I was rebelling. He told me, if I was so all-fired determined to go to that country high school, I'd have to figure out a way to get there. It was thirty-five miles from Atlanta. I got up at five in the morning, dressed, and rode the bus for two hours. Most days, I'd be so damned tired I'd conk out and sleep the whole way."

Her stubborn declaration of independence started the changes that were to lead Cher Shaffer to become an artist. From then on, she stopped trying to be what others wanted her to be, stopped doing what was expected. She began to open herself up to her turbulent, secret feelings and began to explore her visions, even the frightening ones.

"I grew up in a generation," she says, "when it was normal to be blasted out of your mind most of the time. But that wasn't for me. I never took drugs, because I didn't need them. Why should I trip out on some hallucinogen when all I had to do to be in another world was sit down and be quiet for a few seconds?"

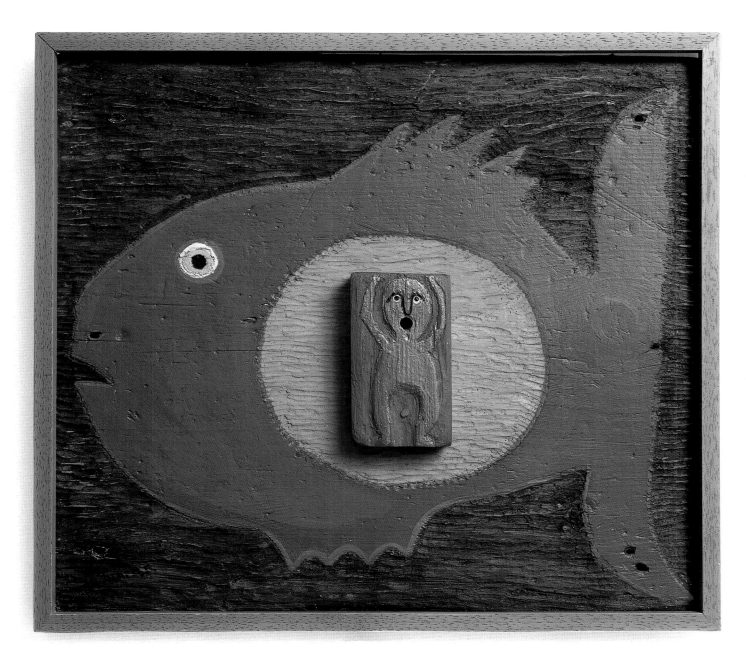

Jonah Crying Out From the Belly of the Whale

She didn't start to paint seriously until her mother died. By then, she was in her early thirties, married and living in West Virginia. While her mother was ill, she went down to Georgia for a visit. "When I was ready to leave, she kissed me goodbye as though it was for the last time. She didn't withdraw, but she severed the cord, because she knew I was going to be without her. The day she died, I remember distinctly, when the telephone rang I knew why it was ringing. When my father told me that mother was dead, I didn't cry."

Remembering it, Cher Shaffer falls silent, then whispers again, "I didn't cry. I told my husband I wanted to be by myself and went into the bedroom. It was dusk, but I didn't turn on the light. I sat in a rocking chair and the tears came. It wasn't hysterical weeping, it was just drip, drip. And then I actually felt my mother touch me, and it was like, it's okay, honey, don't worry. I remember saying, 'Mother, I don't want to lose you.' I had my eyes closed, and it was like I was a child. I was on the farm, eating food my mother had cooked, watching her can tomatoes, touching her." Cher Shaffer's gaze turns inward. She draws a ragged breath. "That's the thing I miss most, touching her."

Her mother's death was the trigger that tripped the wire and set the gears of creation in motion. She began to paint what had affected her powerfully in her early years, scenes of black family life. She found herself able to pull off the rare feat of recapturing innocence, looking at the world with childhood eyes. Becoming a child again was a way of keeping her mother alive, reaching out to her, touching her, exorcising the demons of grief.

In addition to painting, Cher Shaffer has been creating, since early on, clay figures. She has no training in the technique and doesn't want any. "When you don't know any better," she grins, "you can make up your own rules." In *Repent*, the figures are no more than two inches high. A preacher and the stalwarts of the congregation beseeching a drunkard to wash away his sins in the blood of the lamb and come to glory. The piece has the innocence of a child's vision of salvation.

As a compassionate adult, Cher Shaffer is all too aware of the harsh struggle, the misery of being poor and black in Georgia's red clay country. But that isn't what she depicts. She presents black life as it appeared to her when she was seven or eight, re-creating the vibrant colors, the joys, the unquenchable energy. Her paintings have the enduring feeling of folk tales. They are celebrations of homely events. *Jumping Over the Broomstick*, for instance, depicts a ritual that goes back to slavery days, one meant to bring good luck to a bride and groom. The painting has, like the one that followed it, *The New Baby*, a bittersweet gaiety. It is the black world of the rural South, not as it was, but as it ought to have been.

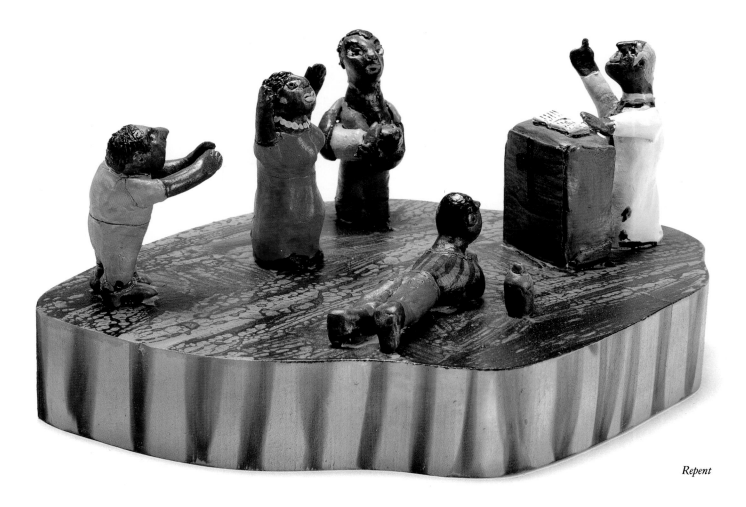

Repent

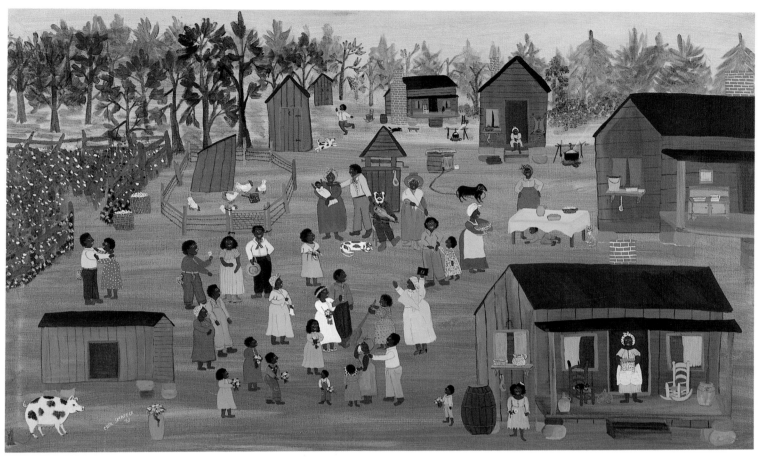

Jumping Over the Broomstick

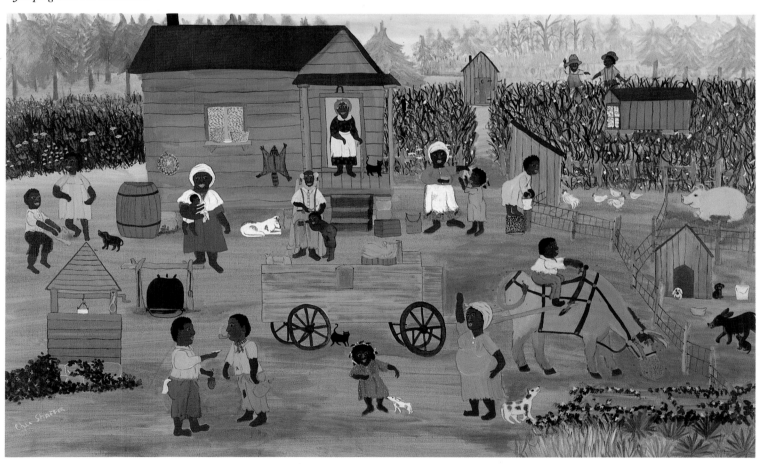

The New Baby

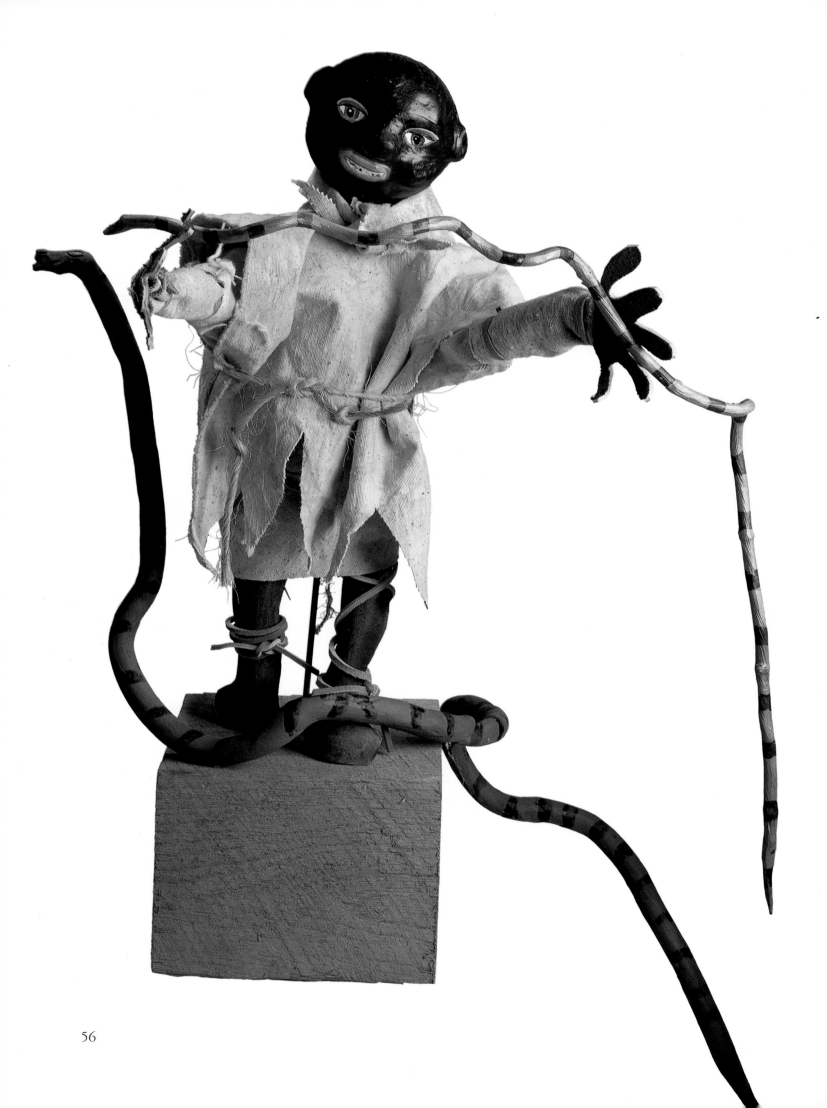

The Snake Handler (facing page), a knee-high figure dressed in scraps of leather and rough cloth, was inspired by raggedy, black, back-country preachers who worked in the fields from can to can't-see, six days a week, and took to the pulpit on Sundays. As a child, Cher Shaffer had peered into a small church in a cotton field and been hypnotized by a preacher who brandished a live rattlesnake, demonstrating the depth of his faith by obeying the words of Jesus reported in Mark 16:18: "They shall take up serpents. . . ."

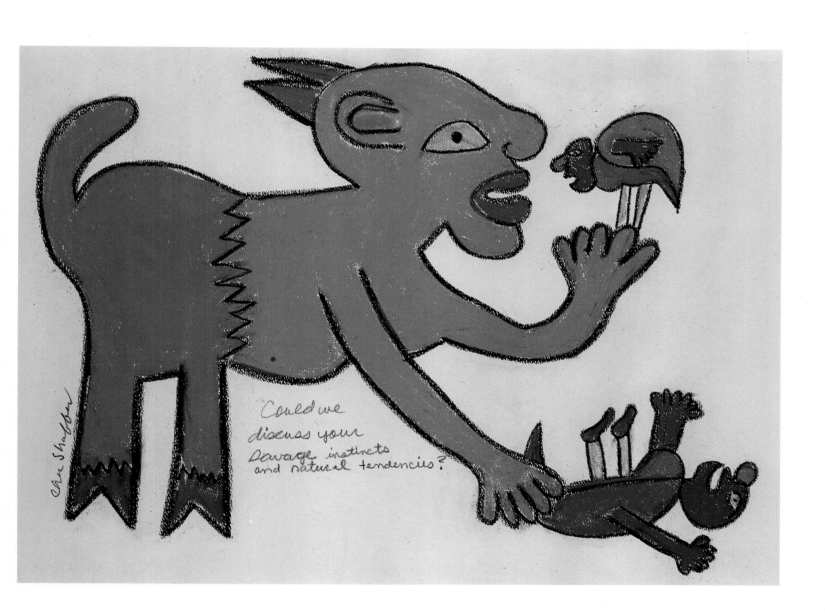

Savage Instincts and Natural Tendencies

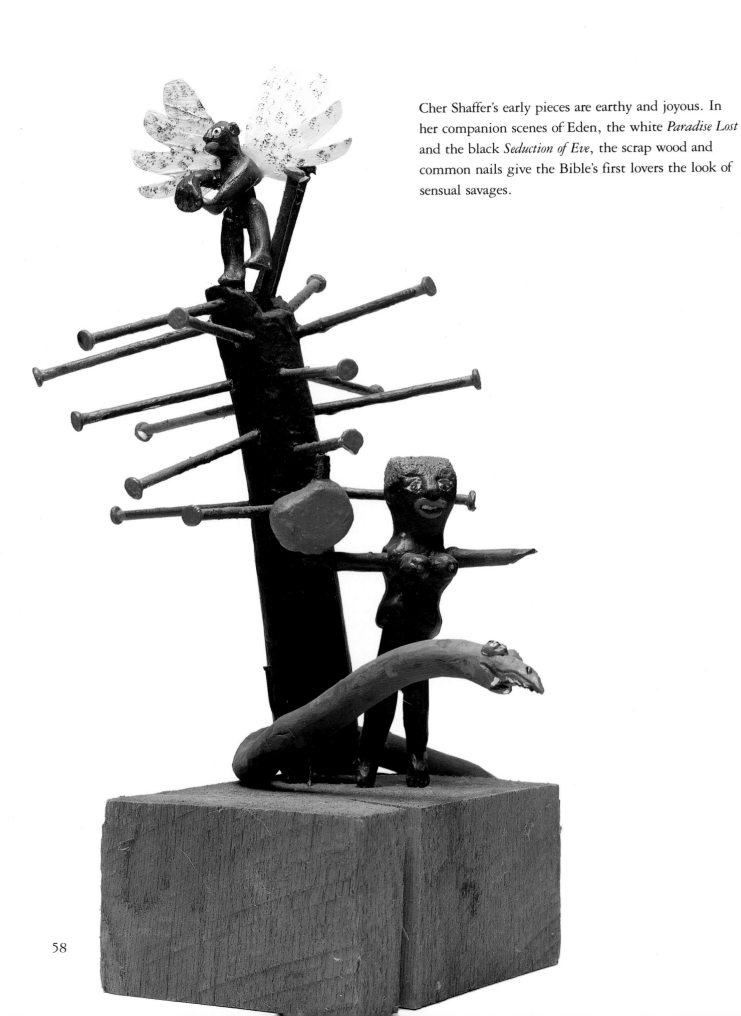

Cher Shaffer's early pieces are earthy and joyous. In her companion scenes of Eden, the white *Paradise Lost* and the black *Seduction of Eve*, the scrap wood and common nails give the Bible's first lovers the look of sensual savages.

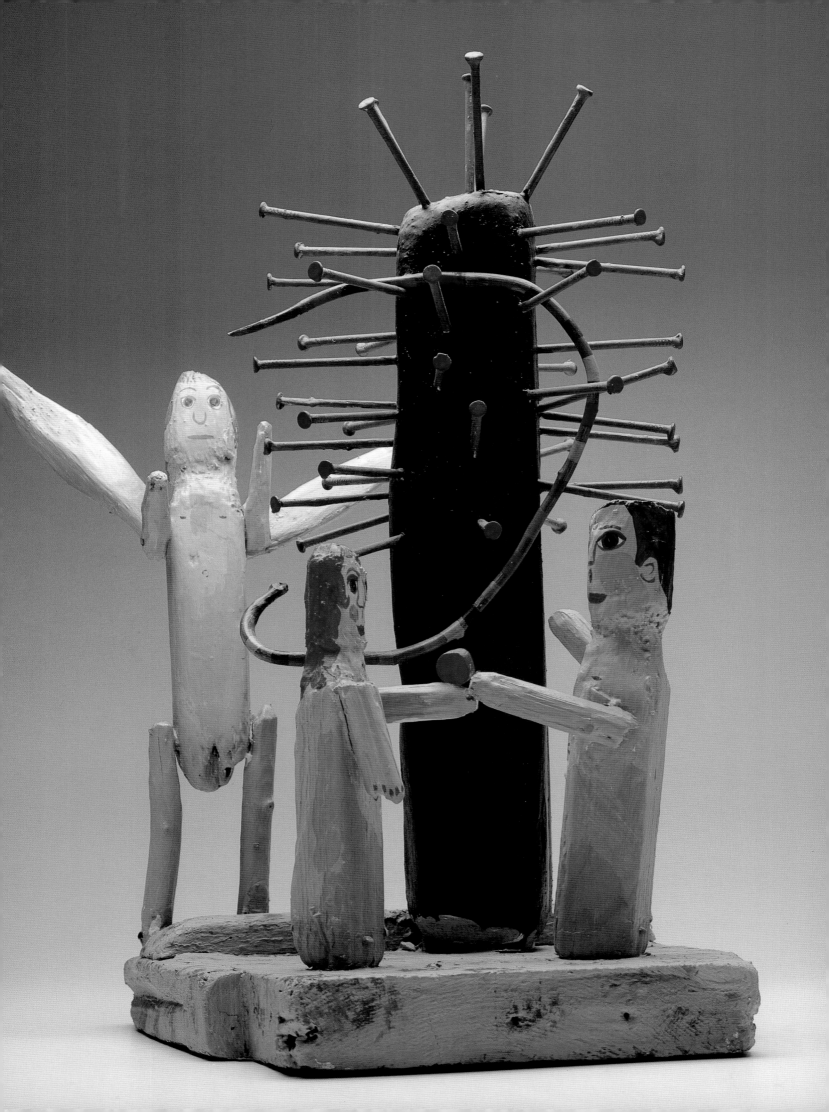

A striking change entered Cher Shaffer's art when a dangerous illness forced her to face her own mortality, deal with the death she had always felt lurked in the dark. She embarked on a series of night paintings. In *Full Moon Madness*, a voodoo priest whirls a chicken around his head, a bird that will be sacrificed to call up the spirits of the dead. To accompany the scene, she has fashioned a poem:

In the dark of the moon is evil conceived,
In the shadow of the moon is evil planned,
In the light of the moon evil comes to life,
> *and there is madness,*
> *full moon madness . . .*
And the earth roars!

Probing deeper and deeper, Cher Shaffer discovered things in herself that disturbed her: selfish, petty, spiteful feelings, feelings that were vindictive and cruel. Out of the heat of this discovery came seven fetishes. From two to three feet tall, her *Oracles from the Fire* are swathed in gauze, decorated with bits of glass, china, beads, and shards of bone. Wearing wolf and sheep's wool and the hair of her daughter Raven, they are Cher Shaffer's protectors, the spirit figures that enable her to control the emotions she hates.

"I'm working out my fear of the dark," Cher Shaffer says softly. "I don't know whether I'll ever get over being scared, but at least I'm able to understand it more. The reason I'm afraid of the dark is because that's when evil spirits come to power. In the act of giving them form, I'm keeping them from taking over my life."

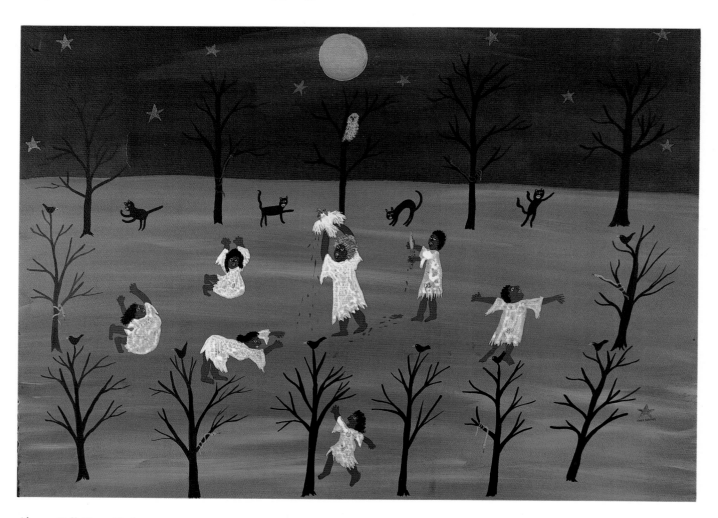

Above: *Full Moon Madness*
Facing page: *Oracles from the Fire: Nightstalker;* overleaf, left to right: *Oracles from the Fire: Tangled Talisman, Wolf in Sheep's Clothing, Celestial Image, Mummy Dearest, Guardian of the Two Full Moons*

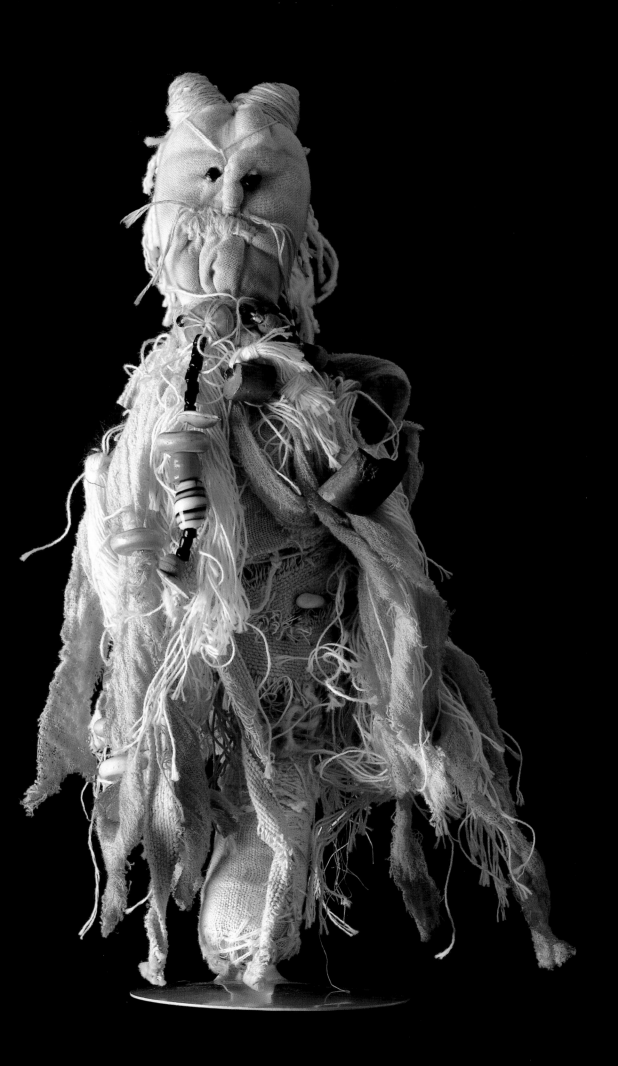

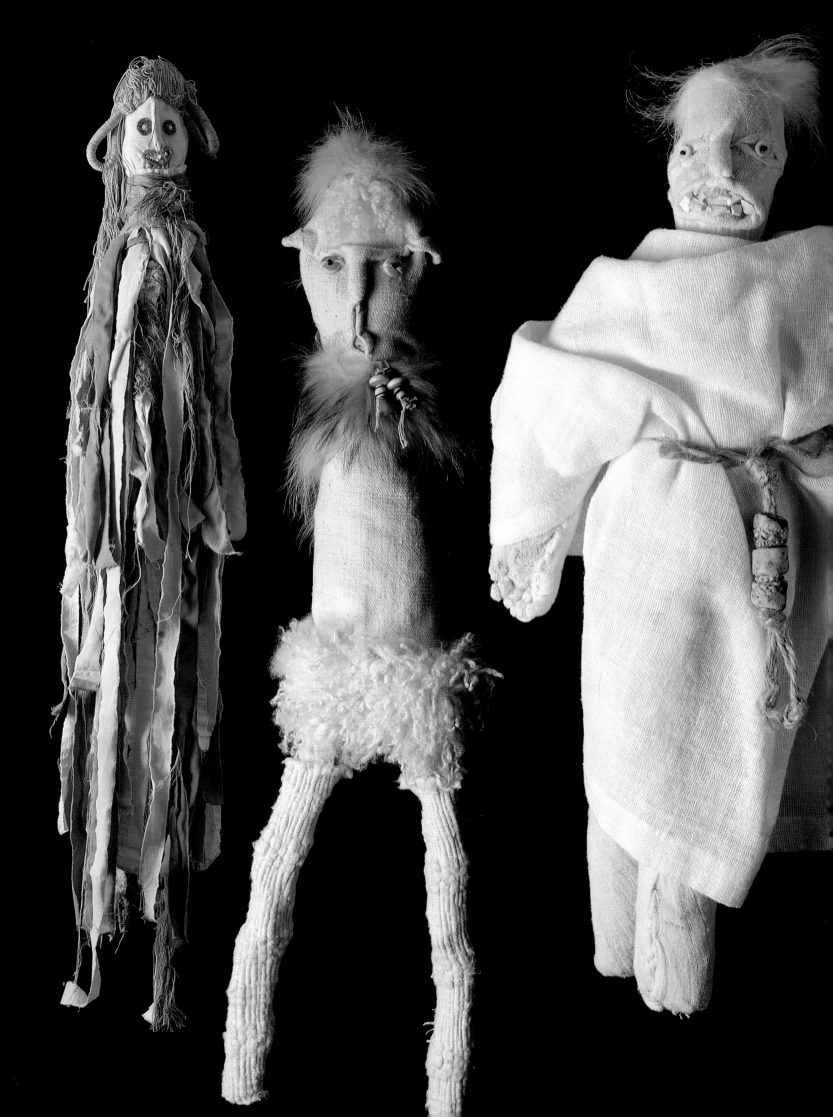

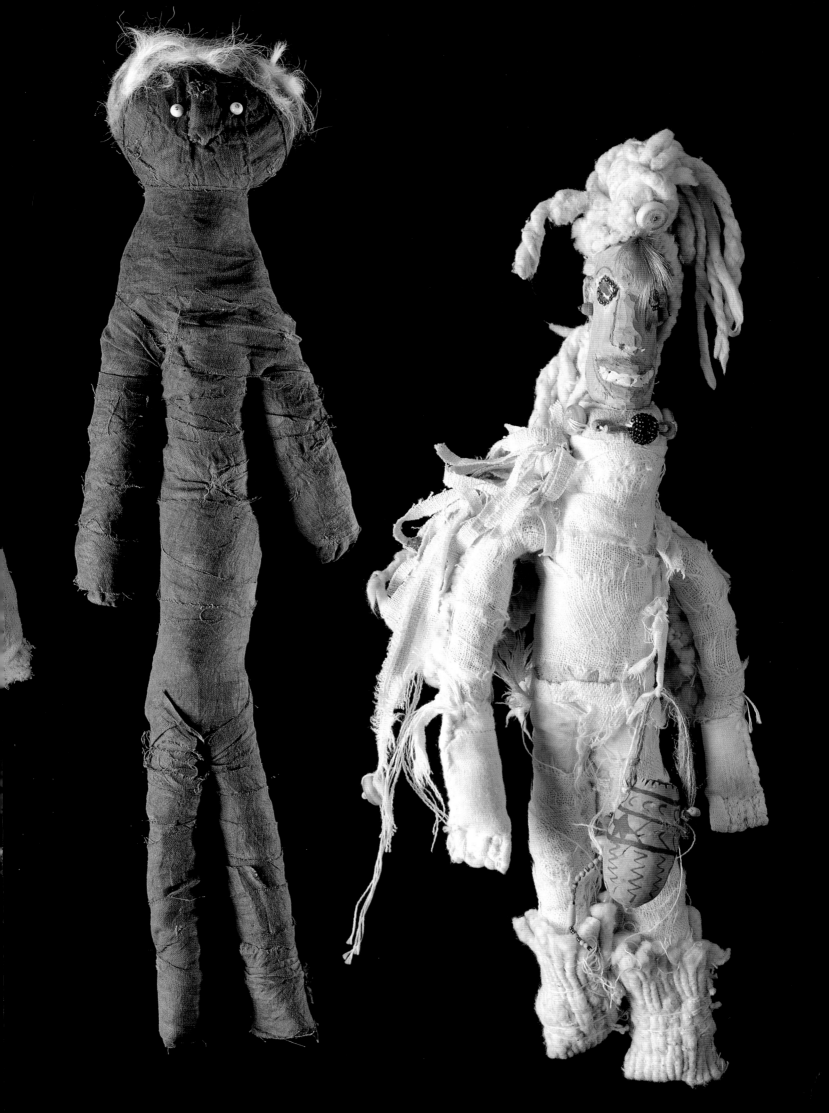

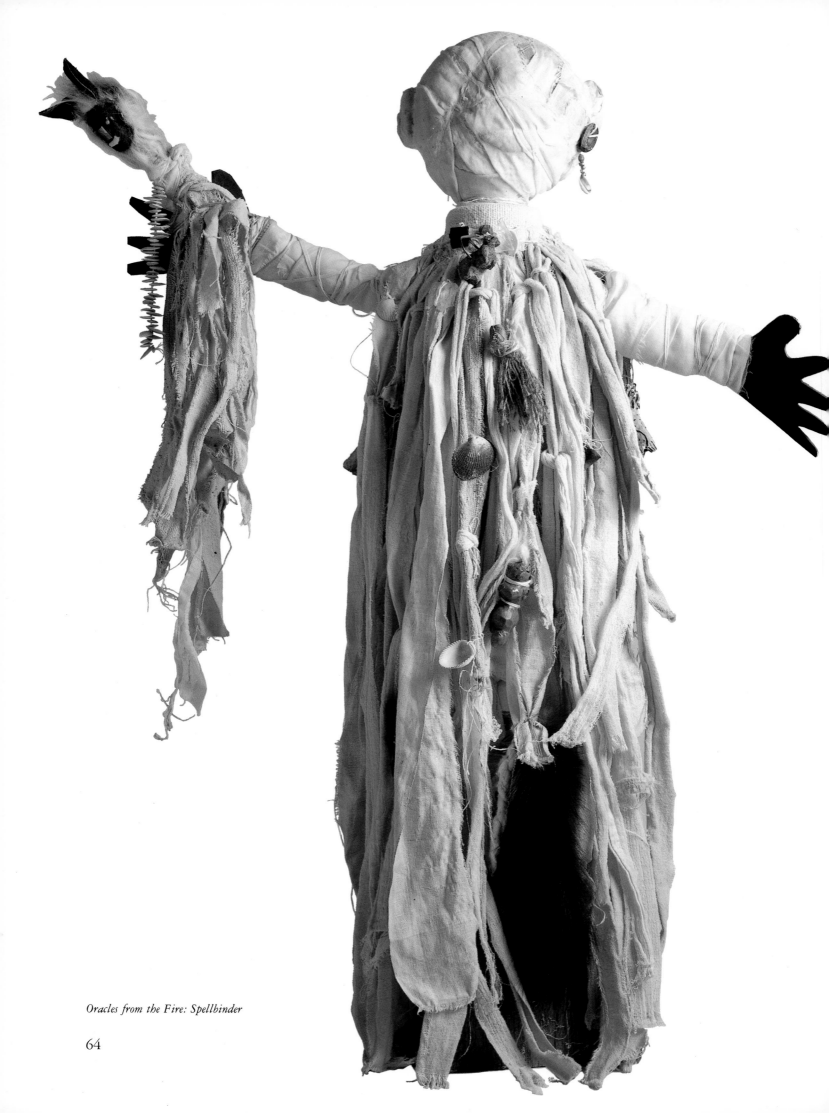

Oracles from the Fire: Spellbinder

64

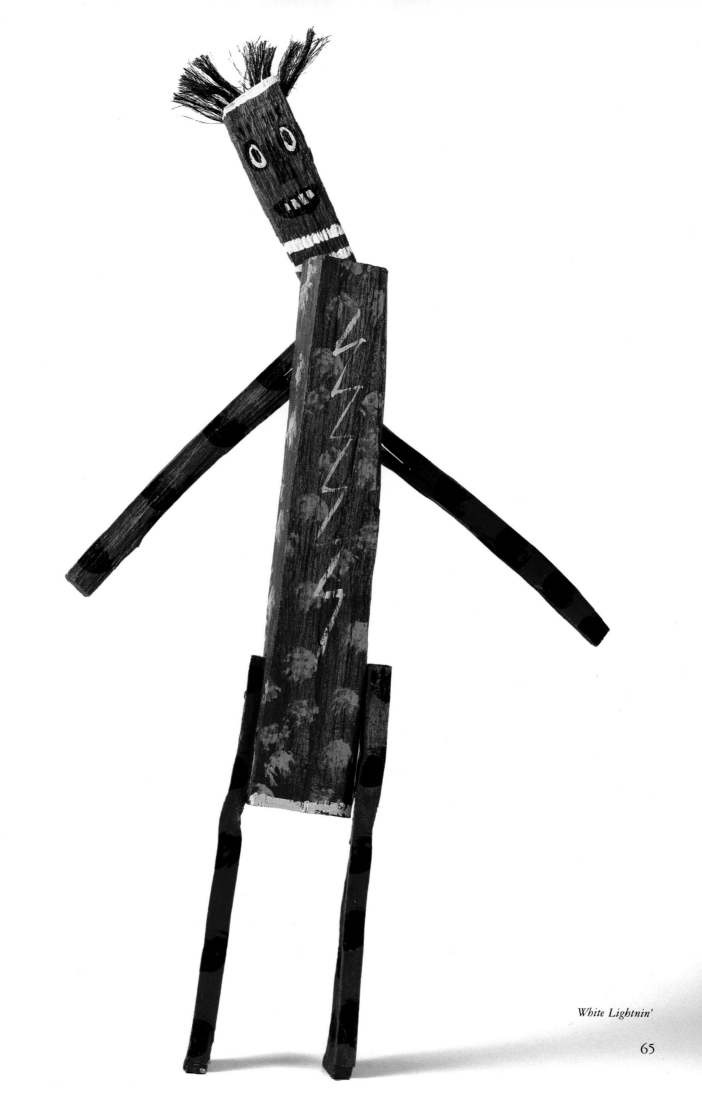

White Lightnin'

Her work has gone from light to dark, from innocence to an awareness of evil. Now light is creeping back. Her silhouettes have the charm of Javanese puppets. Her chalk drawings of imaginary birds and beasts are bright and mischievous. She is creating joyous new sculptures, amulets of fired clay.

"Everything that's natural has a soul," she says. "Earth, stone, even a piece of wood cut off a tree still has a soul. God put that wood there so I could come along and find the soul in it." She caresses a twisted driftwood branch. "Things move and breathe for me. Things speak to me, they speak to me. . . ."

In all its infinite variety, Cher Shaffer's work sings, it moves, it dances. Cherishing the child in herself, she is doing what every artist dreams of doing, creating a world never seen before.

Above: *Medicine Man*

Paradise Lost

66

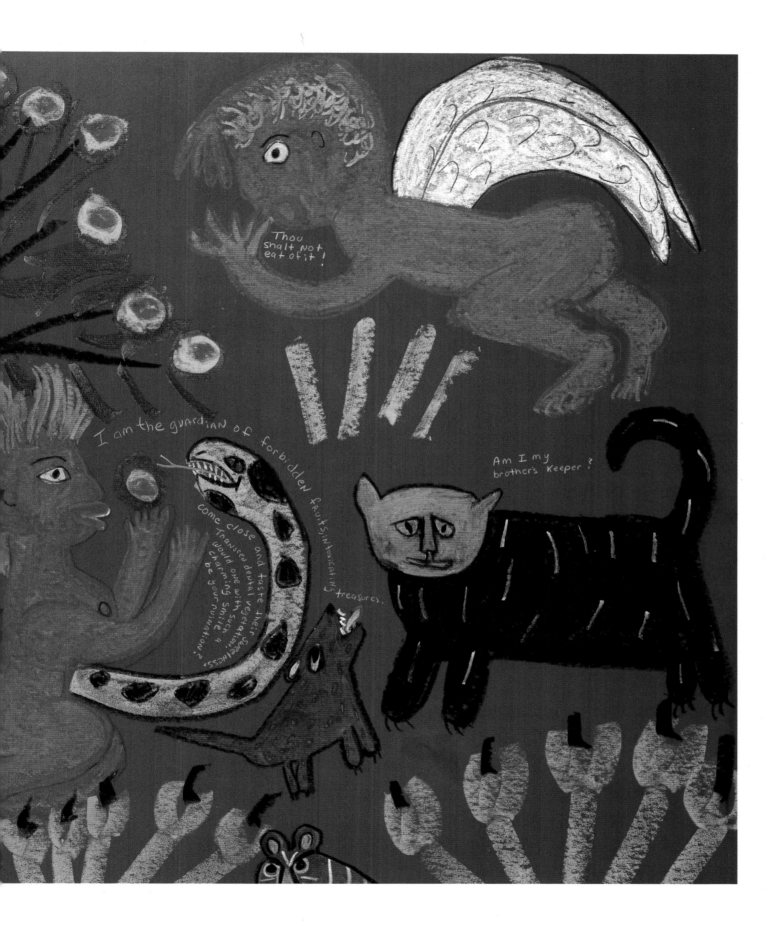

"The best thing about living here is the peace within myself.
The next best thing is the colors.
Just look at those trees, the wildflowers, even the weeds.
Green alone, there are fifty shades of it."

CONNIE McCOLLEY

CONNIE McCOLLEY AND TOM McCOLLEY

GENERATIONS before the Declaration of Independence, white men made their way into the Appalachians. Solitary hunters after pelts, they came and went. The first settlers followed, most of them from the stinking slums of London, the bleak Scottish moors, the bogs of Ireland. Few had any skills. The skilled craftsmen who voyaged to the New World had no desire to risk their necks in the mountain wilderness. They set up shop in the coastal cities where there was money to be made.

Unskilled as hunters and trappers, remote from any marketplace, the Appalachian pioneers who survived were those who quickly learned how to use an axe, a plow, a flintlock, and a skinning knife, the ones who learned the edible wild greens and berries from the Indians.

Centuries back, homesteading—living off the land—was a mountain way of life. For some people living in the Appalachians, the dream of homesteading is still alive.

The West Virginia road winds through Wildcat, Little Birch, and Strange Creek. It branches at Big Otter. If you hit the town of Left Hand, you've turned the wrong way. Past Chloe and up a hollow, outside his home on the mountainside, Tom Mc-Colley is riving a young white oak, making basket splints.

He splits the tree into halves, then quarters, then eighths. Sitting astride his shave horse, he uses his drawknife to slice off the bark. Working with a froe and his razor-sharp pocketknife, he peels apart finer and finer strands.

McColley baskets rival the best American Indian baskets in their perfection of technique, evenness of splints, tightness of weave, and the subtle eloquence of their color and design. Like the Indians, this husband and wife work out of a long tradition. But beyond that, many of their baskets are daring leaps into a world of shape and pattern all their own.

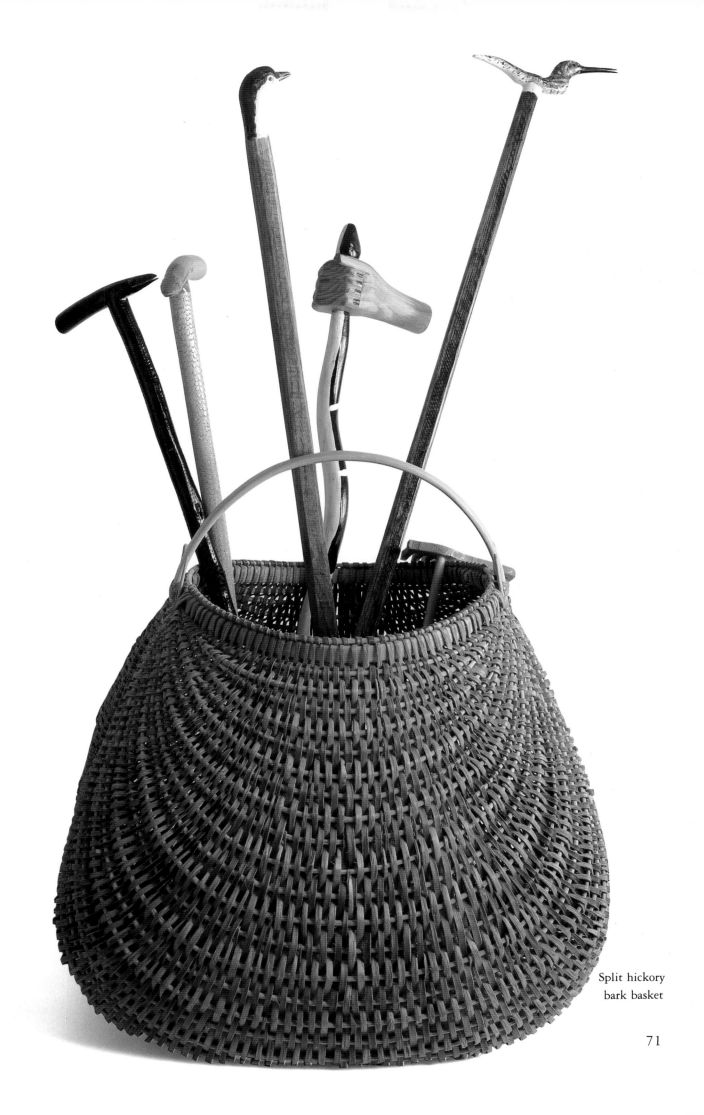

Split hickory
bark basket

Tom McColley comes from the sleepy whistle stop of Napoleon, Ohio. When he met Connie, he was driving an ice-cream truck in Columbus and she was working in a bakery. Tom McColley grins in reminiscence. "We didn't know the first thing about farming. What we shared was this feeling of wanting to get out of the city, live simply, go back to nature. We heard there was cheap land to be had in West Virginia, and we set out from Ohio to find us some."

What they found was a deserted farm. It was autumn, and the weeds were up over their heads. They pushed through the brush, up to the house. It had been empty for a dozen or more years. Some of the window panes were missing, and part of the floor had been eaten out by groundhogs, but they knew it was the place for them. With a homesteader's dogged

determination, they spent days shoveling out broken glass, leaves, and dirt, tacking up plastic over the windows, and repairing the floor. They bought a big cast-iron stove from an old lady who lived up the hollow and hauled it out of her house with a rope, onto the muddy road.

"We got it into a wheelbarrow," Tom McColley recalls, "but dragging it home took forever. We didn't have any wood. I figured to cut some, but before I could do it, wouldn't you know, there come a blinding snowstorm. We were freezing our tails. Only thing we had for heat was a little camp stove that ran on white gas. By the time I got the big stove hooked up and ran the pipe out through one of the broken windows, here comes our neighbors' boy with a feed sack full of firewood."

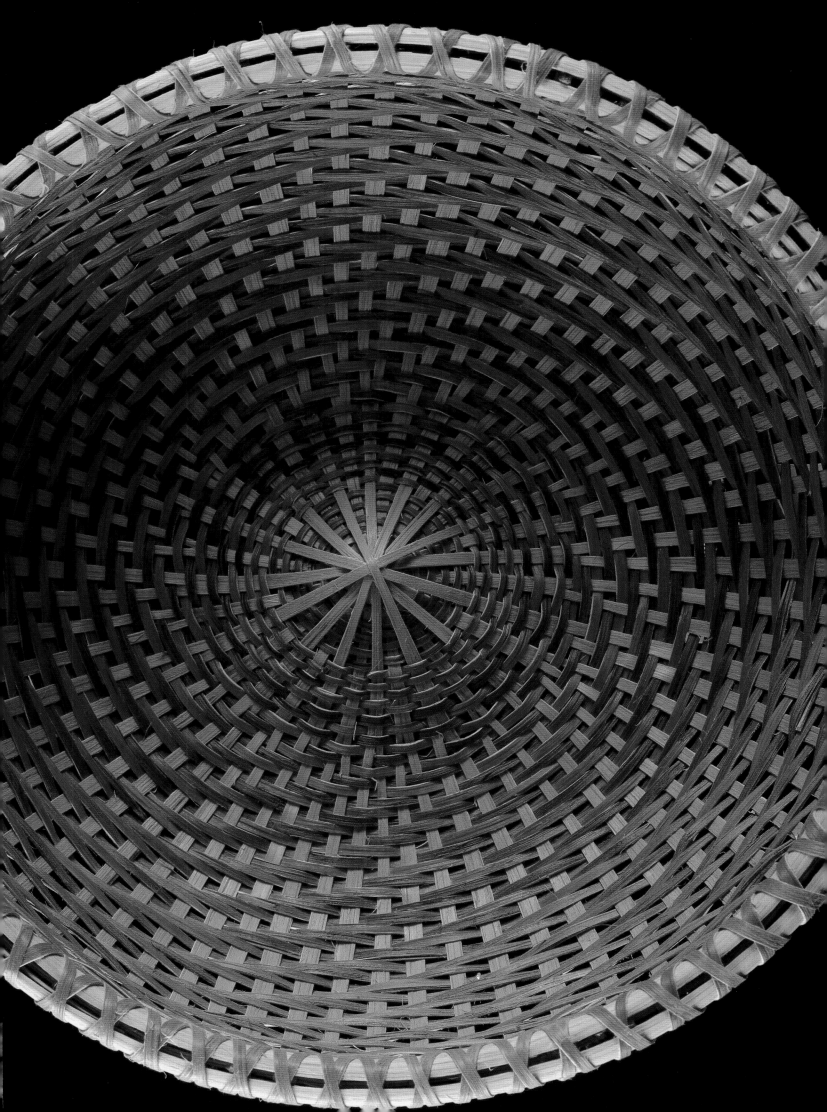

When the money ran out, they had to sell their rattletrap pickup truck. They had a work pony. Tom McColley built a cart they could use to go into town to shop and buy feed for the chickens and animals.

Connie McColley smiles at the memory. "We had to walk four miles to pick up our mail. On pretty days, I loved it. I'd collect wild herbs, you know, see what was growing, pick flowers and put them in my hair."

When their money ran out again, Connie McColley went to work in a hubcap factory. A friend who also worked there gave her a lift to the factory, but she had to walk the first six miles. She crossed a rickety, swaying, slippery footbridge, hanging onto the guard ropes with both hands and clenching her lunch sack between her teeth.

The McColleys cut brush, planted their first garden, and put up fences. They'd never done any of those things before. They just jumped in and figured it out. "When you live in a hollow," Tom McColley says, "there's no back way. You take the same road out as you take going in, so you're always passing your neighbors. You get to know them. They'd show us how to do stuff, like stringing barbed wire. It was nice working for ourselves for a change."

At a county fair, Connie McColley was intrigued by a display of baskets. She came away determined to make one. Borrowing an old basket, she studied it.

"Everything is exposed. In your mind you can take it apart and see exactly how it was put together." Tom McColley went out with an old mountaineer whose property adjoined theirs, cut down a young white oak, and split it. All he had was an axe and his knife.

They started by making the traditional shapes: the double egg, the bail-handle market basket, Shaker baskets. Tom McColley made the ribs and the handles. Connie McColley wove the splints. Bit by bit their imaginations soared, and they began to experiment with original creations, crossing the boundary where craft becomes art.

White oak basket with maple handle

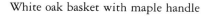

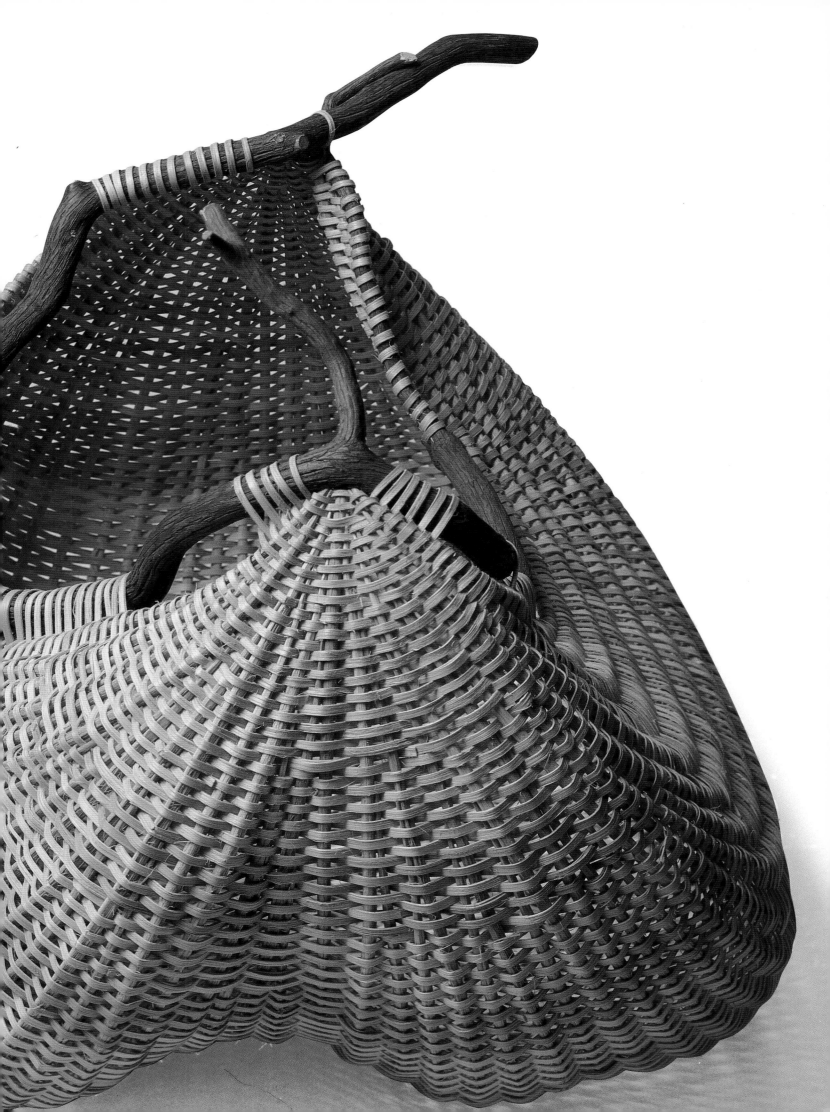

Weaving a basket, Connie McColley works an intricate geometry of red, gray, olive, and pale purple splints in and out, around the ribs and the forked handle, a strangely shaped maple branch. She talks as she weaves. "When we came to the farm, it was like, okay, we're going to do everything, grow our own food, produce our own electricity. We were going to go back to the land for real. I was even going to make my own shoes. Basketry was just another one of those things, like Tom killing a deer and me tanning the hide."

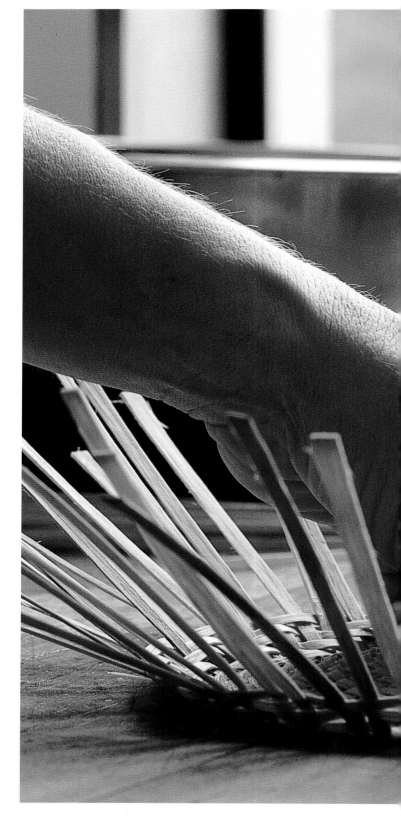

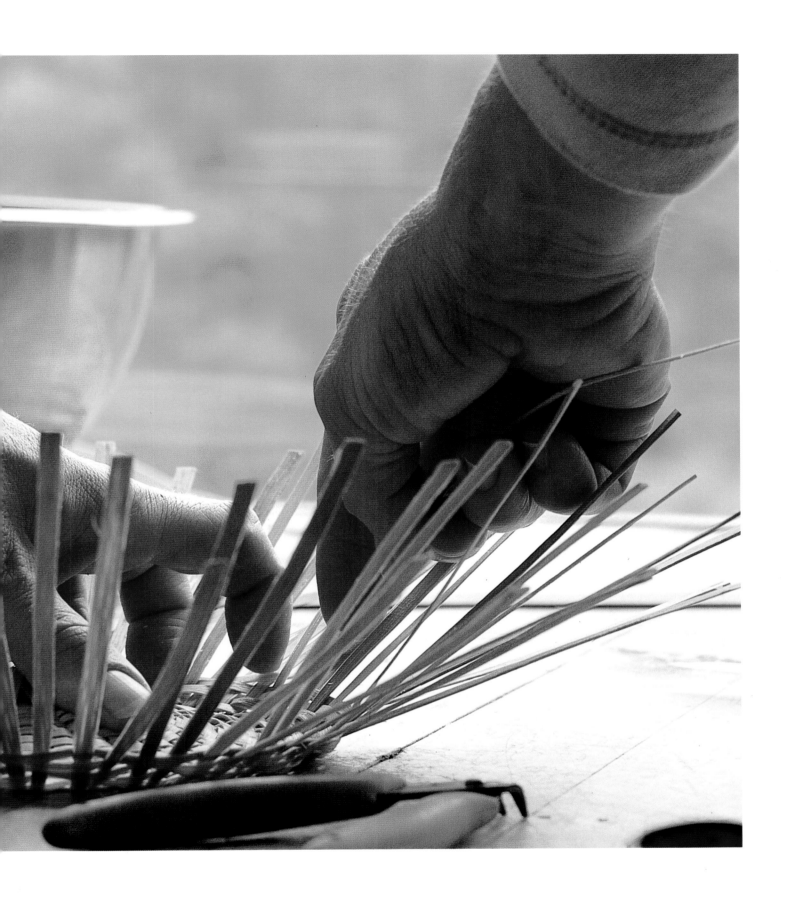

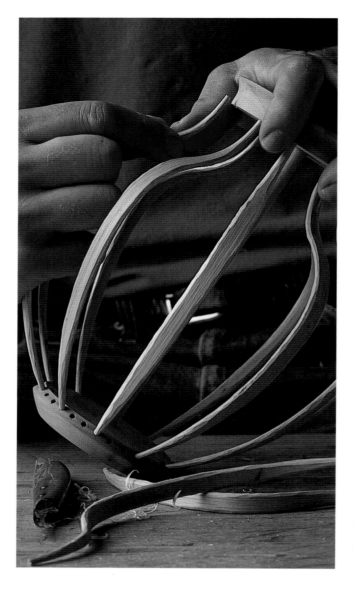

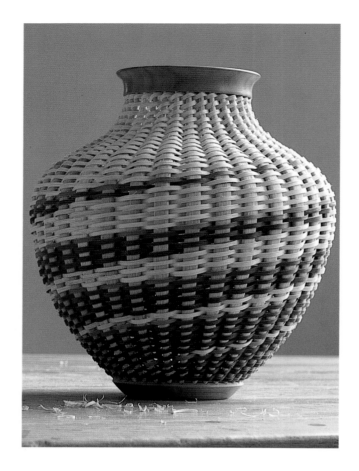

When she tried making shoes, it was winter, icy and snowing. She'd been told that the hide had to be soaked in wood ash and water until the hair came off. What she hadn't been told was that wood ash and water make lye.

"Well, okay, so I take the hide out of the wood ash and hose it off. My hands had a slick feeling, and they burned. I kept washing them, but I couldn't get them from feeling like they were on fire. Whew, the pain. Well, so, forget about making shoes."

High on a ridge, silhouetted against the sky, a huge basket hangs from a slanting pole. Woven of wild grapevine, some of it as thick as an axe handle, it is a swing for the McColley children, Tara and Jacob. Down the ridge below it, on a flat stretch, are rows of corn and tomatoes, lettuce, beans, broccoli, and Connie McColley's herb garden, smelling of sage, basil, mint, and rosemary.

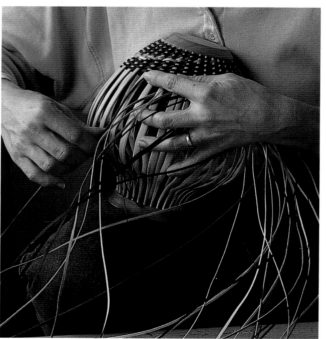

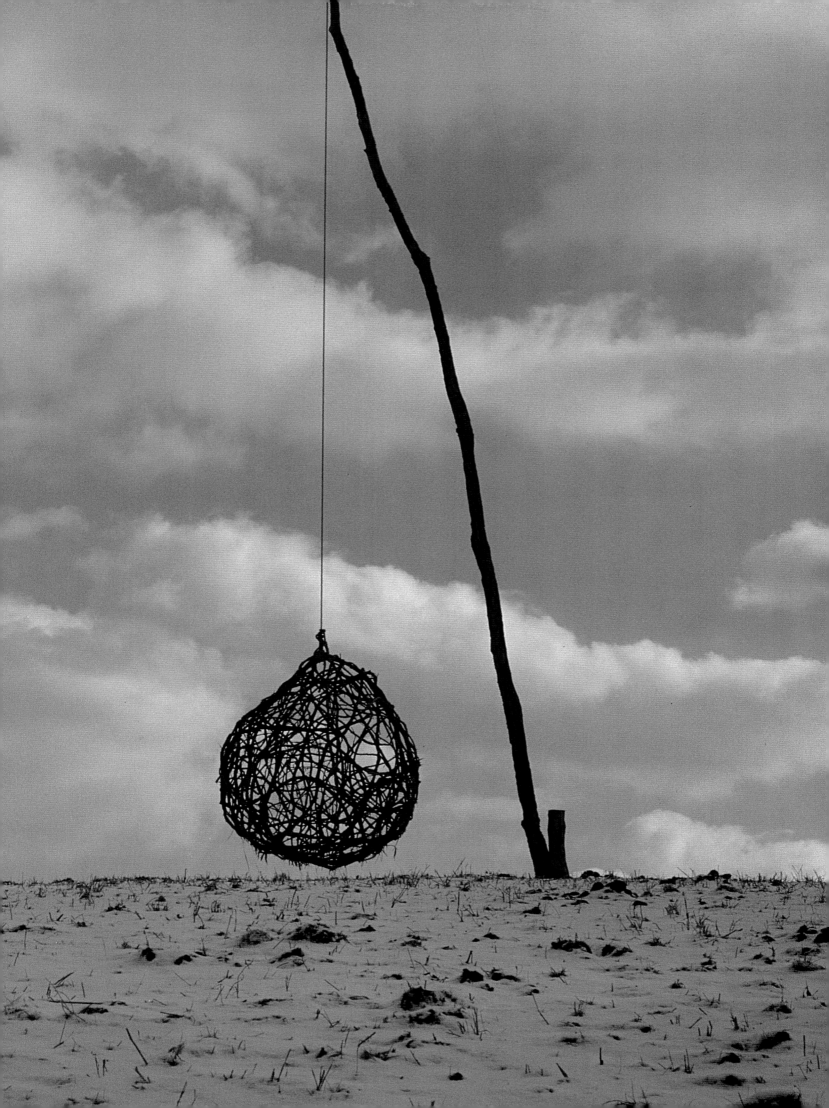

Above: a snaky limb decorates Tom McColley's tool
shed; facing page: natural dyed white oak weavers

Oddly shaped tree limbs, gnarled, snake-curved,
crazily twisted, lie scattered across the hillside and are
mounted on the walls of the tool shed and outhouse.
Not far away, above the garden, is the new home the
McColleys have just finished building. Its rough
poplar siding blends into the wooded slope, making
the house look as though it has been there for years.
They have an inside bathroom now.

On the porch, oak splints of half a dozen colors have
been hung up to dry. Connie McColley's dye kettles
sit on a wood stove, giving the place the air of the
witches' scene in *Macbeth*. She makes her own dyes,
all natural. Soaked in an iron pot, white oak will
turn a soft gray or sometimes blue. To get other
colors, she uses bloodroot, Osage orange, black
walnut, onion skins, sage berries, and boiled chips of
brazilwood. "I tried using marigolds, but Tom said
they stank like the floor of a chicken coop."

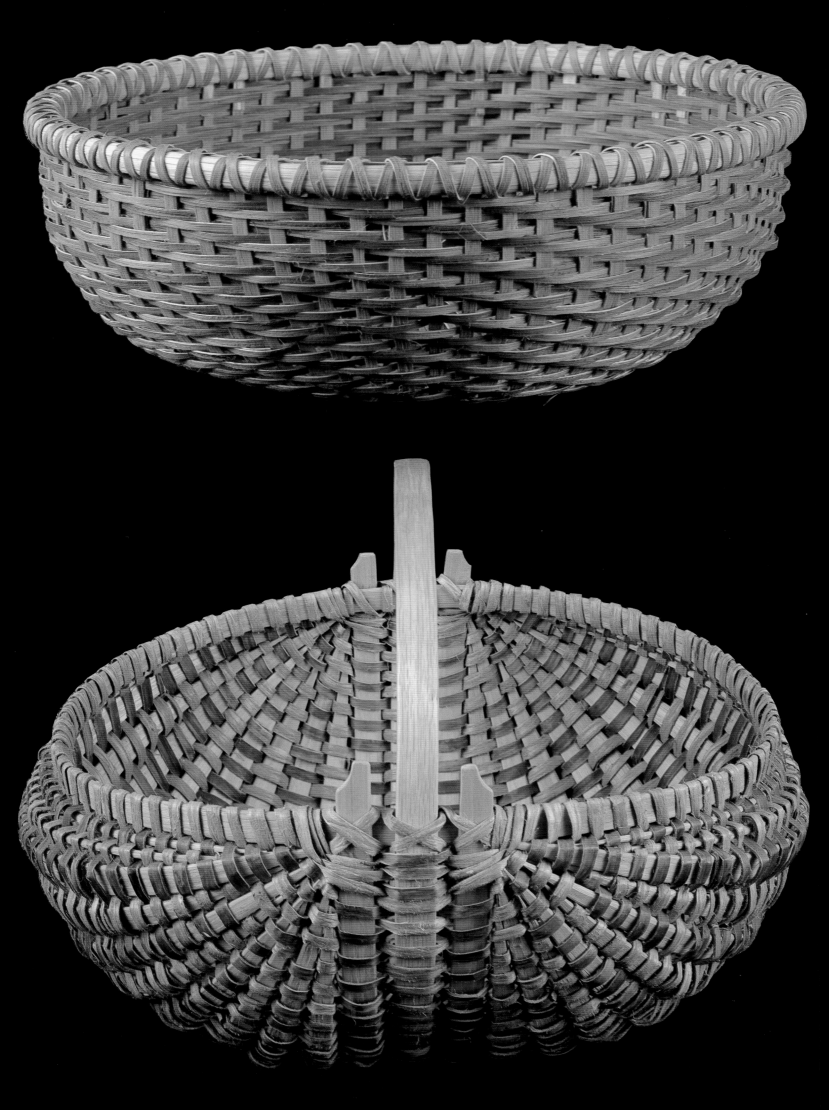

Some of the baskets are natural, some have an austere
pattern of gray and white oak, some are a delicate
weave of rose, violet, pale amber, and earth tones.
"The best thing about living here is the peace within
myself. The next best thing is the colors. Just look at
those trees, the berries, the grasses, the wildflowers,
even the weeds. Green alone, there are fifty shades. I
love the wine reds, the oranges, the velvety scarlets of
the dogwood and maple leaves when they turn in the
autumn. They make commercial colors look like
neon."

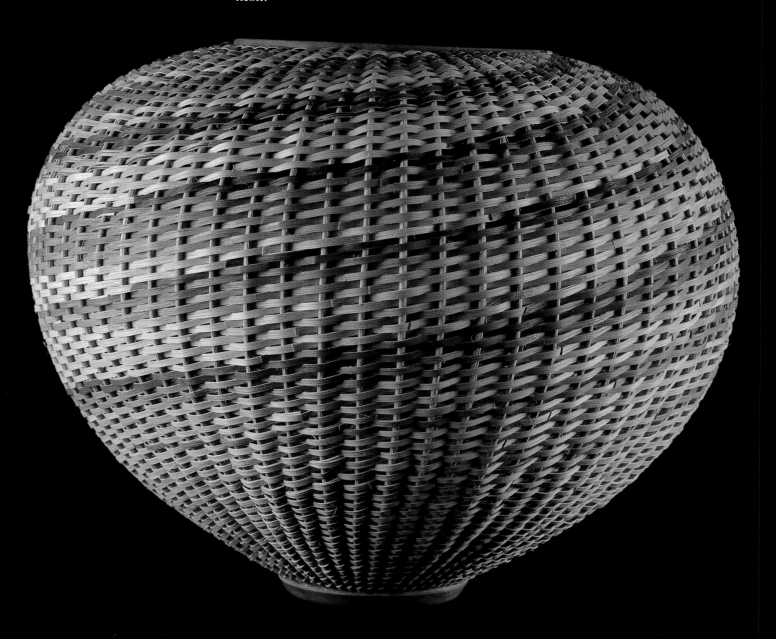

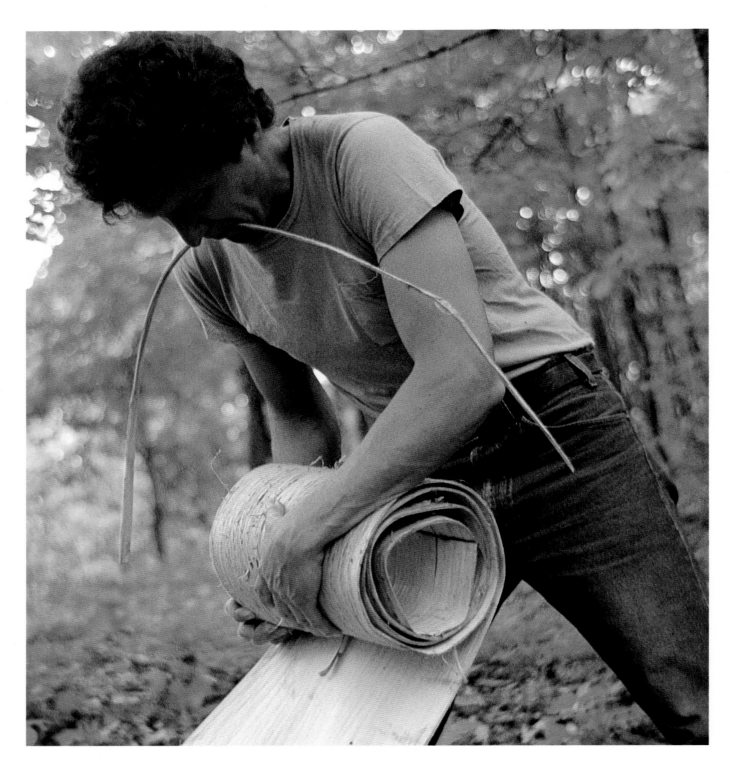

Tom McColley's favorite part of making baskets is at the very beginning. "That's both pure pleasure and learning. Like some people go to art galleries, I go to the woods."

Climbing over rocks and fallen trees, ducking low branches, shoving aside briers, he makes his way through a thick stand of hickory and sourwood, red oak, black oak, post oak, pin oak. What he's hunting for is a white oak four to seven inches thick, with a five or six foot stretch of trunk that is straight and free of branches. There is no such thing as a perfect tree. He can never be sure of what he's got until he gets it home and splits it. Still, he's come to where he doesn't cut as many bad ones as he used to.

Facing page: hickory bark basket

84

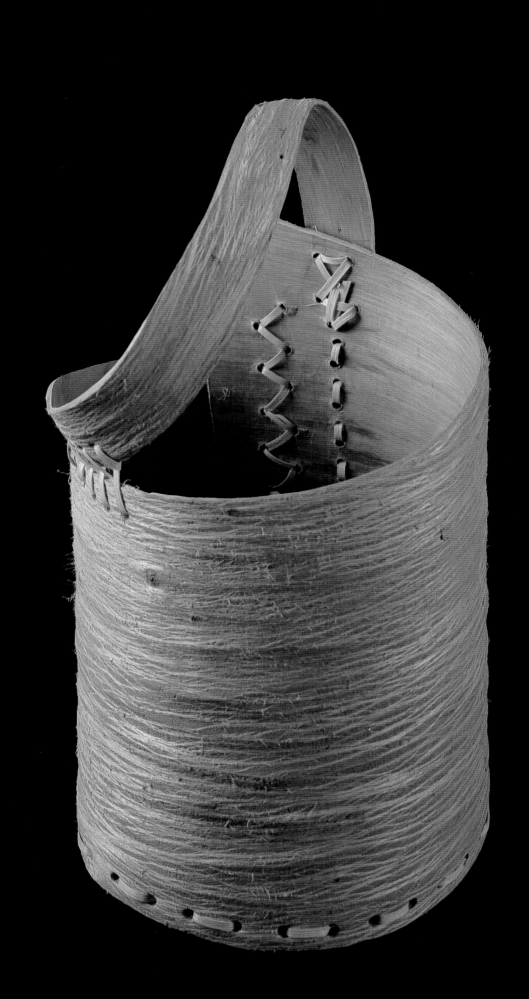

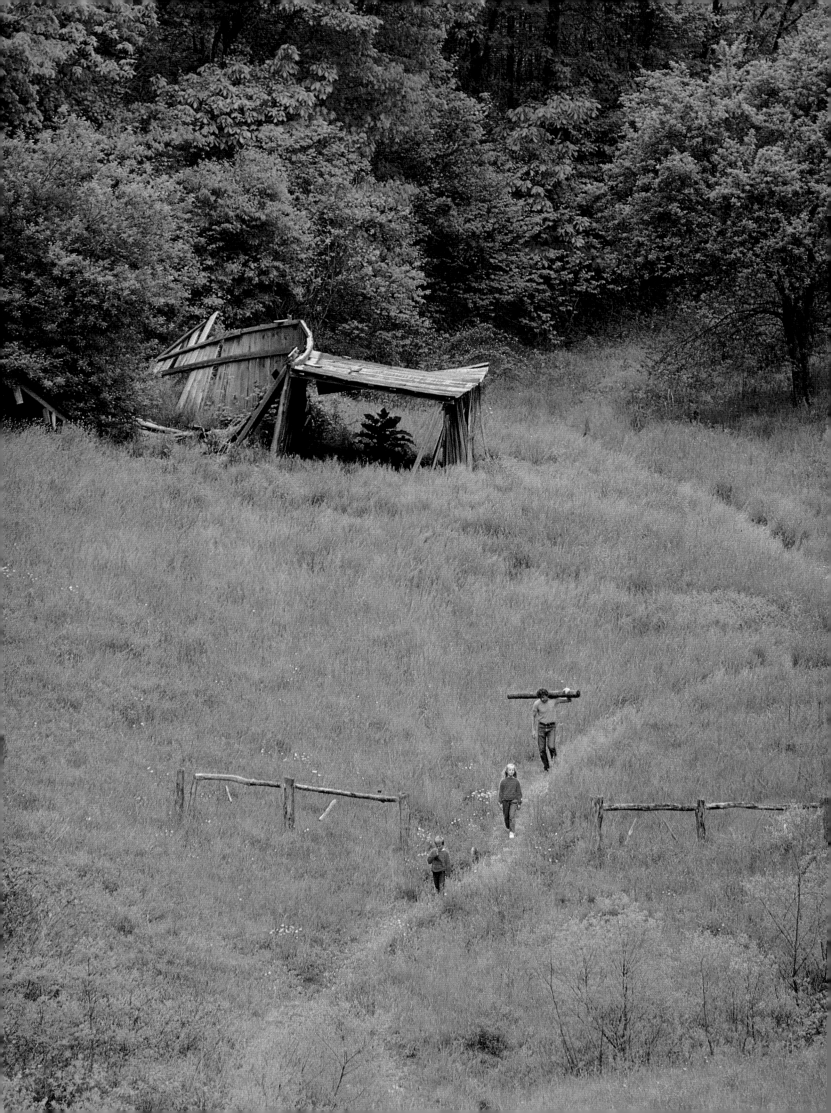

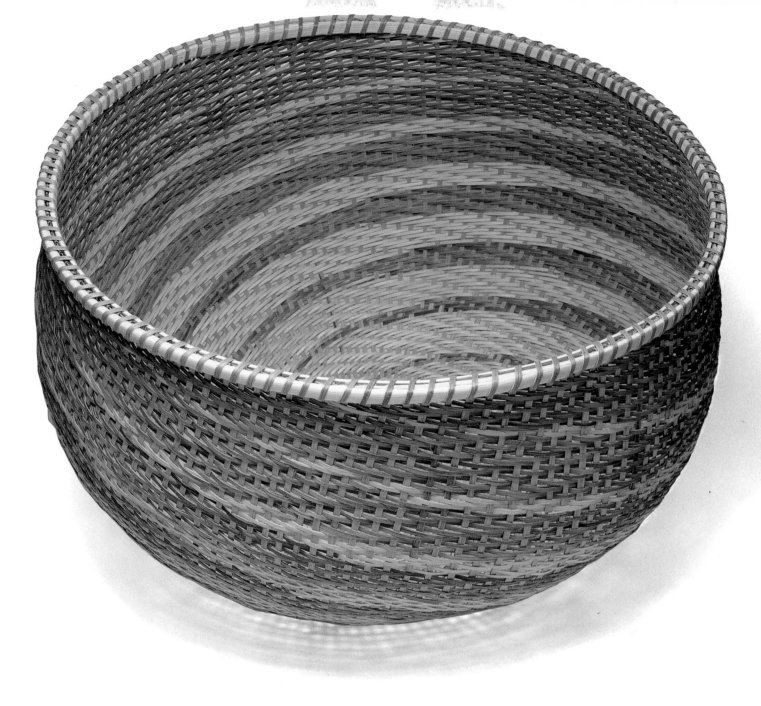

He is always searching for unusual branches, the misshapen ones. He lugs them home, strips off the bark, and lives with them until he can imagine them as part of a basket. "I don't very often use sketches. I start work in three dimensions, setting the branch on a flat surface, turning it, clamping ribs to it, trying it every which way, until I can see the form emerging, like a baby being born."

Almost all of the McColley baskets are white oak, but now and then they'll use hickory bark. Tom McColley takes along Tara and Jacob when he goes to get it. They help him pry the bark free and lead the way when he carries it down the mountain and across the fields.

Her day's weaving done, Connie drops in a rocking chair. The echo of Tom's axe rings in the air. Up the hollow, he is splitting wood for the stove, and Tara and Jacob are tossing it into the truck.

"I have two children I like," Connie says contentedly. "You can get ones you don't, you know. I like where I live, I like who I'm with, I like what I do."

Rising, she crosses to the window and gazes out wistfully. "The leaves on those poplars . . . I'd give anything to get that shade of green. . . ."

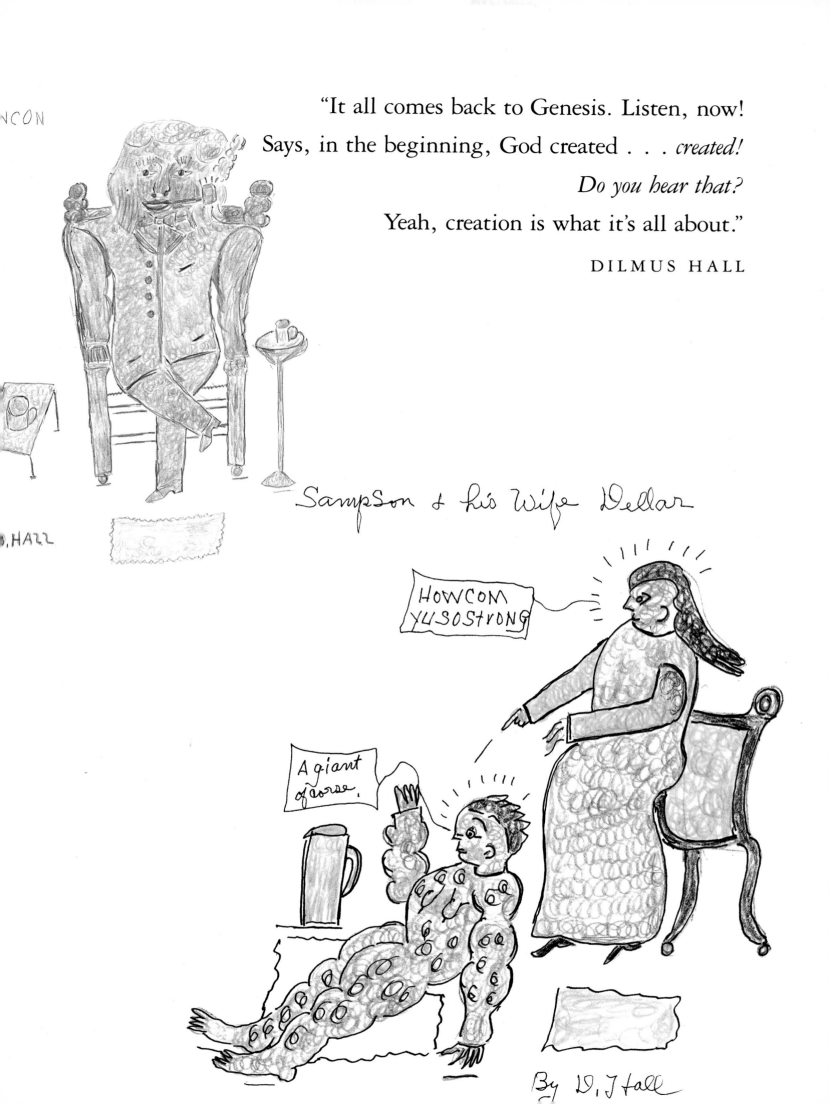

"It all comes back to Genesis. Listen, now!
Says, in the beginning, God created . . . *created!*
Do you hear that?
Yeah, creation is what it's all about."

DILMUS HALL

DILMUS HALL

DILMUS HALL has the speaking style of a back-country revival preacher, the confidence of a riverboat gambler, a Charlie Chaplin walk, and forty-seven ways of expressing pleasure, from a chortle to a cascade of laughter. He sports a porkpie hat, baggy black pants, and a pajama top under a worn tweed jacket. More than a man and an artist, he is a force of nature.

He addresses you with an accusing glint in his eye, a hellfire fervor: "You listenin' to me? *You listenin' to me?* God is the creator, yes, he created us in his image, so each and every one got the power to create!"

His voice is mesmerizing, orchestral, deep cello tones rising to trumpeting brass, changing to woodwind:

"The Lord is my shepherd. Yes! Those are great words, that is true *sanctification*, 'cause he is the almighty-uh, the all-wise-uh, the *everlasting!* You know what I'm sayin'? You have him to take care of you through all your troubles, my friend, through all you life."

Preceding pages: from Dilmus Hall's sketch book

Dilmus Hall is one of twenty-two children of a Georgia sharecropping family. "I'm the only one left. They're all gone now." He is evasive about how old he is, chuckling, "I got eighty, and I just stayed there. I'm not getting any older." He tilts his hat back at a cocky angle. "I'm gonna stay eighty for the next fifty years. Hah! Hooeee!"

He lives alone in a cramped, two-room, cinder block house filled with stacks of his crayon drawings, many of them sprung from the Old Testament: *Samson Pulling Down the Temple, Solomon's Sweetheart, Then the Lord Answered Job Out of the Whirlwind.*

To Dilmus Hall, the Bible is more than a chronicle of the days of Abraham, Moses, and Jesus. It is all happening *now*. The people of Genesis and the Gospels swirl along his street. When he calls a sassy, man-chasing neighbor Jezebel, he doesn't mean she *resembles* the biblical wanton. She *is* Jezebel, scheming, brazen, sashaying past.

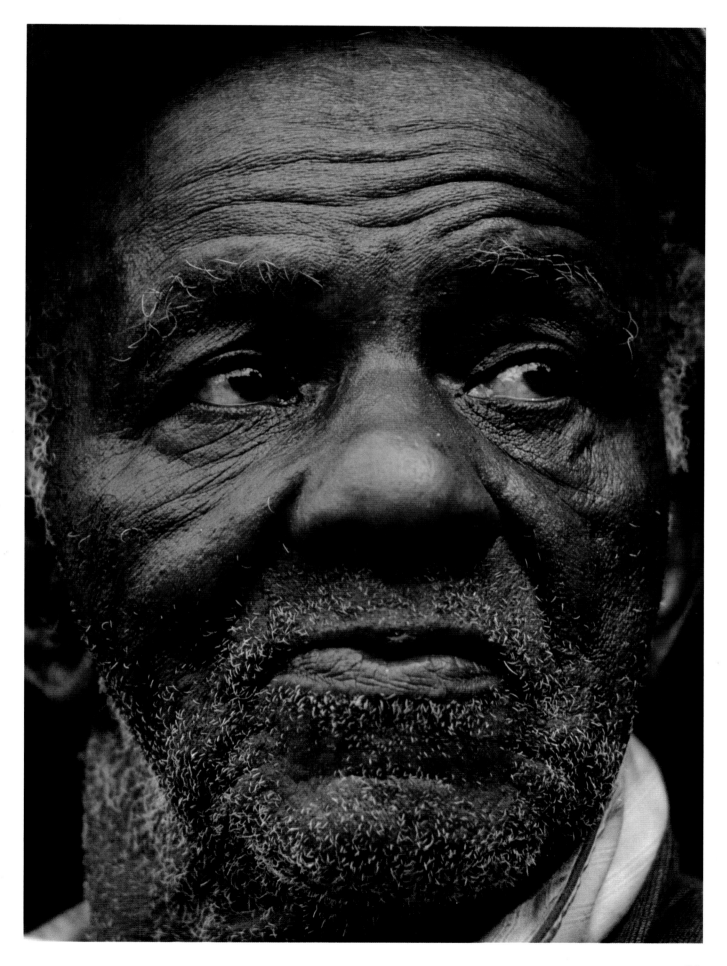

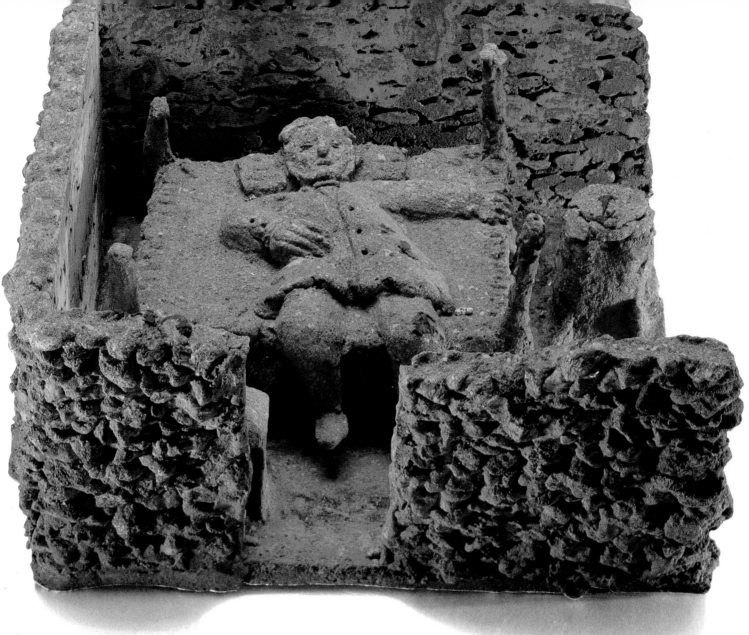

Dr. Crawford on his Deathbed

A dusty magnolia tree droops over a yard cluttered with tools, rolls of wire, lumber scraps, rusty paint cans, a broken electric fan, and Dilmus Hall's startling works of art: a concrete butterfly, a concrete dog with blue china eyes, a concrete lamb sculpted with a delicacy that defies the material of which it is made.

"Concrete, now, it ain't nothin' but dust. There has been so many people tinkered with the Bible, different inspired men trying to follow what God wanted. It all comes back to Genesis." Starting in a low growl, his voice abruptly leaps an octave to a piercing cry: "Listen, now! Says, in the beginning, God created . . . *created! Do you hear that?* Yeah,

creation is what it's all about. God done formed man out of the dust of the ground. That's what I'm doing, using the talent God gave me to create things out of dust."

If concrete seems an unlikely material to use in creating small sculptures, it is somehow fitting for Dilmus Hall. He delights in the unusual. His restless mind is constantly searching out odd bits of knowledge. He may invent his own version of a biblical scene or embroider history, but the spine of truth is there. His *Dr. Crawford on His Deathbed* pays homage to Dr. Crawford Long, the nineteenth century Georgia physician who was the first to use ether as an anesthetic when he performed surgery.

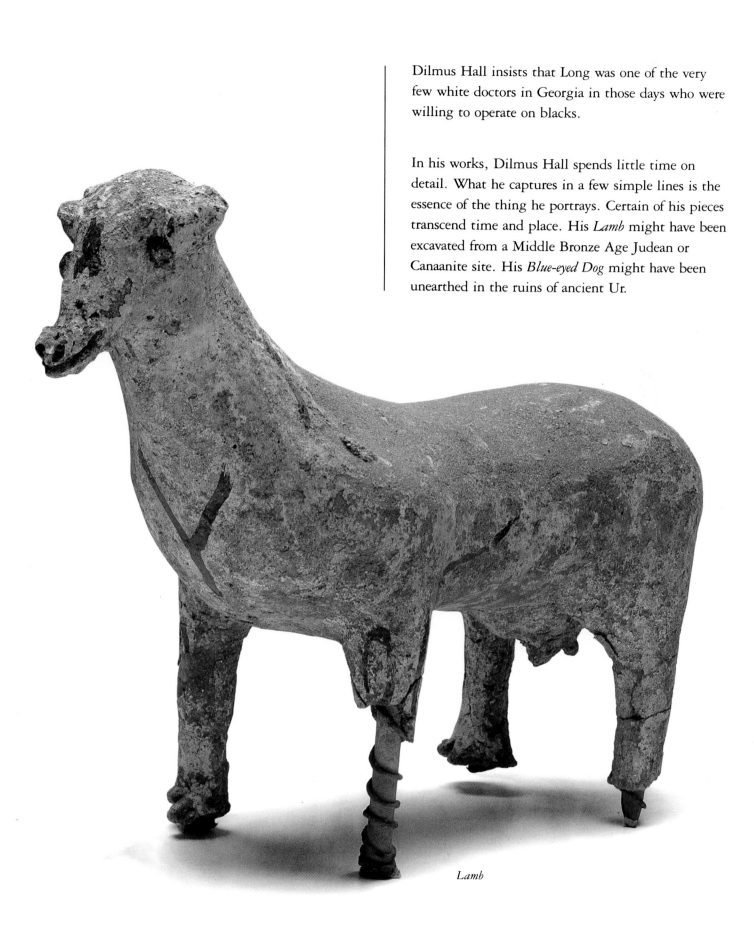

Dilmus Hall insists that Long was one of the very few white doctors in Georgia in those days who were willing to operate on blacks.

In his works, Dilmus Hall spends little time on detail. What he captures in a few simple lines is the essence of the thing he portrays. Certain of his pieces transcend time and place. His *Lamb* might have been excavated from a Middle Bronze Age Judean or Canaanite site. His *Blue-eyed Dog* might have been unearthed in the ruins of ancient Ur.

Lamb

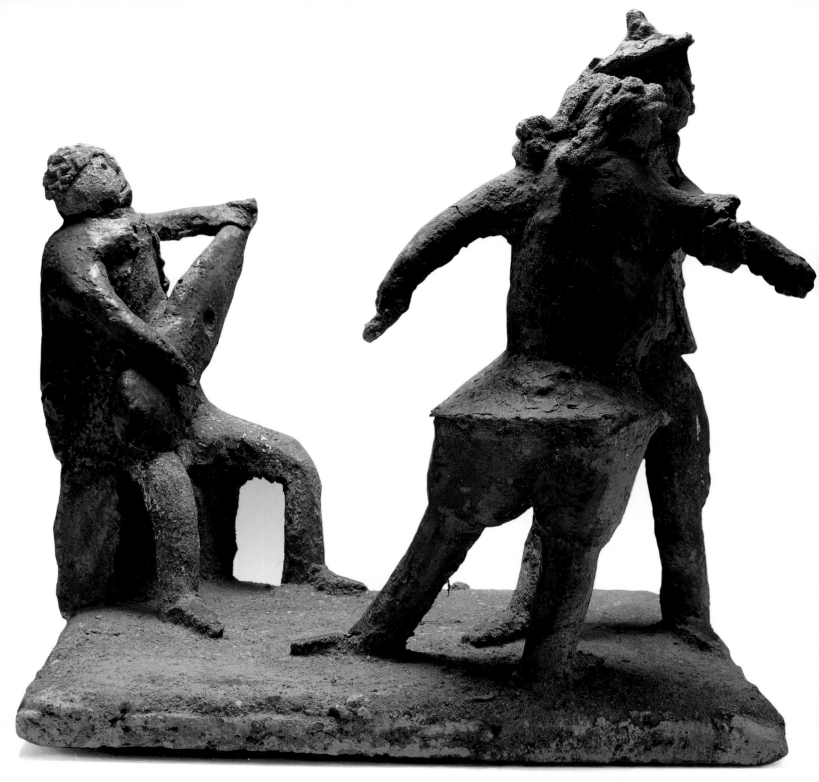

The Mexican Bunch

Dominating Dilmus Hall's yard are three almost life-size figures. A drunkard sprawls on a pallet, passed out. A sodden drinker slumps at a table, bottle in hand. A fearsome, goggle-eyed, bucktoothed devil stands over him, holding a rock in his upraised fist.

"Satan, he's makin' that old boy go on drinkin'. *Keep on drinkin', or I'm gonna mash your brains out!*" He cackles with laughter. "The devil is in our daily life. He is going to and fro, seeking in many ways. He have a lot of ways to take influence of a person. You do what he says, you sin the way he want you to, or he's gonna whop you." A short laugh breaks loose, sharp as a rifle shot. Then he speaks with taut, suppressed fury: "Whop you, yes, that's what he's gonna do!"

Facing page: *The Drunkard's Devil*

94

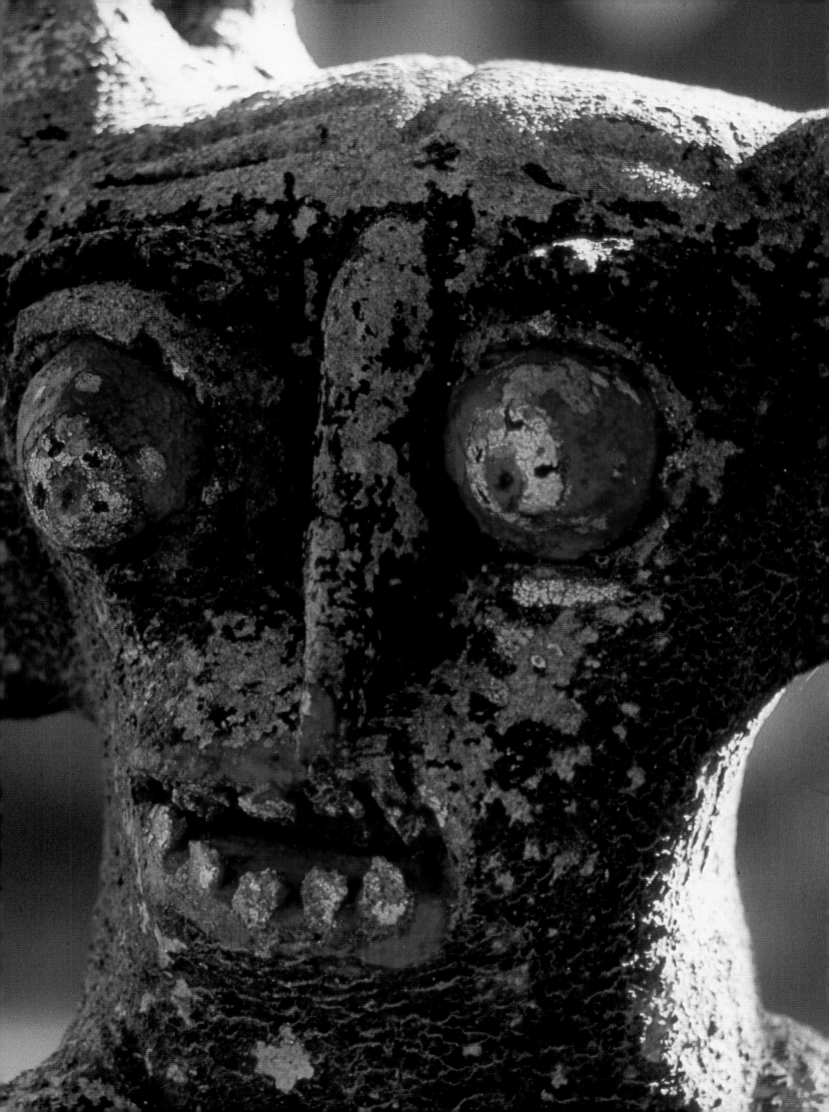

When Dilmus Hall was young, he used to go into the woods to collect sap off the pine trees. "Chewing gum, we called it. I'd work it to where I could make things out of it, birds and animals."

His father didn't think much of his son's talent. He considered picking cotton to be a boy's only worthwhile occupation. But Dilmus Hall's mother loved the little figures he brought to her.

In those days in Georgia, the planters, the Klan, and the sheriff saw to it that a black man understood what his place was. All he was good for was mule work. Leaving the farm during the Depression, Dilmus Hall got a job swinging a pick on a road gang. Then he turned his hand to coal mining. In 1917, he went off to war. He served in the Medical Corps, carrying the wounded on stretchers across torn, bloody French battlefields.

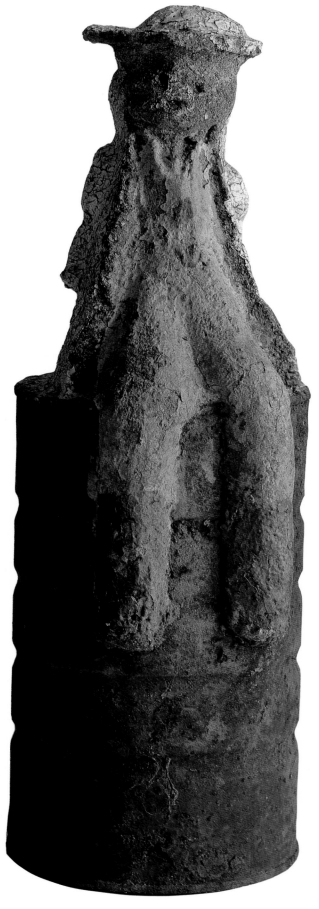

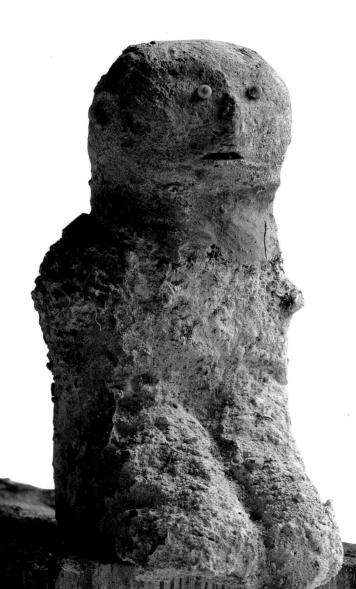

Above: *Man on a Tin Can;* left: *Sittin' Around*

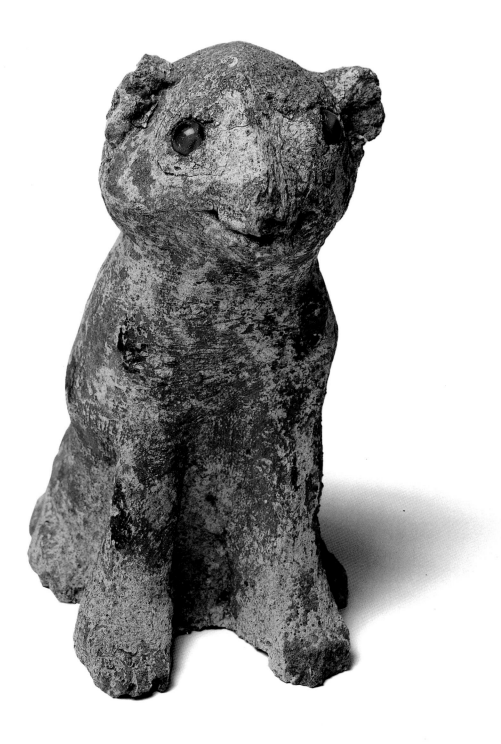

Blue-eyed Dog

He came home to work in a hotel, first as a porter, then a waiter. "For twenty-five years, I served people." Twenty-five years of pushing a mop and carrying a trayful of dishes, of saying "yessuh" and "nosuh" to white folks didn't crush Dilmus Hall's spirit, but it might account for the edge of wrath that, now and then, creeps into his preaching.

He married, but his wife is dead now. "She was a splendid woman, and I sure loved her. Early on, she got sick, and I took her to the doctor. He examined her. Says to me, 'Hall, you won't never have children.'" Laughter bubbles up as he leans back and lets out in a yell of triumph, "*Fooled him!* Whooeee, yes, I fooled him. He didn't know me, didn't know about the gift of my talent. 'Cause I sure did make children. I'm still making 'em, out of concrete, and whatever else I can find to do with."

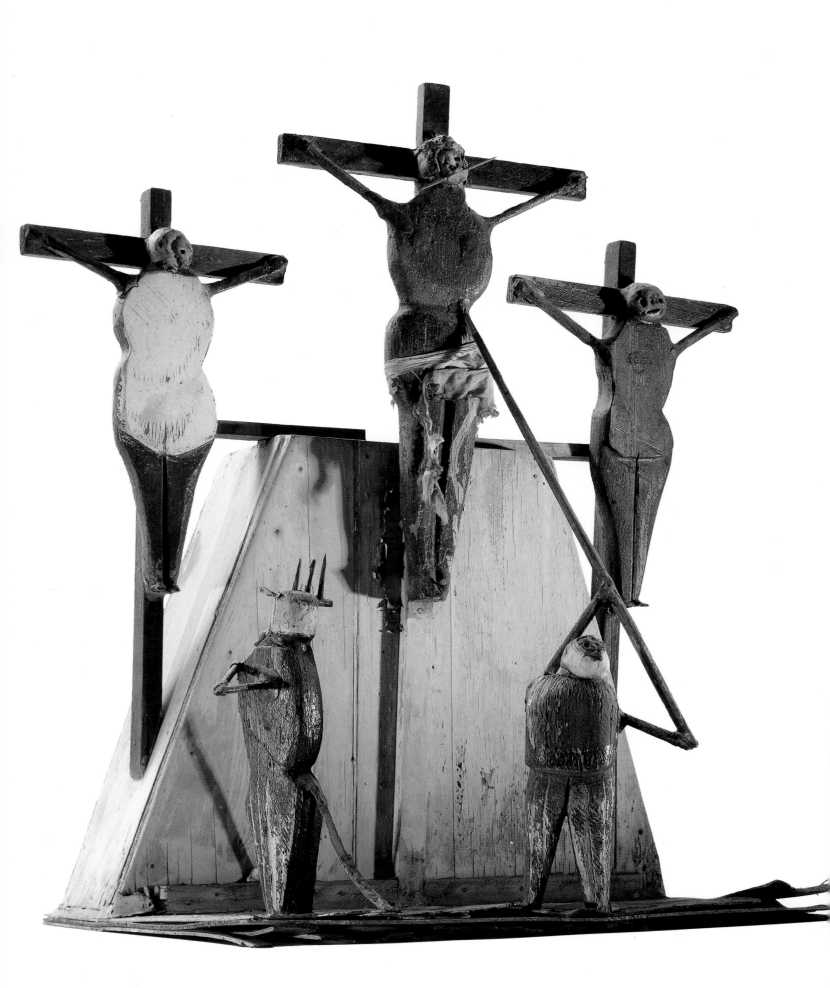

Dilmus Hall's masterwork is his *Crucifixion*, made of wood, putty, and bits of rag. Nailed to the cross, stabbed by the spear of a Roman soldier, and flanked by the two thieves is an agonized Jesus whose mouth is pierced by a splinter. "That's death he's crushin' between his teeth."

For all of Dilmus Hall's strutting and hellfire sermonizing, there is anguish woven into his laughter. Anguish, anger, and a fierce faith.

"If God gives you the talent to make something that will celebrate mankind, your work will stand, *do you hear me?* It will testify to the goodness of life after you're done gone. *Yes!*"

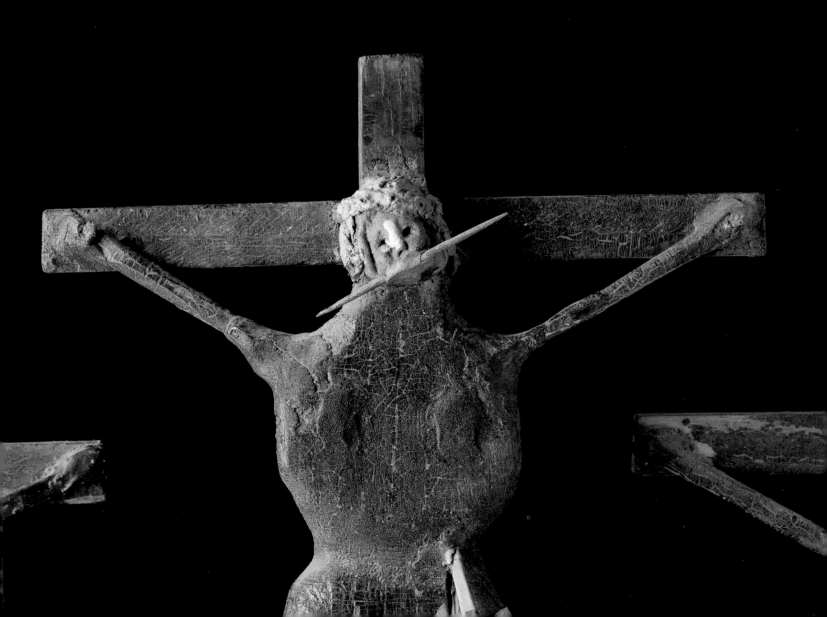

"Every night when a breeze comes up,
John Henry'll commence pecking away, driving that steel . . .
He's like me, only satisfied when he works."

CARLETON GARRETT

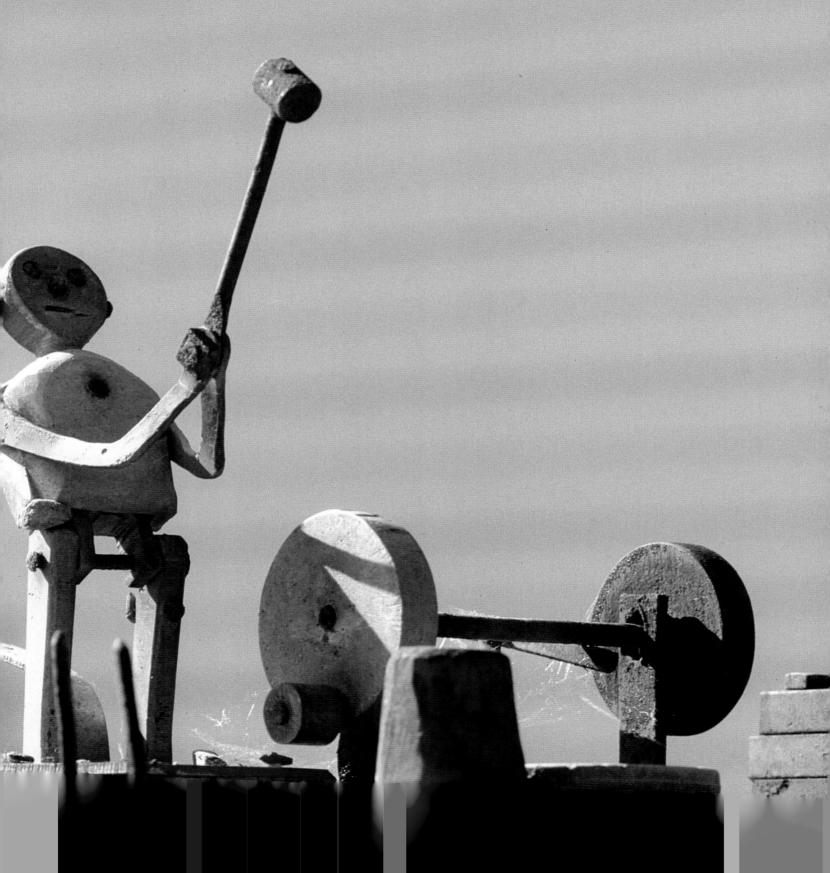

CARLETON GARRETT

THE CHIEF LANDMARK of Flowery Branch, Georgia, is the barn red depot sitting beside the railroad tracks that run down the middle of its main street. A somnambulant town, it's not much more than a yawn on the map, but living in it is an artist who is part of a tradition that goes back to certain French masters who flourished at the court of Louis XIV.

Flowery Branch's Carleton Elonzo Garrett is a maker of automatons, marvels of ingenuity that combine carving and mechanics in artworks that come alive.

The son of a chain gang guard, Carleton Garrett had the good luck to be born and raised a stone's throw from a grist mill driven by a swift stream. Growing up, he prowled around the mill every chance he got, hypnotized by its machinery. He watched the whirling flywheels, the plunging drive shafts, and the turning cogs. Machinery was power. Learning how it worked was exciting. It provoked youthful fantasies of one day creating something that would make people sit up and take notice of him.

As a young boy, Carleton Garrett made whirligigs, flutter mills, water wheels, and a tiny steam engine built out of a muscle salve tin and the spout of a kerosene can. Everything he made generated power, but it wasn't harnessed to anything. That would come.

At a fair, he watched a demonstration of the new Overland automobile. Speeding up a ramp, it took off, flying through the air to land on a far ramp. In his yard, he built his own set of ramps, and on his homemade bicycle, performed the same death-defying feat. He dreamed of amazing carnival crowds with daredevil leaps, but because he was poor he settled for a job at the Chattahoochee Furniture Company factory. His dreams still burned, but he kept them locked inside.

For most of his life, he turned out assembly-line tables and chairs. He still loved to tinker with machinery, and so when he was offered the job of running the local waterworks, he leaped at the chance.

Preceding pages: whirligig: *John Henry*

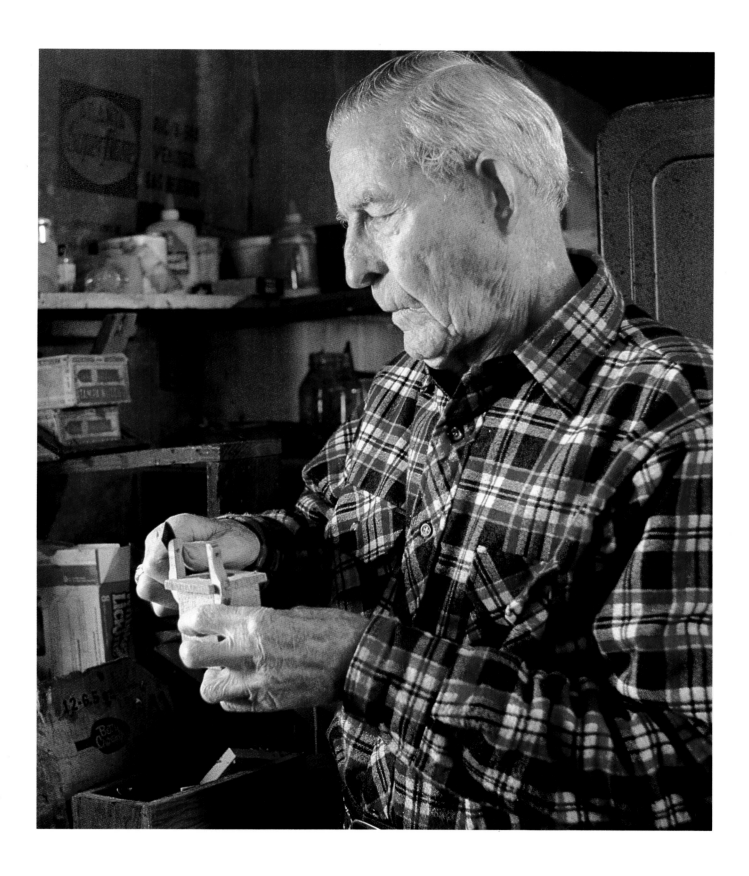

When he finally retired, Carleton Garrett checked into the hospital for a long-needed operation. It was a success, and when it was over his doctor advised that if he wanted to get well and stay well he'd have to keep active—advice one doesn't need to give a mountain man. In Appalachia, idleness is a sin more serious than arrogance or gluttony.

Even before he was on his feet, Carleton Garrett started whittling. The first piece he carved was a scene of the hospital he had just left: himself in bed surrounded by nurses, orderlies, and visitors. The figures were charming, rendered in an unsophisticated style all his own.

Left: *Family Discussion;*
facing page: *Visiting Hour*

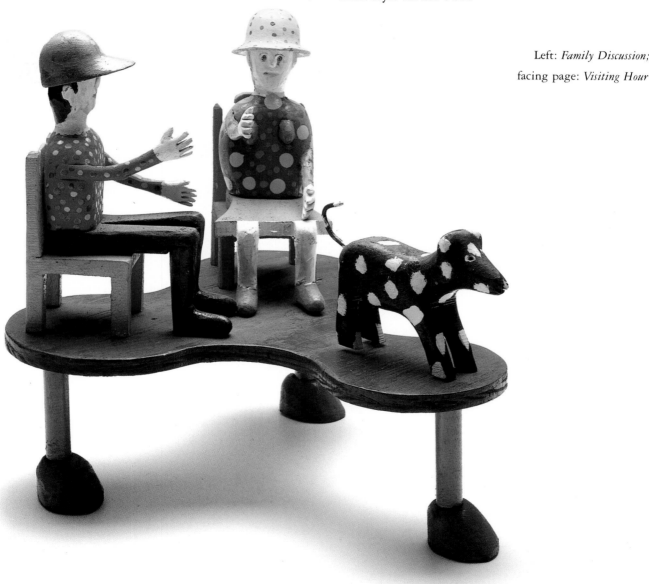

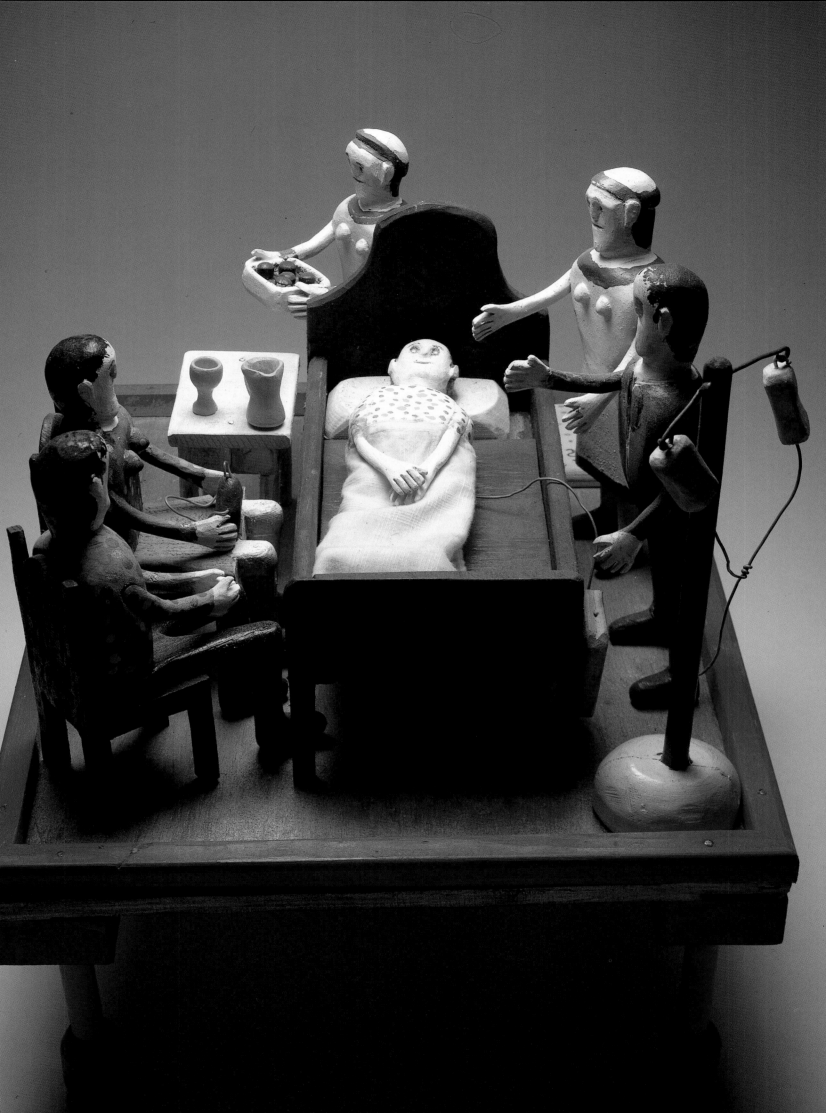

He began to carve toys for his grandchildren: tractors, cars, and whimsical, polka-dot animals. Then the motor of a fan short-circuited, and while he was repairing it he got the idea of creating figures that moved. He began to devise a piece with a dozen or more characters animated by a complicated system of cams, rotors, gears, cogwheels, and activating rods driven by another motor salvaged from another old fan. The works would be hidden in a brightly painted box on which the piece sat.

Working with only a drill press, a band saw, and a pocketknife, he created a miniature courtroom. In it the judge pounds his gavel, a lawyer pontificates, and the jurors nod or shake their heads. Next he created a church with a preacher gesturing as he delivers a sermon, an organist playing, a sexton ringing the church bell, and a parishioner taking up the collection in a plate fashioned out of a bottle cap.

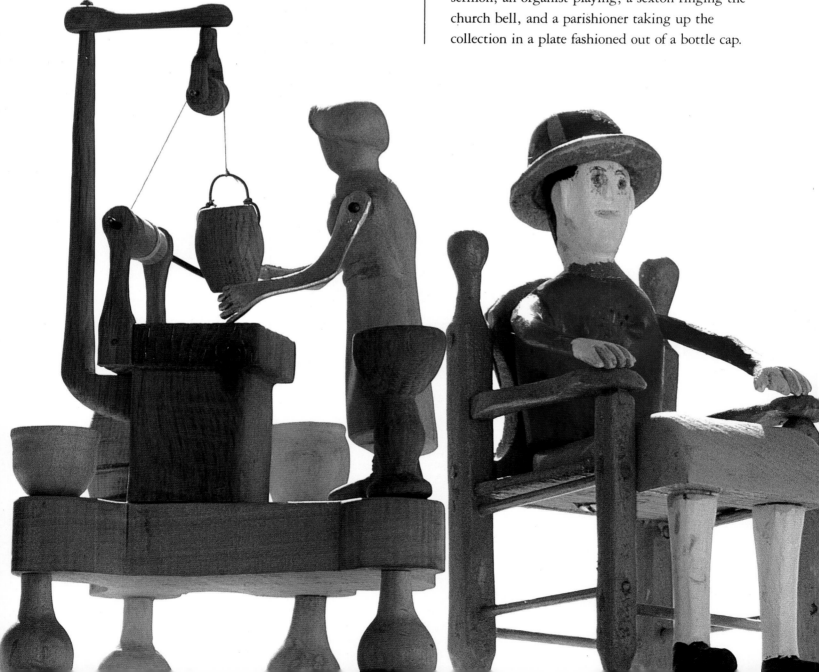

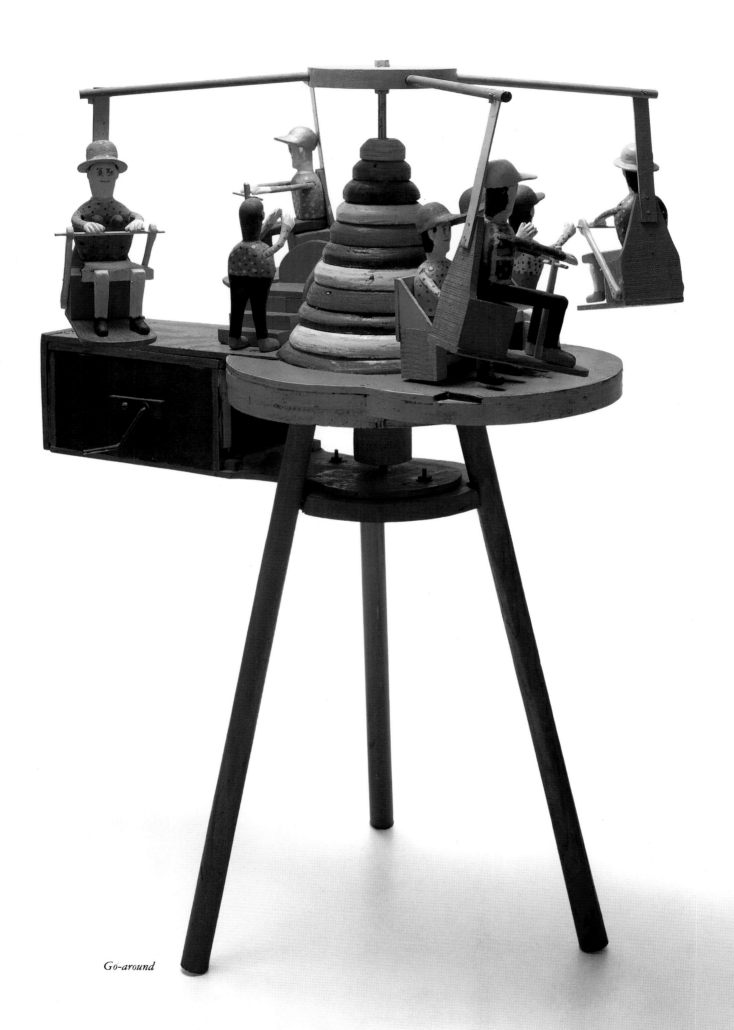

Go-around

Outside Carleton Garrett's house stands a windmill he made. Its turning blades set John Henry to swinging his hammer. "Every night when a breeze come up he'd commence pecking away, driving that steel. Drove my wife crazy. She raised the roof, told me I was going to have to do something about that racket. I added a lever so's I could turn him off, but I can tell he don't like it much. He's like me, only satisfied when he works."

Carleton Garrett fulfilled his boyhood dream of mesmerizing the crowd at a carnival when he was invited to demonstrate his art in 1982 at the World's Fair in Knoxville, Tennessee.

He has just finished creating a miniature merry-go-round in an amusement park. He tests it, plugging it in. The hidden motor whirs, the tiny horses and riders prance in a circle, passing men and women on benches and others eating and drinking at tables. The scene has a childlike gaiety. Tickled by it, Carleton Garrett grins, the boy in him still alive.

Right: *County Fair*

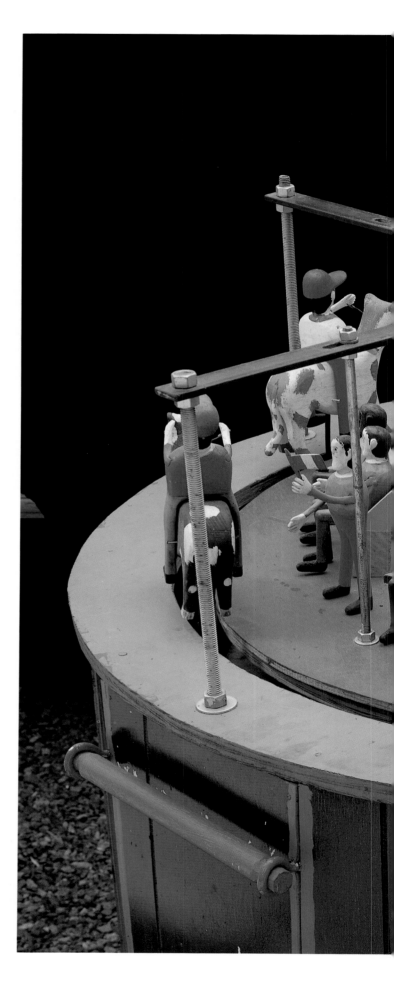

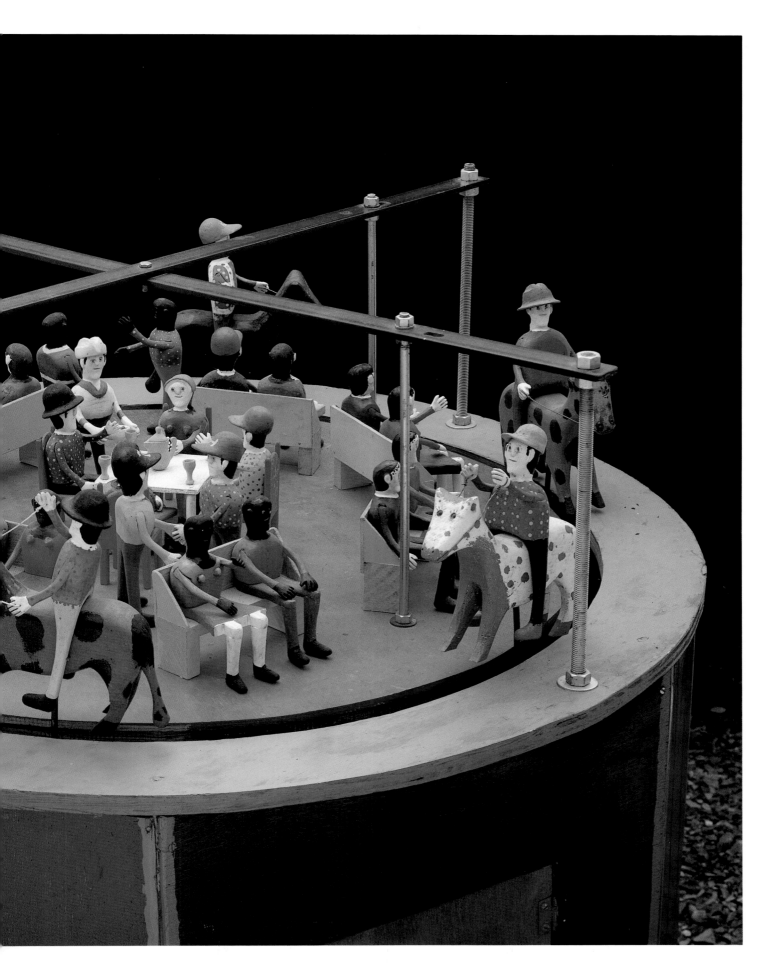

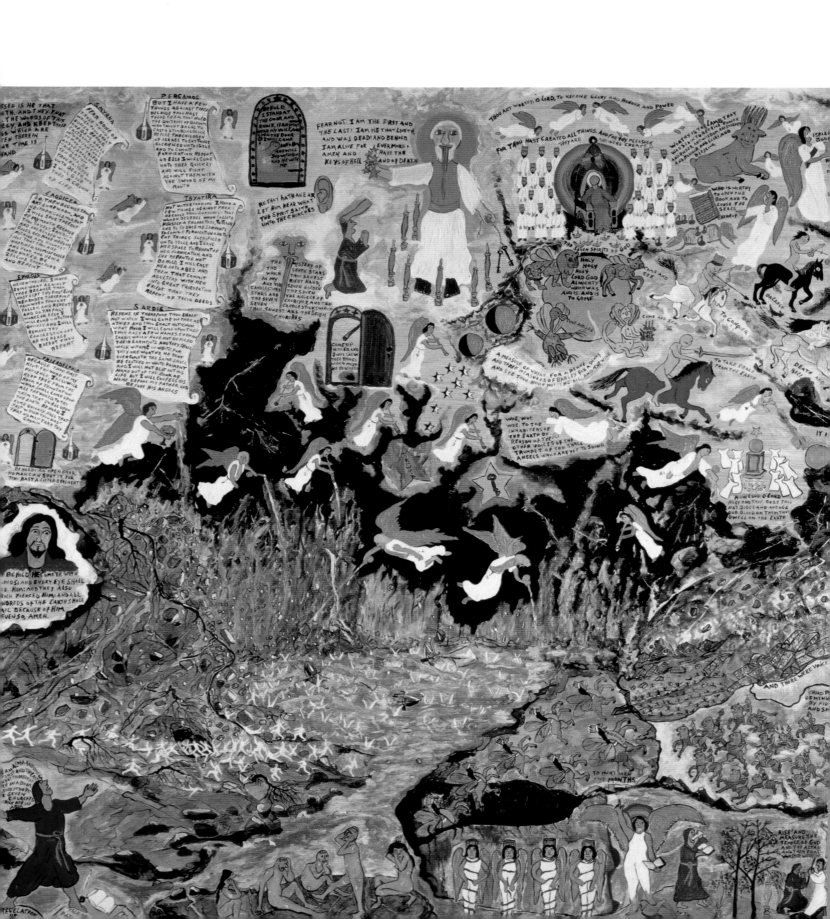

And I looked and, behold, a pale horse,
and his name that sat on him was Death,
and Hell followed with him.

(REV. 6:8)

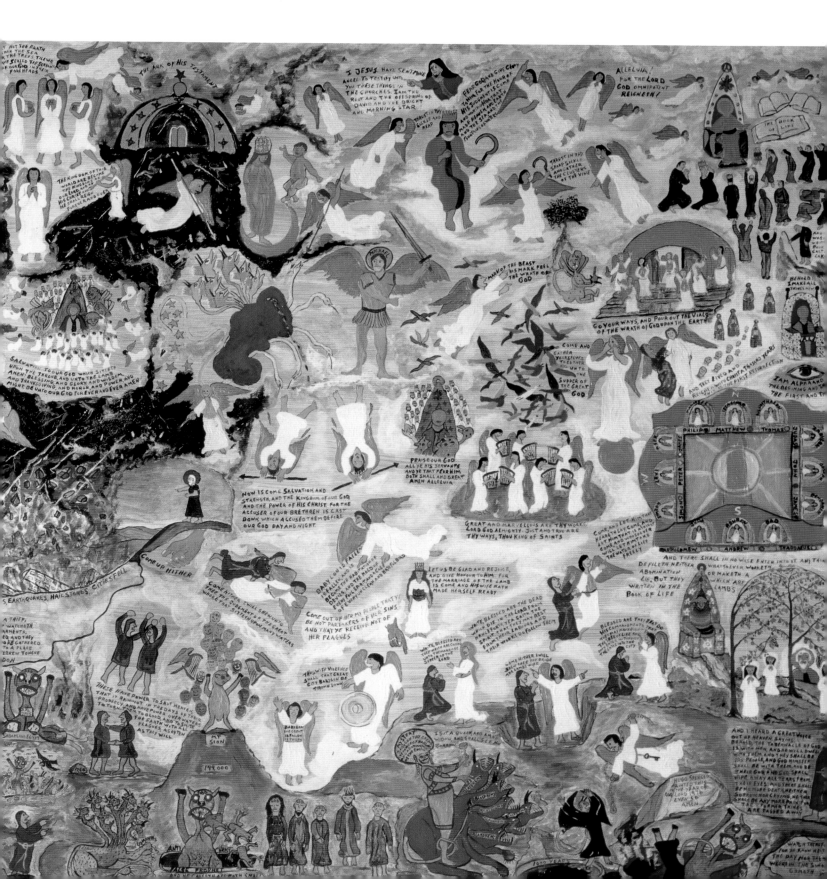

HUGO SPERGER

HUGO SPERGER's *Revelation* covers an entire wall of his living room. It is a vision of the sulphurous day of reckoning prophesied by John in the New Testament's final book, a vision of The Time Of The Beast. The chaotic canvas swarms with the clash between battalions of angels and the dark demons of hell. A fiery-eyed God looks down on Babylon, mother of harlots. A volcano of molten rock pours out of a lightning-streaked sky. The shark-toothed, horned Beast squats in flames.

And there were voices and thunders, lightnings,
 earthquakes,
hailstones. Cities fell.
 (Rev. 16:18–19)

"We were strong believers in hell. When I was five or six, I had an experience that will remain with me until I die. It was winter. Outside, the ground was covered with snow. Me and my two brothers were in the living room, by the stove. All of a sudden Mother pointed out the window and shrieked, *'It's the devil!'* I'll never forget her scream. It sent chills down my back. I rushed to the window and looked out. Coming across the snow, humped over, almost crawling, was a figure in black with a hideous face and squinty eyes. We boys ran to the dining room and locked ourselves in, terrified, crying, wailing, scared out of our wits. We heard the thing crash into the house. It smashed the glass in the kitchen door and clumped to the dining room. It rattled the knob. It banged and pounded. I felt sure my time

had come, and this monster would kill us all, or grab us and fly with us straight to hell. Suddenly, the door stopped shaking. The house fell quiet. Mother yelled to us to come out. The devil had gone back to hell. We were saved this time, but he'd come back if we weren't good. It was a long time before I began to suspect that the devil was Father, his face caked with a mask of flour and soot. I had nightmares about it for years."

Gazing at *Revelation*, Hugo Sperger smiles dryly, "My wife says I shouldn't paint things like that." He purses his lips and shrugs. "I paint what I feel."

I paint what I feel. Those words are blazoned on the banner of self-taught Appalachian artists. They don't know and don't care what is in fashion. They don't try to calculate what will sell. They create out of emotion and need.

A scuffed Bible lies on the paint-smeared table beside Hugo Sperger's easel. He says it is there only because "it has fifty pictures on every page." He confesses that images of hell and damnation teem in his mind but insists he is not very religious. The dark superstitions of his parents turned him away from church.

"My folks brought a lot of beliefs with them from the old country. If you had white spots on your fingernails, those were the devil's marks. Every one

Preceding pages: Revelation

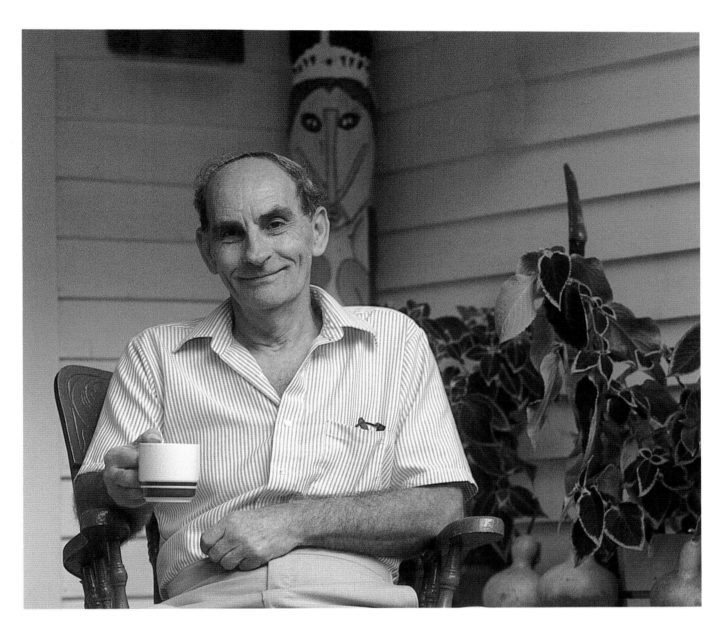

was for a lie you'd told. If your eyebrows grew together above your nose, like mine do, it showed you had werewolf tendencies." He laughs. "So far, I haven't turned into a werewolf. Not the four-legged kind anyway."

Hugo Sperger lives with his wife, Faye, in a house with a gingerbread trim of knobs, spindles, and spikes. A weathervane rooster crows atop its green tin roof. The house sits facing the deep Kentucky woods, not far from Elk Creek.

His wife started him painting. He was well into his forties when she gave him a set of oils and some

canvas for Christmas. He says, "I fell in love with art from that moment on."

Hugo Sperger's parents were German immigrants. His mother was a stolid woman who scrimped and hoarded and worked herself to exhaustion. His father farmed, did pick-and-shovel labor on the county roads, and brewed illegal beer to pick up an extra dollar or two.

It was a childhood slashed with violence and tragedy. His father was unpredictable. There were times he'd be cheerful, singing away, "but when he lost his temper, he was like a bull gone crazy, hitting and

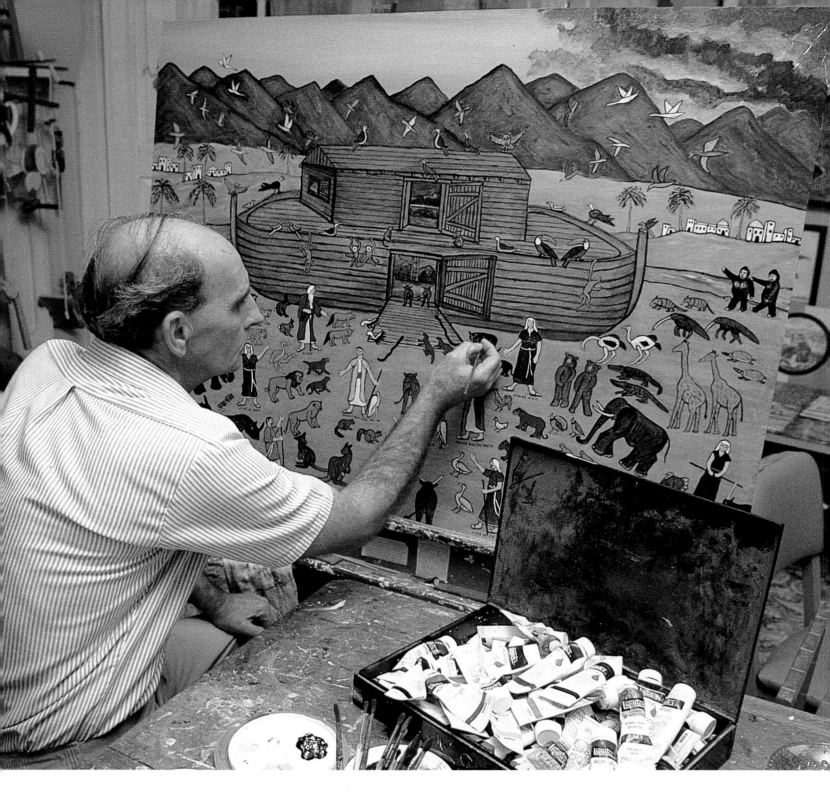

hitting. I remember him beating me so hard that I think he would have crippled me if I hadn't run away."

In the winter dark, when Hugo Sperger was twelve, his home caught fire, an overheated chimney setting the place ablaze. In a few minutes, it was an inferno. The family barely managed to escape, stumbling outside in their night clothes. The house burned to

the ground, destroying everything they owned.

"I stood barefoot in the bitter cold, my teeth chattering, watching my whole world go up in flames." The family was shattered. The boys were put out to live with neighbors. Hugo's mother went off to the city to work as a cleaning woman. His father found a job in a typewriter factory and lived alone in an abandoned chicken coop.

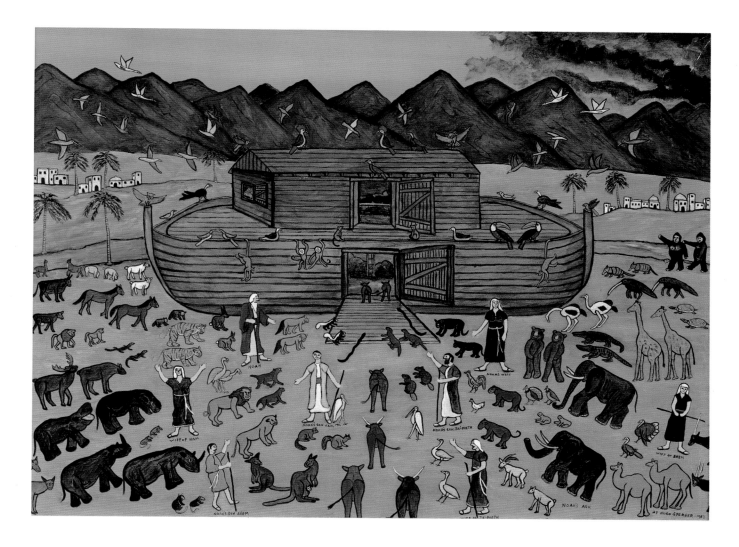

For young Hugo Sperger, life with the neighbors was misery. "The wife was a drunk, and the son resented me. Every time we got within five feet of each other, he was at my throat. Finally, I couldn't stand it another day, and early one morning I jumped out of the window and high-tailed it to my father. I pleaded with him to let me stay and he gave in." He helped his father cover the walls of the chicken coop with plasterboard, add on a room, and build a pump house and privy. Slowly, the family members were reunited again.

Hugo Sperger kept begging his father to let him quit school. "Back then, education wasn't stressed like today. Hardly anyone I knew finished high school, let alone went to college. Most of us thought education wasn't all that great. You didn't need it to milk the cows or slop the hogs."

At eighteen, he was bored with working at odd jobs and hungry to see the world. He'd always been intrigued by his father's Iron Cross, awarded for bravery in World War I. He wrote to the army for information about joining up.

He was cutting down trees for firewood one day when he looked up to see a figure striding toward him. It turned out to be a recruiting sergeant. "All he had to do was look at me to know I was just a dumb kid. He greeted me with, 'How'd you like to spend the winter in Hawaii?' What a liar he turned out to be. I volunteered, and they shipped me to Fort Hancock, New Jersey. Hell of a long way from Waikiki."

On his first leave he made a beeline for New York's Bowery. An innocent country boy looking for action, he prowled past winos and worn-out hookers and

took in the sidewalk menagerie of lost souls. Every other door was a gin mill, a one-arm joint, a tattoo parlor, or a fleabag hotel. It was a kaleidoscope of surreal images that, transformed, were years later to emerge on his canvases.

World War II exploded, and Hugo Sperger ended up on New Guinea where a hundred thousand Japanese were locked in a bloody battle with the Allied troops.

After the war, he plunged into the classic life of an itinerant American worker. He ran a lathe in a munitions plant, worked in milk bottle and type-writer factories, put in time on the assembly line at Fisher Body welding side panels on Chevrolets, ran a punch press stamping out parts for Frigidaires. It is a minor miracle that out of all that drudgery came an artist who creates haunting works, a kind of Kentucky mountain Hieronymus Bosch.

Through the years of sweat jobs, the grinding repetition of fitting on parts and screwing on bolts, he was sustained by his fertile imagination. Part of his mind was in another world. The deafening clangor, the chemical fumes, the glare of spitting acetylene torches, the relentless purgatory of factory life called up visions he was later to paint. An artist is lucky. He can experience fertile defeats.

Hugo Sperger's paintings open the door to a disturbing, eerie universe. Even the most peaceful works are somehow sinister. *Listen to Your Children, Mothers* depicts processions of seemingly calm, mosaic figures moving through a landscape of fragments. The air is bright, but one is left with the sense that these figures were warned, that they should have known better, and that they are condemned to continue marching through this senseless jigsaw puzzle until the end of time.

Listen to Your Children, Mothers

In *May You Have Just Enough Clouds in Your Life to Make a Beautiful Sunset* (above), the title's sardonic good luck wish is offered to placid men, women, and children scattered around a broad stairway. Almost all of them face away from the steps, unaware of the huge, popeyed Medusa head that rises above them, an implacable god that seems to spell approaching doom.

Hugo Sperger survived a life of violence and mind-deadening jobs and went on to art. How he did it is a mystery. Perhaps the answer lies in the motto he got from his father. It is scrawled in German across one of his paintings: "What doesn't destroy me makes me stronger."

That's as good a description as any of Hugo Sperger's life.

Overleaf: *Creation*

117

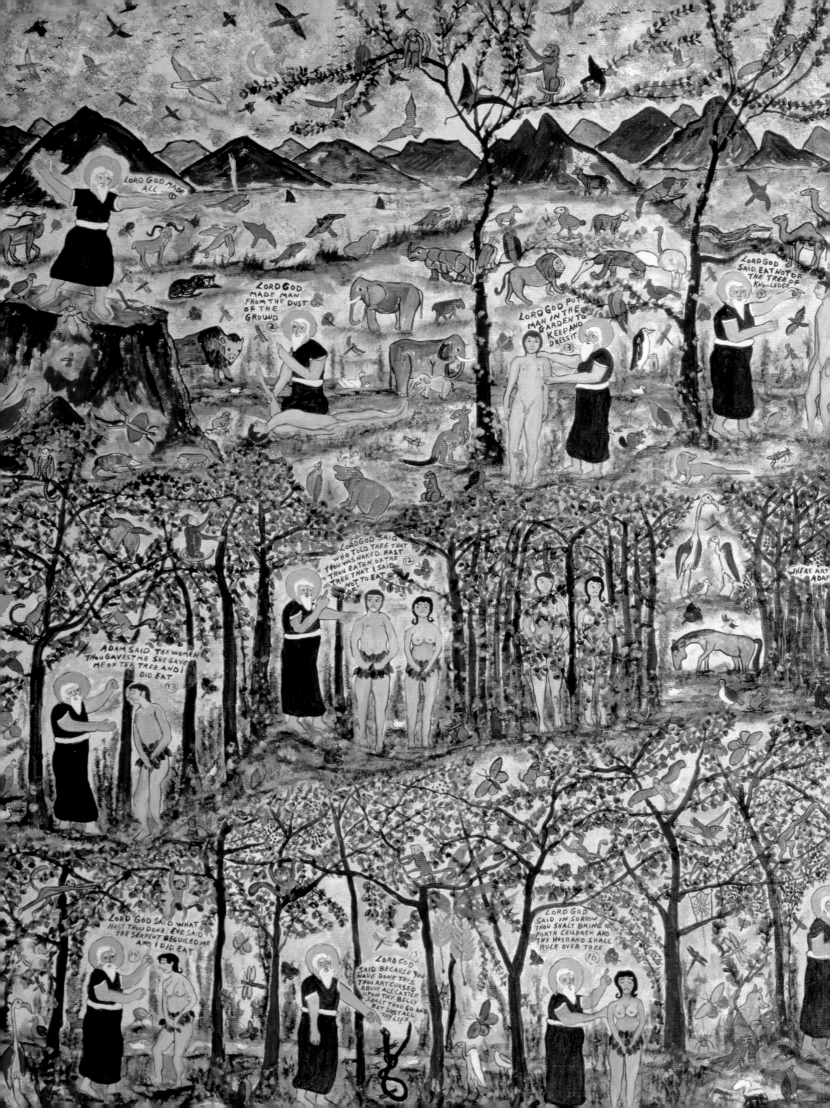

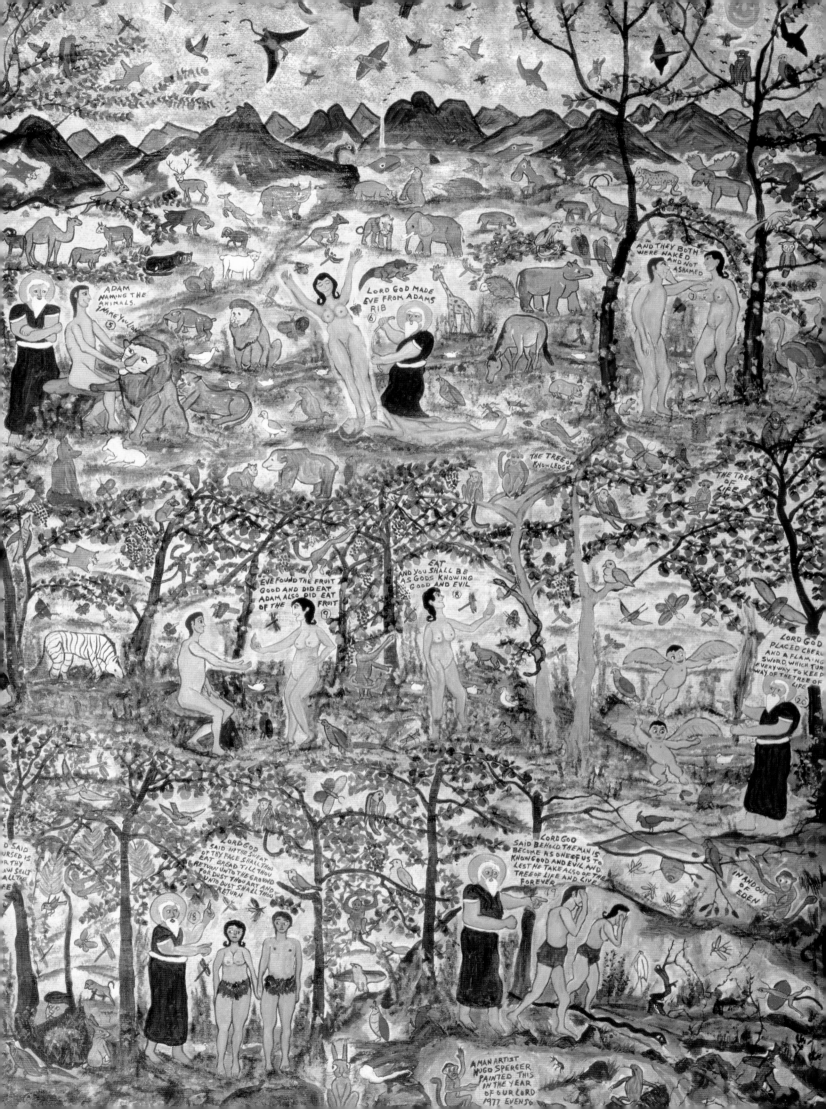

ADAM NAMING THE ANIMALS. I NAME YOU LION. (5)

LORD GOD MADE EVE FROM ADAMS RIB (6)

AND THEY BOTH WERE NAKED AND NOT ASHAMED

THE TREE OF KNOWLEDGE

THE TREE OF LIFE

EVE FOUND THE FRUIT GOOD AND DID EAT ADAM ALSO DID EAT OF THE FRUIT (9)

EAT AND YOU SHALL BE AS GODS KNOWING GOOD AND EVIL (8)

LORD GOD PLACED CHERU AND A FLAMING SWORD WHICH TUR EVERY WAY TO KEEP WAY OF THE TREE OF LIFE (20)

D SAID URSED IS R THY OW SHALT ALL THE FE

LORD GOD SAID IN THE SWEAT OF THY FACE SHALT THOU EAT BREAD TILL THOU RETURN UNTO THE GROUND FOR DUST THOU ART AND UNTO DUST SHALT THOU RETURN

LORD GOD SAID BEHOLD THE MAN IS BECOME AS ONE OF US TO KNOW GOOD AND EVIL AND LEST HE TAKE ALSO OF THE TREE OF LIFE AND LIVE FOREVER (19)

IN AND OUT OF EDEN

A MAN ARTIST HUGO SPERGER PAINTED THIS IN THE YEAR OF OUR LORD 1977 EVEN SO

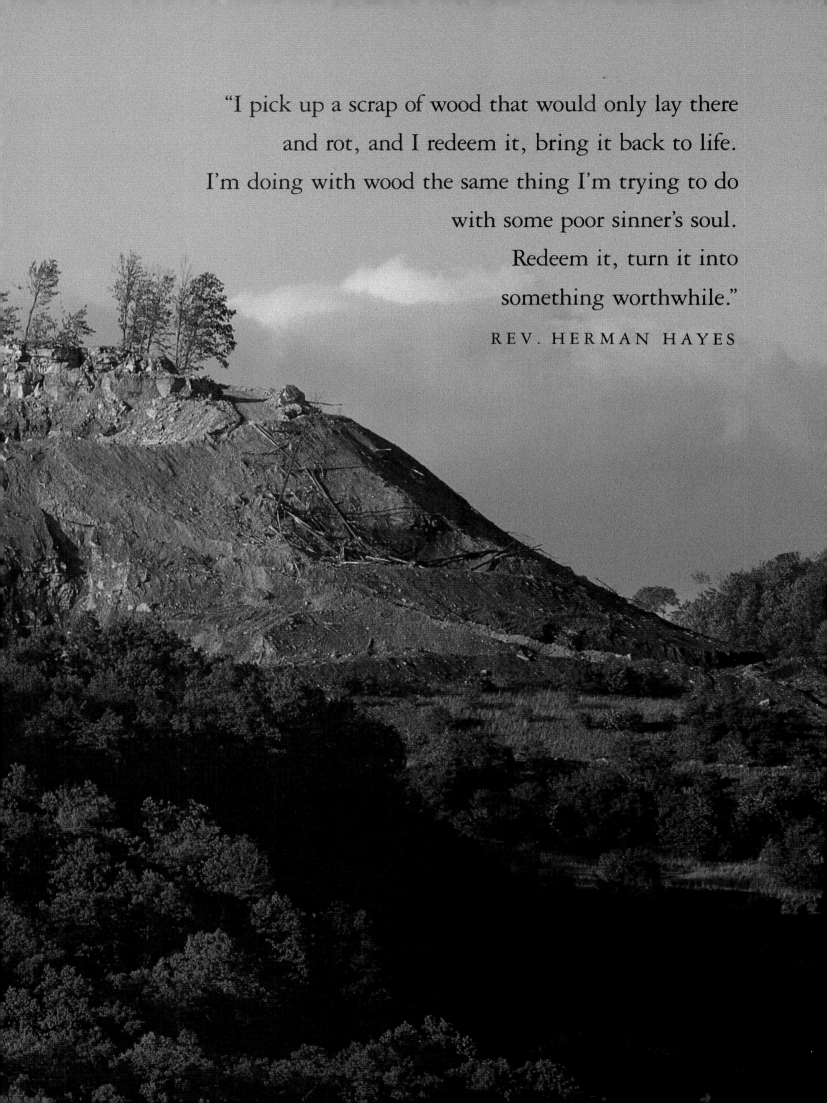

"I pick up a scrap of wood that would only lay there
and rot, and I redeem it, bring it back to life.
I'm doing with wood the same thing I'm trying to do
with some poor sinner's soul.
Redeem it, turn it into
something worthwhile."

REV. HERMAN HAYES

REVEREND HAYES

INSIDE AN ARENA, church service is going on. The preacher stands at his pulpit. A lady pounds dementedly on the piano. Filling the rising bowl of pews, the congregation of more than seventy bawls a hymn. Among them sits an angry patriarch with a wild beard down to his waist, a man wearing a wooden leg and a leering grin, and three mothers holding diabolical children. The congregation is a rogue's gallery of pious faces, furious faces, malicious faces, faces twisted in wicked glee.

Carved out of mahogany, bass, willow, walnut, buckeye, ash, and pine, the figures in the congregation are little more than an inch high. The church arena is constructed of Popsicle sticks and measures less than nine inches across. The sculptor who created it is Reverend Herman Hayes. A Methodist minister, his sharp features, widow's peak, and sardonic smile make him look more like Mephistopheles than a man of the cloth.

"My favorite theme throughout my ministry has been love of God and God of love. God loved me enough to lift me up and keep me out of jail. I'd have landed there, you can bet on that, if I hadn't been saved."

A picture of Jesus is pasted on the band saw in the basement workshop of his home in Hurricane, West Virginia. On his workbench are chisels, gouges, and homemade knives. Their wooden handles are adorned with carved figures. They hold delicately honed, old-time straight-razor blades.

"One time, when I was about twenty, I counted the knife scars on my hand. There were thirty-five of them. I don't even want to think about how many there are now."

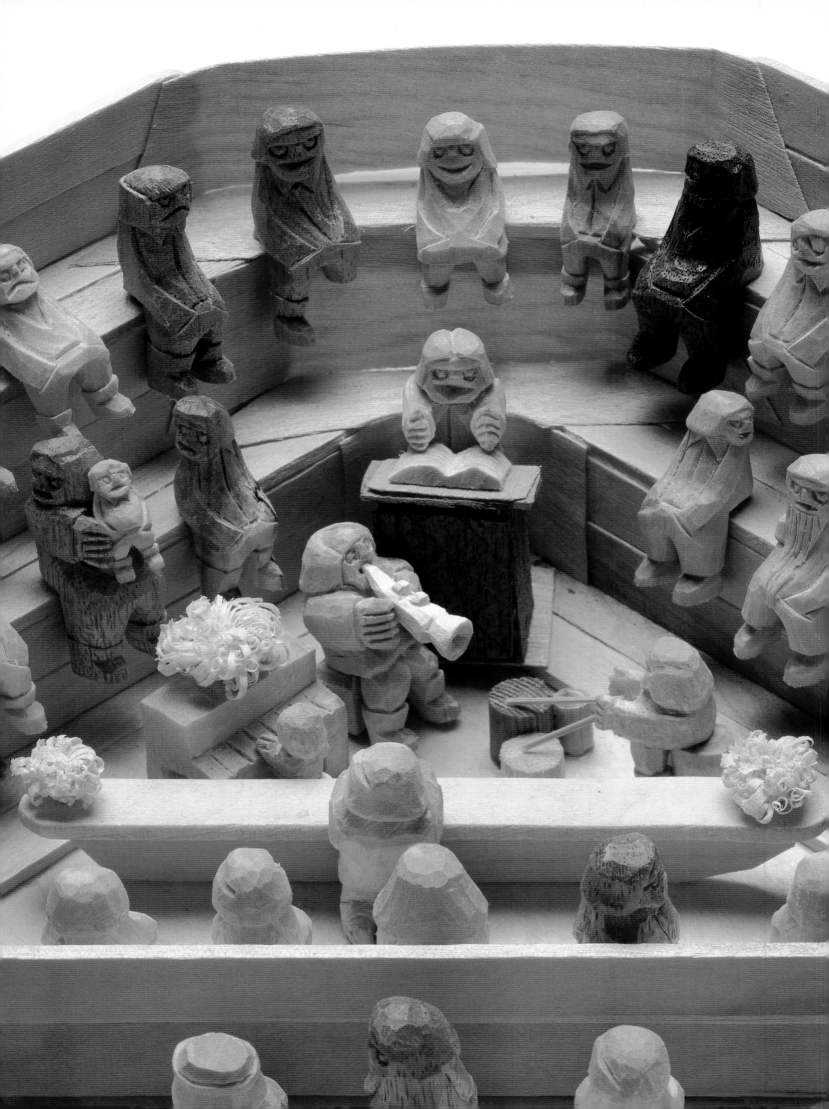

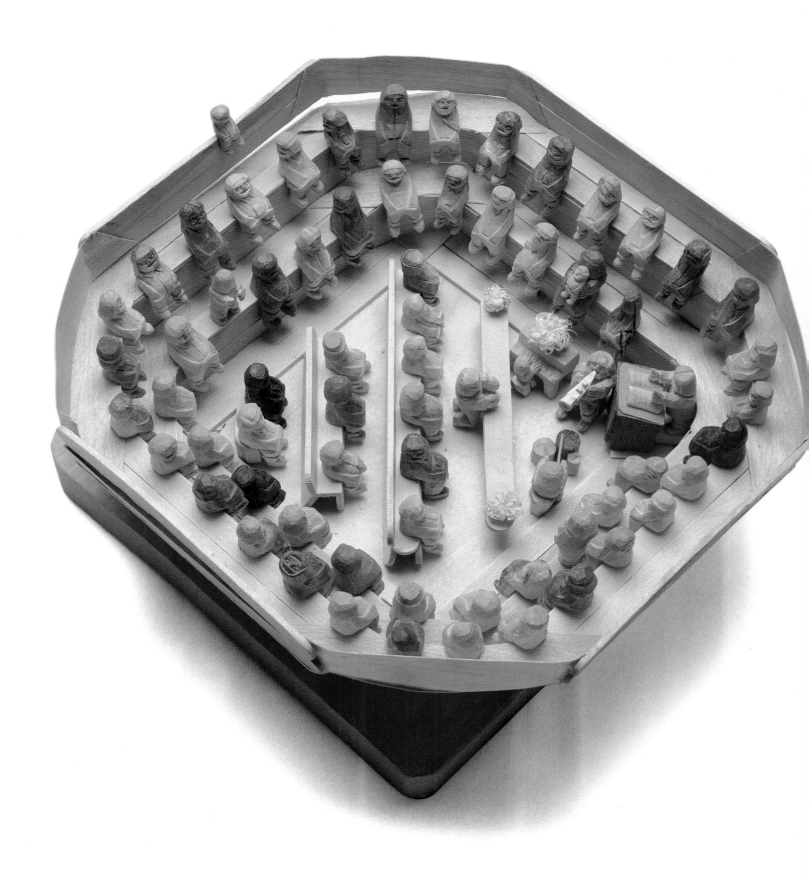

Sunday Meeting

Overleaf: chess set.
The light pieces are lynn wood,
the dark pieces poplar.

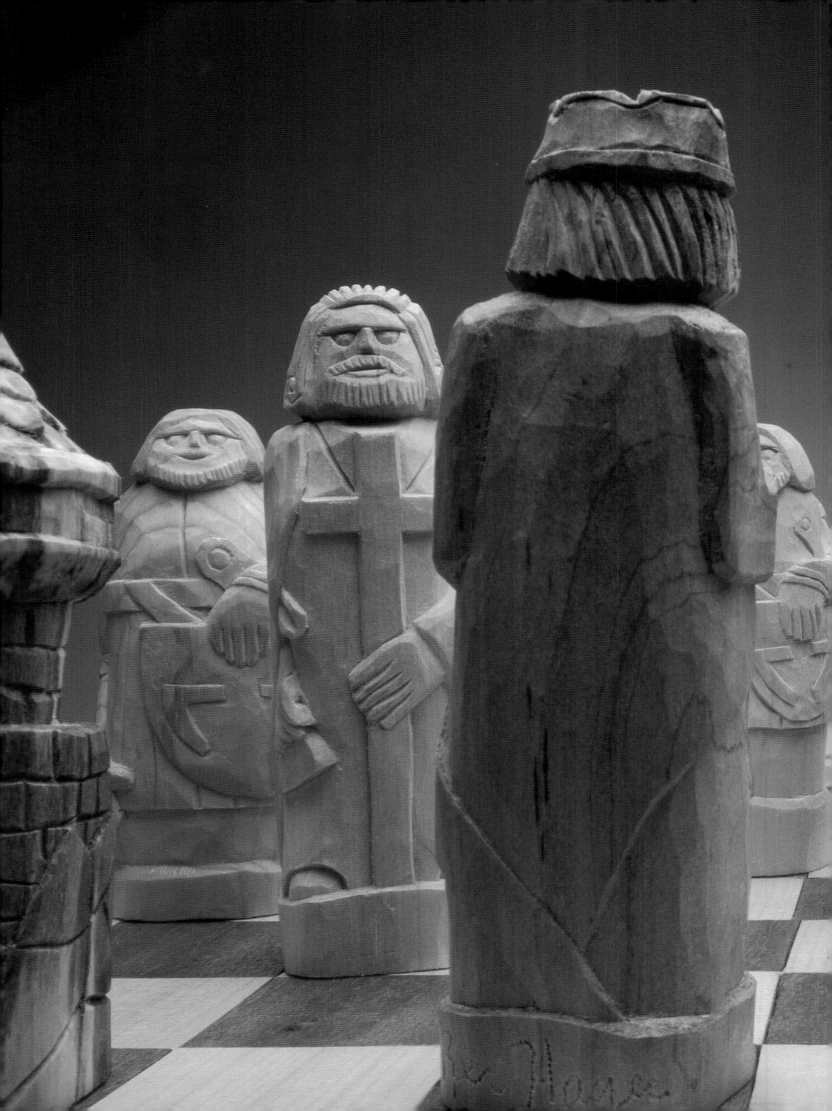

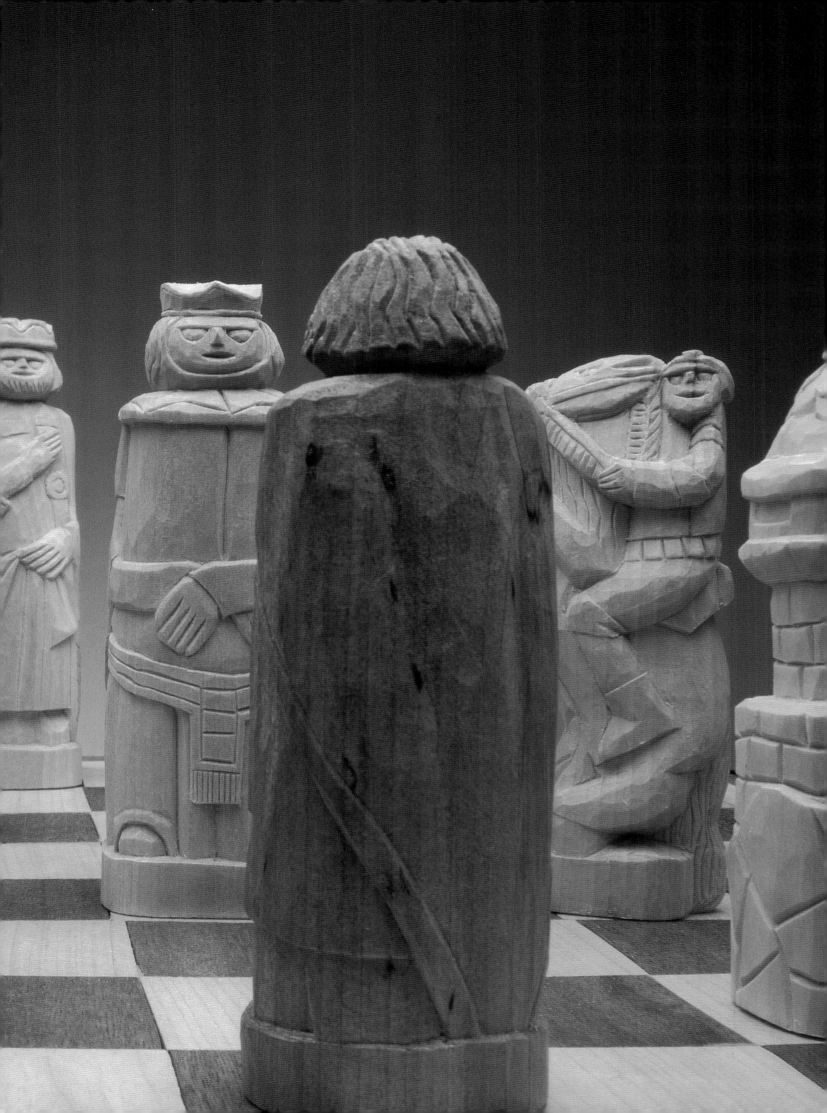

Reverend Hayes is shaping a hat for *Russell*, a three-foot mountain man in overalls who holds a pitchfork with coat-hanger wire tines. Carved with a peg that fits neatly into a hole on the top of his head, Russell's hat can be doffed and clapped back on.

"If something I carve helps somebody laugh away dire circumstances, if it will make a child have delight, I'm glad."

Most of Reverend Hayes's pieces have something about them that evokes a smile. Mischievous babies bedevil their parents. Giant women stand on the shoulders of tiny men. Children stand on their heads with three grownups balanced on their upraised toes. The air of a loony sideshow surrounds it all.

He has compassion for the poor and the mad, but he's not one to suffer fools. When he exhibits his work at a fair, his answers to questions he's heard a thousand times are dry and polite:

WOMAN WITH BEEHIVE HAIRDO: How long does making one of these take?

REVEREND HAYES: Till it's finished.

BELLIGERENT MAN: If I had a mind to, I could whittle something like that. Where do you get your wood from?

REVEREND HAYES: Trees.

THIN-LIPPED MATRON: Well, it's nice, but you're asking too much for it.

REVEREND HAYES: It took me ten hours to carve. If I sell it for the price I got on it, that'll come to two dollars an hour. If you want to work for less than that, ma'am, go right ahead. I think the fruits of my labor are worth every dime I'm asking, and likely more.

Right: *Russell;* facing page: *Uncle John*

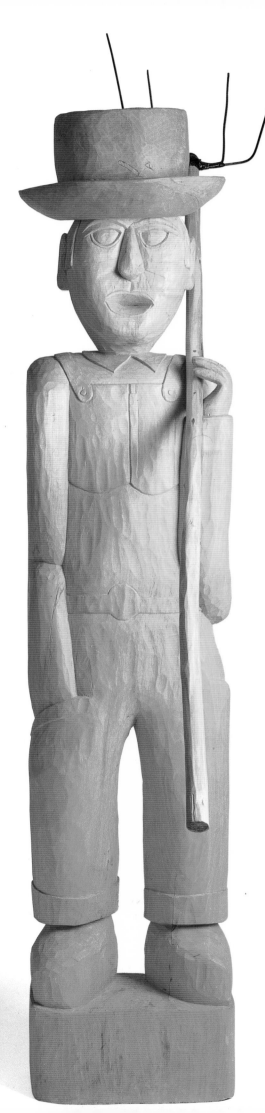

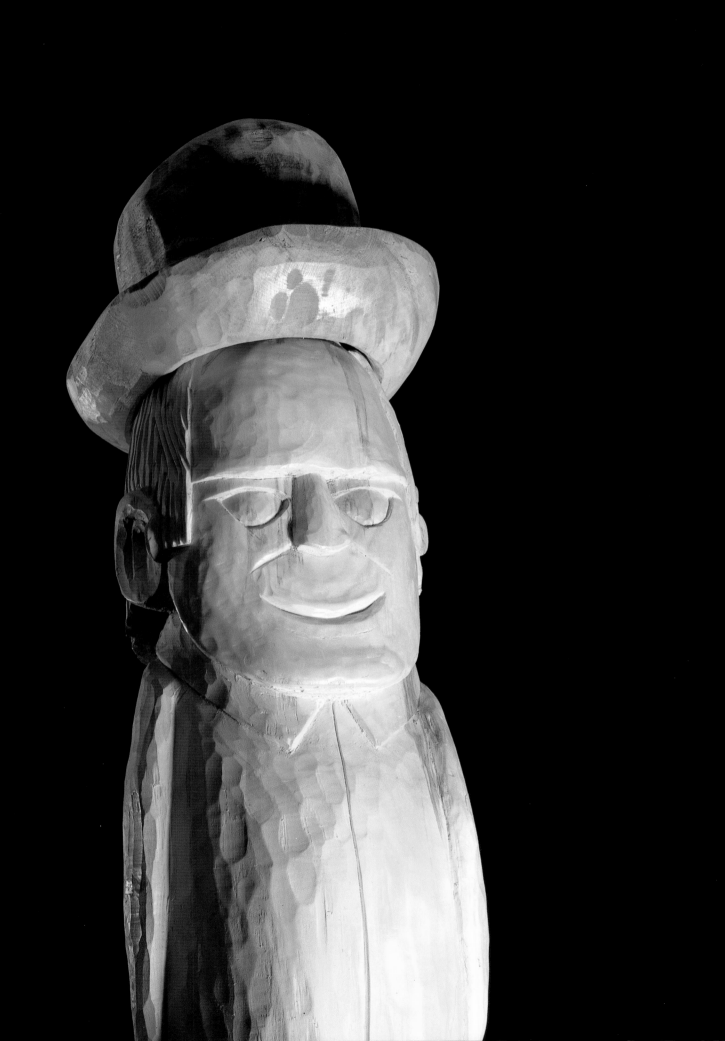

He makes no excuse for his lively interest in money. "Jesus preached poverty, but he was divine. I'm human. I don't hold myself above what I can earn by honest work."

Honest work started for Herman Hayes when he was twelve. The son of a pipe fitter, living near the bank of the Oak River in West Virginia, he hired out to neighboring farmers to hoe corn and bale hay. In his teens, he was putting in cisterns, digging beds for them twenty-two feet deep. "It took muscle, I'm telling you. It's not easy to throw dirt up twenty-two feet. And it was dangerous, know what I mean? The soil was real sandy, and it could cave in and bury you."

He got into boxing. A scrappy bulldog of a middleweight with dancing feet and a nice left jab, he fought forty-eight amateur Golden Gloves bouts. He won forty of them.

"You might say I got into fighting by self-preservation. I had four brothers, and we were always raising sand. You either took care of yourself rough, or else. When we'd get into an argument, my dad would just put the gloves on us, and tell us to settle it. We'd go until we dropped, or cried and begged him to let us stop."

World War II ended Herman Hayes's boxing career. He joined the marines and shipped out to Okinawa. There he repaired engines on dive bombers that were flying through murderous flak to hit the entrenched Japanese.

Before he entered the service, when he was eighteen, he'd felt the call. Nothing came of it. "I was sort of a rattlebrain. My dad laughed at the idea, told me I was out of my mind for thinking I could ever preach."

When he landed back in the States and took off his uniform, the call to spread the gospel took hold again, stronger than ever. He tried everything he could think of to fight it off. He got a job at Coca-Cola on the bottling line. He couldn't see it leading anywhere, so he left to work as a door-to-door salesman, peddling electric sweepers and magazines. It sharpened his line of gab and taught him about the human comedy. Popping into strangers' homes, a salesman sees lots of peculiar stuff. The lunacy he encountered was later to emerge in his art.

The call wouldn't go away. "It's not thinking you can preach, it's thinking *you've got to*. If you really feel it, then there's nothing else. No matter if you try fifty other things, which I did, even to the point of getting drunk, you can't get away from it. I couldn't. It'd come back. Finally, I went up on the mountain and preached to the trees. Come down, and that Sunday I preached in church, and six came to the altar to be saved."

For Reverend Hayes, there is a thread that connects preaching and carving. "I pick up a scrap of wood that would only lay there and rot, and I redeem it, bring it back to life. I'm doing with wood the same thing I'm trying to do with some poor sinner's soul. Redeem it, turn it into something worthwhile."

Proudly, he points out the chess set he has recently carved. The pieces are medieval in appearance, some in armor, some in royal robes. Instead of white and black, the opposing figures are fashioned out of contrasting dark poplar and pale bass woods.

"It's pleasing to find out people like my work well enough to pay for it, but even if they wouldn't pay a cent, I'd still go ahead and carve. I love wood. I've always loved the grain of it, loved the smell. I carve because it's fantastic to take an old piece of wood and turn it into something that somebody will cherish and keep for years and years."

He regards *Russell* with a narrowed, calculating gaze and decides to add buttons to the overall straps. "I carve because I can't help myself. I hope to keep my eyesight and be able to carve when I'm eighty. If I can't carve, I don't want to stay here that long."

Push-ups

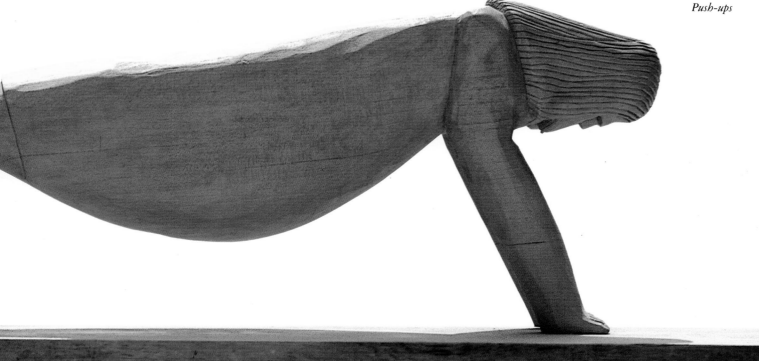

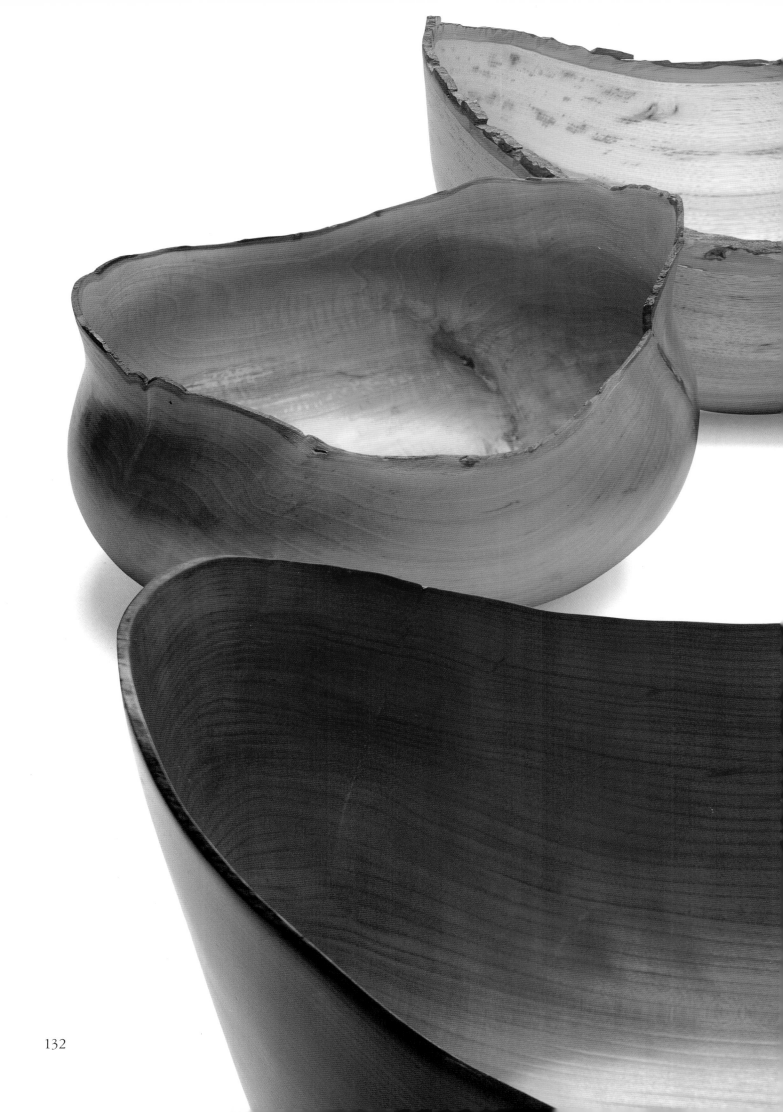

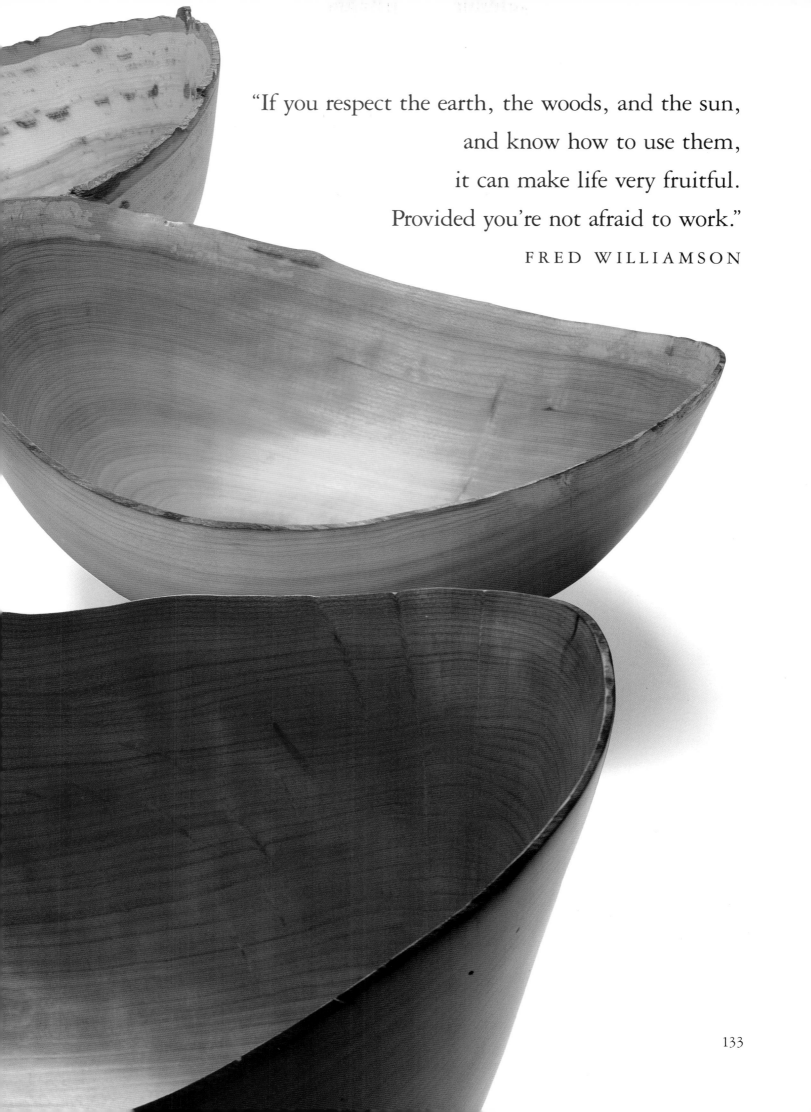

"If you respect the earth, the woods, and the sun,
and know how to use them,
it can make life very fruitful.
Provided you're not afraid to work."

FRED WILLIAMSON

133

FRED WILLIAMSON

APPALACHIA is a drama of contrasts. It is a region that breeds proud, hard-working people and sorry specimens who haven't lifted a finger in honest labor since the day they were born. There are mountaineers defeated by unemployment, dependent on charity, blind to the beauty of the hills. And then, there are families like the Williamsons.

With his penetrating green eyes, reddish beard, and austere features, Fred Williamson looks like a West Virginia version of Vincent Van Gogh. His wife, Jacque (pronounced Jackie, a bobtailed offshoot of Jacqueline), is fine-boned, skillful, and competent. They have two young sons and a small daughter, and their way of life is as close as it gets to independence these days. They have what it takes to thrive in the mountains: toughness of sinew, a strong spirit, a closeness to nature, and an attachment to making do with what they've got.

"We decided we weren't going to live in a way that was driven by money," Fred Williamson says as he sharpens his chain saw with a slim file. "If you respect the earth, the woods, and the sun, and know how to use them, it can make life very fruitful. Provided you're not afraid to work."

He cherishes wood. Trees are his passion and his support. His craft is making furniture. His art is creating sculptural, strikingly grained, almost paper-thin wooden bowls.

The son of a Presbyterian minister, Fred Williamson spent his early years on the outskirts of the bleak coal-mining town of Hazard, Kentucky, where his father ran a mission. He was five when the family moved to what was then the Belgian Congo, where Reverend Williamson was sent to spread the glory of the Christian faith. In his first school term, young Fred Williamson found that he was expected to learn French and write with a quill pen. He managed to avoid doing either.

His African boyhood was a jungle echo of Huck Finn's, spent building rafts and tree houses and getting into as much mischief as he could. He also began to make ivory carvings. Both his art and his games ended abruptly when the colonial government was overthrown in the struggle for independence. The Belgian Congo became Zaire, and the Williamson family was hastily airlifted back to the United States with no more than a chest of grandmother's silver, a crate of books, and the clothes on their backs.

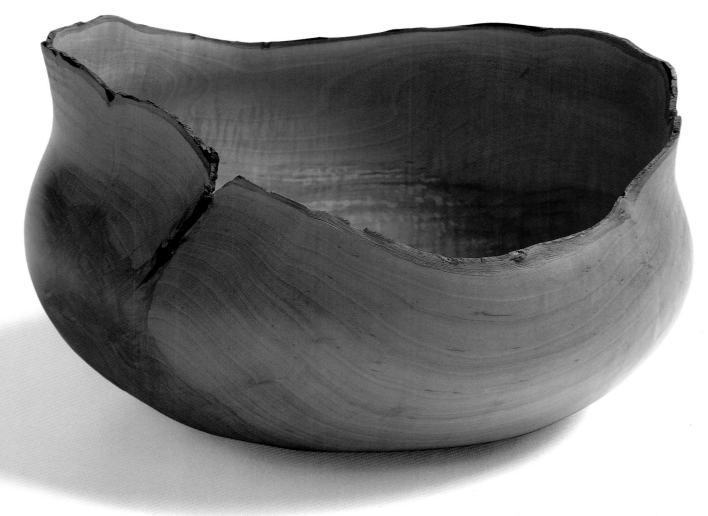

Spalted maple bowl with natural bark line

It was while his father was teaching at a Presbyterian school in Richmond, Virginia, that Fred Williamson met his future wife. Jacque Williamson lived in the country then, where her father ran a church camp for children. They went off to college together. She finished, and he stuck it out for two years. "I got what I wanted out of it," he says with satisfaction. "In spite of all the traveling, I had a very provincial, Presbyterian view of the world. College opened my mind to other ways of living a spiritual life, other avenues of reality."

He got a job in a wood-carving shop. "We turned out all sorts of things, from hand-carved, gold-leaf signs to ships' figureheads." He took to working with wood like a bird to the air. He had found what he loved to do.

On a West Virginia mountaintop is the home the Williamsons built for themselves, a sprawling, comfortable place. Like all the other structures they've put up, it is angled to take advantage of the sun. Solar energy warms the greenhouse, seasons the wood in the drying shed, and runs the icebox Fred designed.

Chickens range free, and three goats browse in the yard. Besides keeping down the weeds, the goats provide milk, butter, cheese, and even ice cream. Now in autumn, a mulch of wood shavings protects the large garden, enriching the soil for the coming spring. Squash and apples rot on a compost heap. In the greenhouse, there will be peppers, lettuce, and tomatoes for the picking as far into the winter as Christmas day. In a good year, the Williamsons put away as many as eight hundred quarts of fruit and vegetables. They grind their own peanut butter and make their own flour with a hand-cranked mill. When they were roofing the house, they camped out and did their washing in a stream. Jacque Williamson made their soap then. She still does.

In the kitchen, Jacque Williamson and their middle child, Ryan, are baking bread. The youngest, three-year-old Rachel, is cheerfully pounding on her own small wad of dough. The oldest, Nathan, is off in the workshop, making himself a model boat. The children are educated at home, the local school being woefully inadequate when it comes to stimulating imagination and encouraging creativity. With a degree in education, Jacque is prepared to teach the basics, and the family's lifestyle offers a fountain of knowledge to be found in the workshop and the woods. Books and music are everywhere in the house, games are constantly being invented, tools are there for the using. The Williamsons don't own a television set.

Behind Fred Williamson's workshop, the ground is littered with logs, some of them too thick for a man to embrace. Log sections sit on a bed of shavings to keep them from drying too quickly and splitting. The carpet of shavings also prevents his chain saw from hitting stones. As much as he can, he uses shavings from spalted wood. The work of an invisible fungus, spalting adds a handsome tracery of black, gray, and brown markings to the grain, patterns that enrich the beauty of the wood.

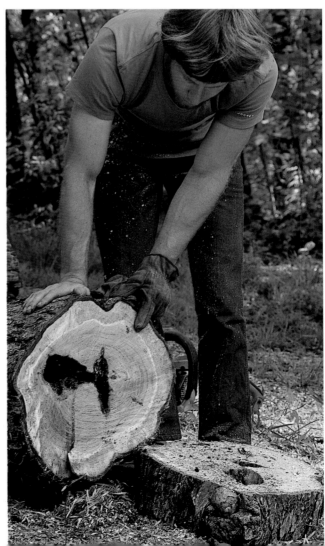

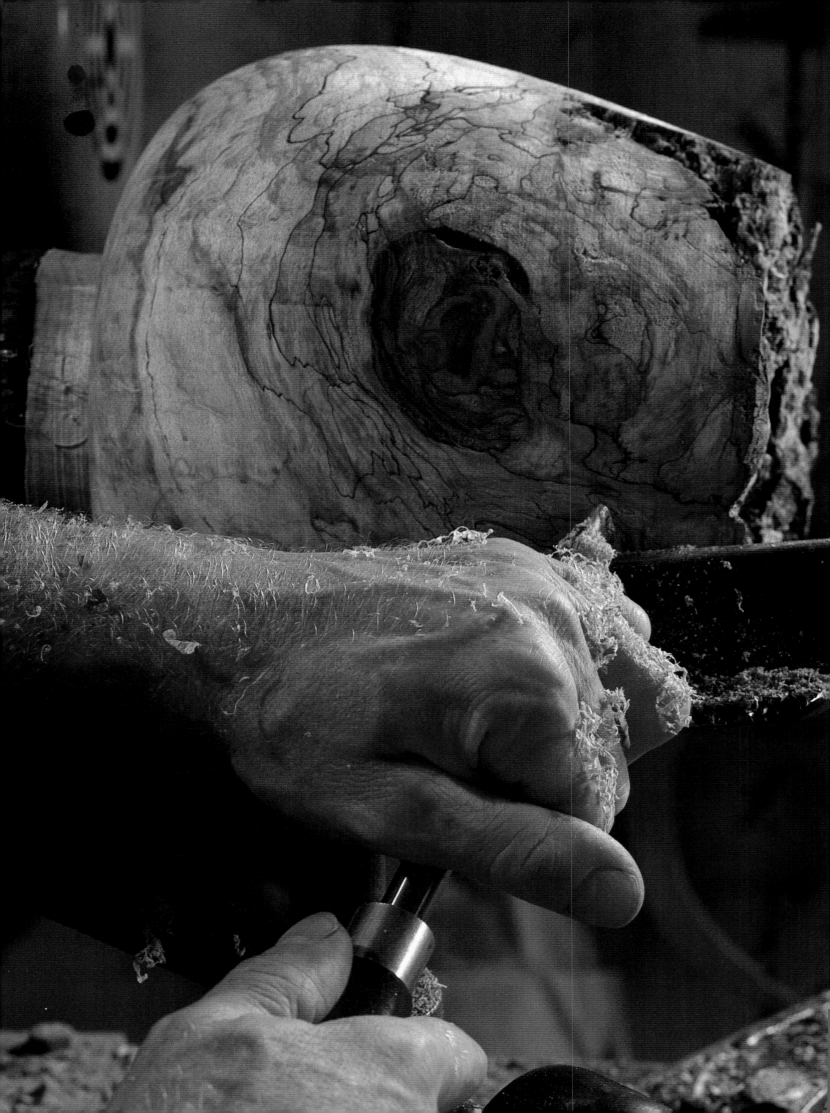

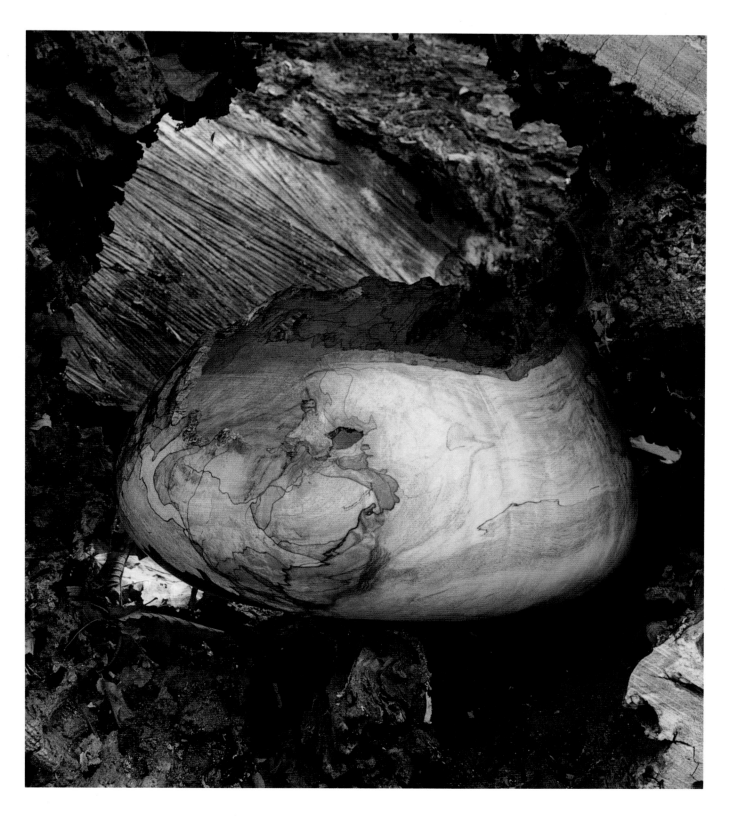

Friends, neighbors, and the county forester get in touch with Fred Williamson when there is a tree that has to come down, one that is sick or old or has been weakened by a storm. If it is a tree he can use, he offers in exchange one of the bowls he makes out of it. Most prized are those made of burl, a hard,

knotty knob with a grain of convoluted whorls, and the bark-edged bowls that are so difficult to create.

To make a bark-edged bowl, Fred Williamson selects a broad log with thick bark, a wood with rich grain, like apple, cherry, maple, or mockernut hickory. A

bowl is a cross-section of the tree, its rim the outer edge, its bottom the heart wood.

Preparing to square off a section called a blank, Fred Williamson crosses his fingers and prays, appealing both to Lady Luck and to God. He handles his chain saw with precise skill. A slip, the slightest clumsy movement can mar the bark.

He sets the blank on his workshop table and stares at it, visualizing the bowl that will emerge. As it springs alive in his imagination, he sketches its oval on the blank with chalk. Using a small, electric chain saw, he roughs out the bowl and cuts the bottom flat. Then he finds the center of the bowl with a compass. He screws a metal plate to the blank at the center and mounts it on his lathe. Every step now is careful, thoughtful, delicate. He spins the blank by hand to check the balance. If its weight is off-center, it must be taken off and trimmed.

His mood is like that of a surgeon preparing to operate. Setting the lathe at its slowest speed, he takes up what is known as a "long-and-strong turning gouge," a curved chisel with a gleaming blade the length of his arm. Gripping it tightly, he begins to cut, taking corners and bumps off the spinning wood until he has it "trued up."

As he works, feeling out the bowl, carving it, moulding it, Fred Williamson may alter the shape to show off some newly revealed figure in the grain. Always, there are surprises as the wood's inner secrets come to light. Always, there is the chance of a misstep. He could knock off the edge of bark, or an unforeseen weakness in the wood might shatter a half-finished piece.

It can take as long as two days or more to shape a bowl. Then come hours of sanding and polishing, finer and finer stages, ending with jeweler's rouge. In the end, the wood is silken, thinner than an eighth of an inch, but amazingly strong. Fred Williamson makes his bowls out of green wood, letting nature play a role in their design. As they dry, they find their final shape which, like most works of nature, is never perfectly symmetrical.

Both of the Williamson boys have been drawn to the lathe. By the age of eight, Nathan was carving bowls under his father's watchful eye. It is too early to tell whether the art has passed on from father to sons.

At the lathe, Fred Williamson adjusts his goggles and takes up his long-handled gouge. He hits the switch and the blank of maple begins to spin.

Touching his blade to the whirling wood, Fred Williamson sets out on a journey of discovery.

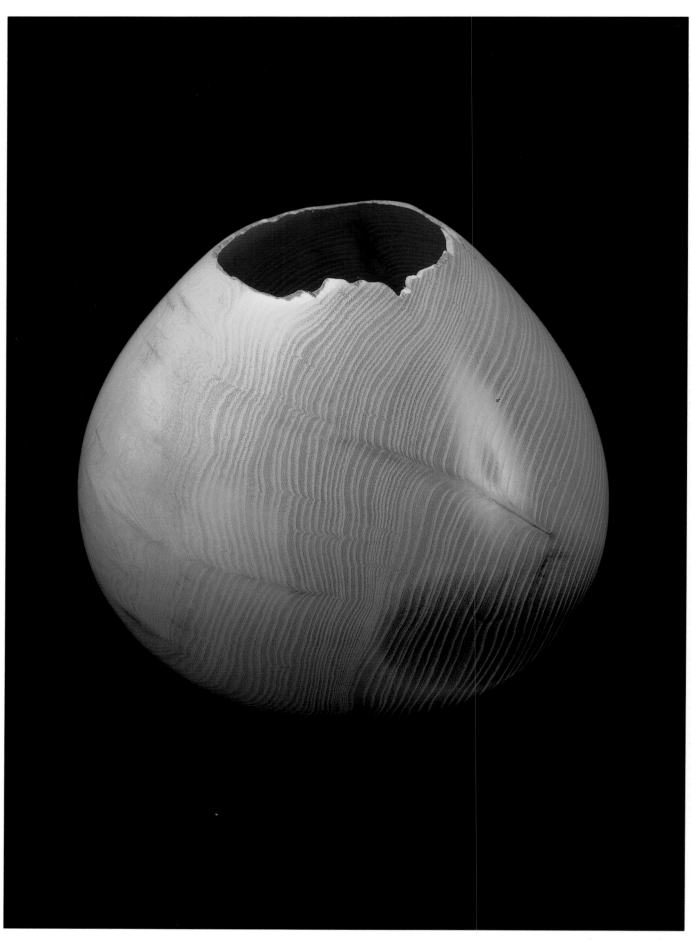

Osage orange bowl

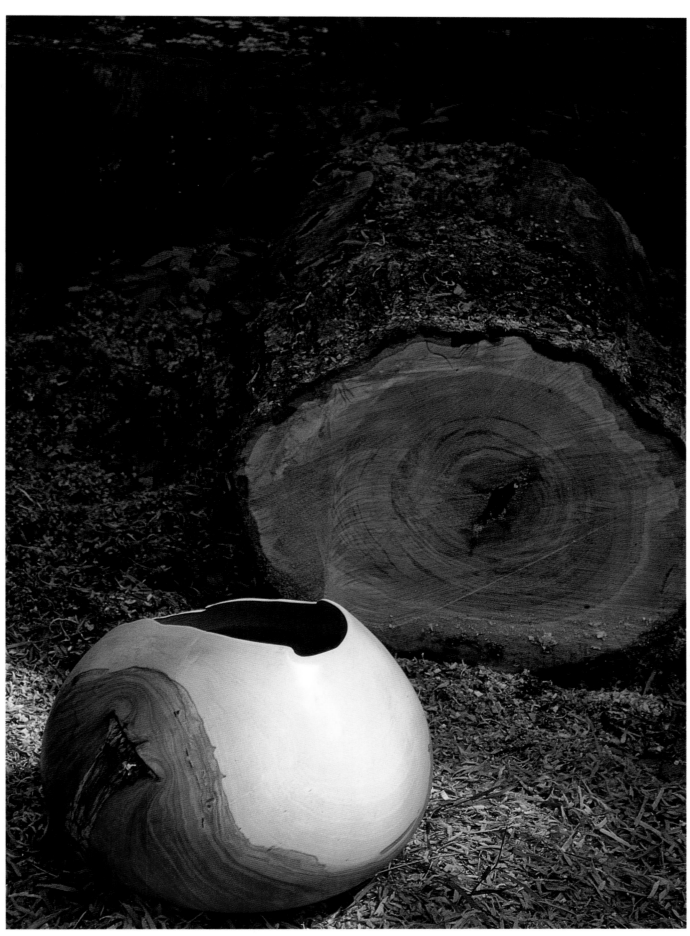

The trunk of a dead sugar maple and the beauty it yielded.

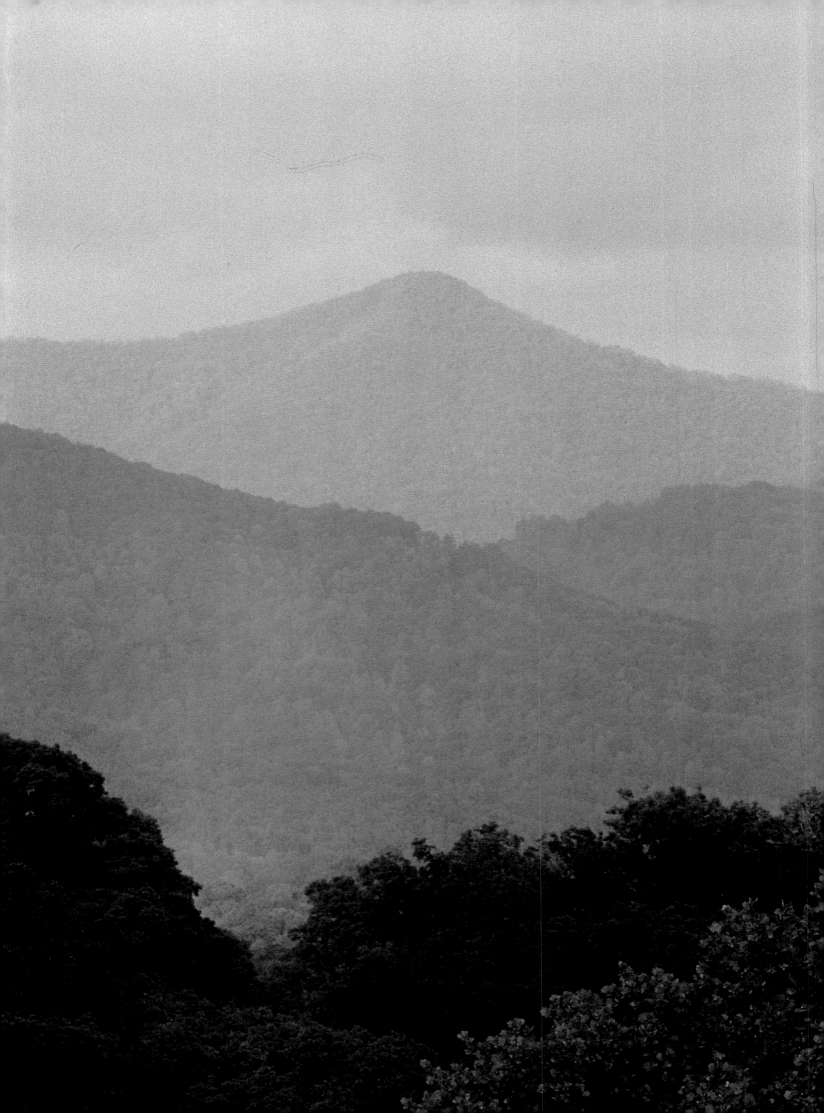

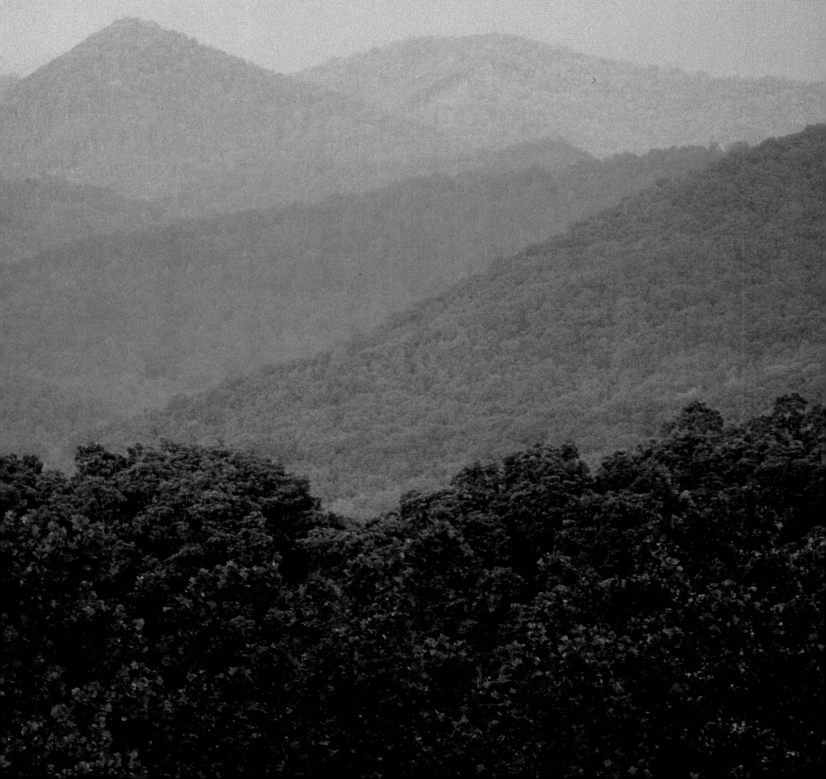

"If I hadn't worked aside from preaching, we couldn't have made it.
In the first year and a half, my work for the Lord
didn't bring in but ninety-nine dollars.
But even during the Depression, I was always able to get a job."

REV. BENJAMIN FRANKLIN PERKINS

REVEREND PERKINS

A BONY MAN with thinning hair and horn-rimmed glasses, Benjamin Franklin Perkins looks like a retired bank clerk. You'd never dream that he is consumed by a burning passion, that he has sacrificed everything for it, including his marriage and most of his worldly possessions. You'd never guess that he has led a life worthy of a picaresque Jack London story, that he is driven to create paintings that are Byzantine in their blazing colors.

The air smells of pine. On the steeple of the rural Alabama church, the hands of the clock point to ten, the hour of Sunday morning service. The hands always point to ten. They are painted on plywood. The church couldn't afford a real one, so Reverend Perkins built the tower and painted on the clock.

A rusted tin roof shelters the entrance. Above the door is a rainbow and a sign:

The rainbow of love from heaven above. God loves you. All are welcome. Please read and take heed. This is God's church, Jesus is the head, the Holy Ghost is the overseer. This is God's house, and the gates of Hell shall not prevail against it. Benjamin F. Perkins, Pastor.

Beyond the church, a flaking, white picket fence lines a double driveway, the twin roads passing beneath worn, wooden arches. At the head of the U-turn stands Reverend Perkins's small home. Halfway between the church and the house he has built a wall of bricks and cinder blocks. It encloses a crypt. The flat stone that covered the opening of the crypt lies a few feet away. Printed across the wall is a message:

This replica of the sacred shrine where our Lord was buried for 3 days, but he rose on the 3rd day as he said he assend into heaven and sat down at God's right hand. All that are in the graves shall hear his voice and shall come forth. All must face judgement. Some will bee saved, some will bee lost.

A short distance past the crypt, on a low slope, Reverend Perkins has erected three crosses. They rise against the sky, a replica of the crucifixion site.

A low roof slanting from the side of the house covers Reverend Perkins's open-air studio. Working hours here are limited to good weather. The rafters are hung with painted gourds the size of basketballs. Recurring motifs in the designs painted on the gourds are the church with its clock tower, the Stars and Stripes, and the Statue of Liberty. Leaning against the wall are finished canvases, some with mysterious religious symbols, some with giant peacocks whose feathers form an intricate pattern of orange, ultramarine, and gold. Nearby, Reverend Perkins sits on a rickety

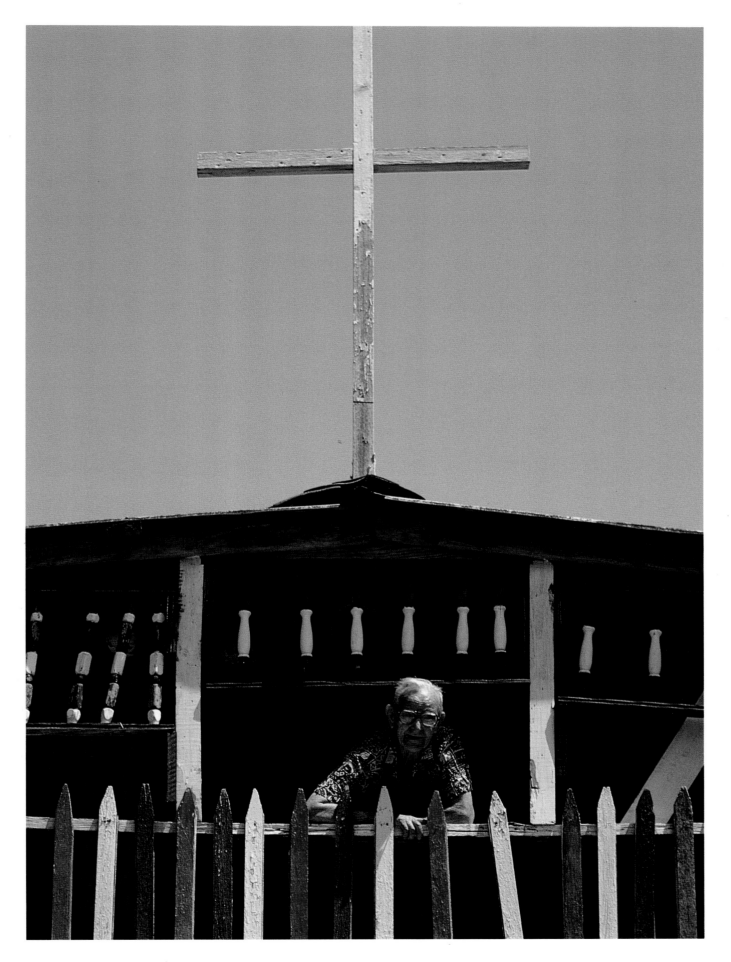

chair, painting. A closer look at his gaunt features reveals the high cheekbones that speak a strain of Cherokee.

"The Indian blood comes from my mother. I don't hardly remember her. She died when I was seven." His gaze turns inward as he recalls. "I never did any sort of art when I was growing up. My father worked for a sawmill. When I was nine, I started working with him, down in Slipsey River bottom, cutting white oaks, some of them four feet thick and a hundred feet high."

Young Benjamin Perkins would pull one end of a crosscut saw, and his brother would pull the other end. "I didn't spend too much time sawing. What I mostly did was train wild horses and mules. Every spring, a few boxcar loads would come in from the west, and there'd be an auction. One pair of horses I'll never forget. They were giants. I kept begging my boss, buy them, buy them, *buy them*. Come evening, they still hadn't been sold. The boss says, okay, I'll buy them, but you'll have to drive them back."

Painted gourds

In the Alabama night, nine-year-old Benjamin Perkins struggled to herd two huge, unbroken horses weighing more than eighteen hundred pounds apiece along twelve miles of country road to the sawmill. The next day, he started to train them. They'd never worn a bridle. He had to use rubber bits to keep their mouths from bleeding.

"They fought me every inch of the way. If one of their kicks had ever landed, I'd have gone to heaven. But I was young, and fast at getting out of the way. When they were trained, they were beauties. The boss figured he could make a nice profit on them. When he put them up for sale, I cried for a week. If some of my family had died, I couldn't have cried more."

His next job was in a cotton mill. Twelve hours a day in the steamy, dust-hazed room where they spun thread.

When I die, don't bury me at all,
Hang me up on the spool-room wall,
Place a bobbin in my hand,
So I can keep on workin' in the promised land;
I got the blues, got the blues,
I got those Winnsboro cotton mill blues. . . .

At sixteen, he left the cotton mill for the coal mines. "I had to load fifteen tons a day to make my five dollars. I stayed on till there was an explosion during the night. I went down in the morning, and the room where I'd been working was all caved in. The boss said he'd give me another room. I told him, no you won't, and walked out and threw my bucket over the hill." He found a job in a steel mill, drawing wire needle thin. On his seventeenth birthday, he joined the marines. On Parris Island, he was detailed to guarding prisoners.

"I hated it. They were unloading barges at night. Each guard was in charge of four prisoners. If one got away, the guard was sentenced to finish his time."

He volunteered to go to Japan to learn karate, and returned to the States to teach it. Then he was assigned to the presidential yacht, U.S.S. *Mayflower*, to guard President Coolidge. When his hitch was up, he got a job working undercover for the FBI.

"I can't tell you what I did. There's people still living, serving life sentences in the penitentiary, that I helped put away. If they ever got out, my life might be in danger. All I can say is one of them killed seven people in Chicago and then two cops in Michigan before we got him cornered in Independence, Missouri, and arrested him."

It was around that time that Benjamin Perkins got the call. It happened in Washington, D.C., one Friday night when he was on his way to a poker game.

"I saw a big sign with a cross on it and just two words: *Jesus Saves*. It kept flashing, *Jesus Saves, Jesus Saves*. Hit me like a bolt of lightning. I kept walking away and being drawn back." His eyes glitter with passion, emotion gripping him as he recalls: "I went into that mission, and they were singing *Nothing between My Soul and the Savior*. I felt the spirit enter my heart. I said to myself, surely, this must be God dealing with me. I answered the call, and that's the happiest day of my life."

He put himself through divinity school by working as a brick mason's helper. After he was ordained, he married and began ministering at revivals and storefront churches. His first revival was deep in the mountains, at a place in Virginia called Hickory Grove.

"I stayed at a house that was very poor. I hated to eat their food, that's how poor they were. I went up on the mountain and prayed, asking God to send me a sermon, and didn't come down till I knew what it was. Romans 10:13. 'For whosoever shall call upon the name of the Lord shall be saved.' "

He supported himself and his wife by working as a commercial fisherman. "If I hadn't worked aside from preaching, we couldn't have made it. In the first year and a half, my work for the Lord didn't bring in but ninety-nine dollars. But even during the Depression, I was always able to get a job."

It was a hand-to-mouth existence. He led revivals in small country churches and in tents lit by kerosene lanterns. Outside the crickets whirring, inside the congregation whipping itself into ecstasy:

Happy day, happy day,
When Jesus washed my sins away!

"Twenty years ago, you could start out with just a Bible and a song book, but you can't do that anymore. You've got to have a church."

Reverend Perkins set about building one. Every dime he could scrape together went for lumber and nails. Finally, his wife had all the sacrifice she could stand. "She said *I do* at the wedding, and twenty years later she said, *I don't*."

It was then that he turned to art. His first creative work was the reshaping of his environment, building his replicas of the sites of the Crucifixion and the crypt.

Then he began to paint. The theme that obsessed him from the start and still consumes him is "the only hope of the world today." He sees that hope as Christianity. Again and again he paints variations on the motif of churches set at the four corners of the world and a cross at its heart. He explains that the

151

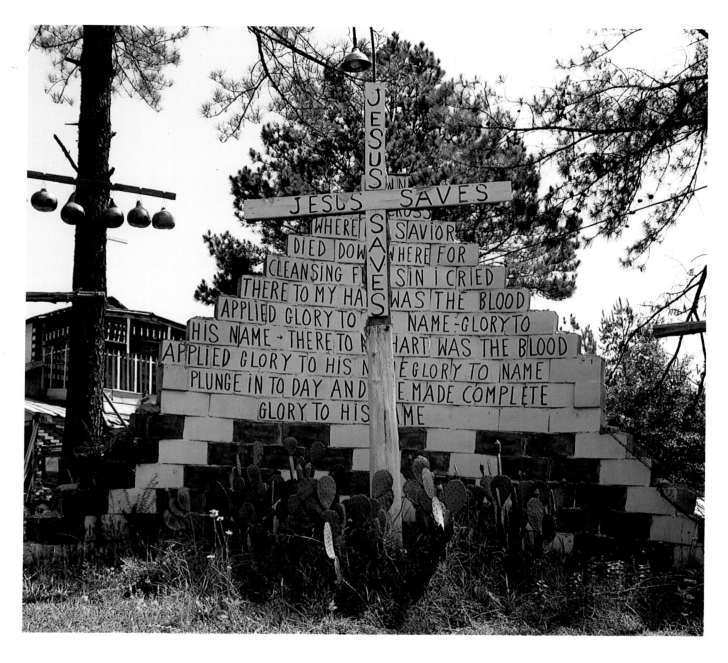

works are inspired by a Bible passage in which Peter says that "one day is with the Lord as a thousand years, and a thousand years as one day."

According to Reverend Perkins, holy prophecy envisions six thousand-year days, at the end of which there will come a thousand years of peace in a world without sin. "We are now eleven years away from the time when the millennial reign will begin."

On a trip to New Orleans Reverend Perkins saw an exhibition of the treasures of King Tut and was struck by a peacock chalice done in eight different shades of gold. Now peacocks cover his kitchen cabinets, giving the small room an exotic air. They flourish their gaudy tails across the walls of his house and on canvas after canvas. The bright birds bring color to his drab, weedy hillside with its spindly trees and fulfill his hunger for gaiety.

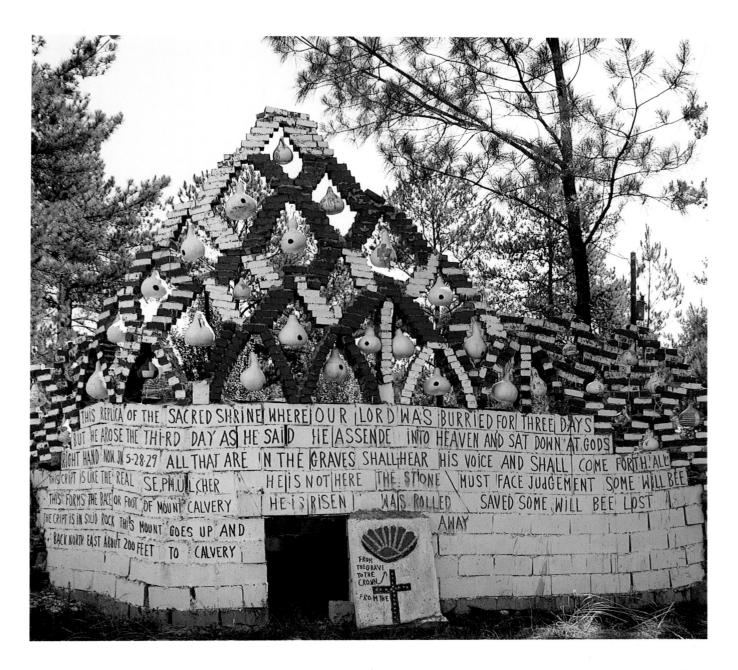

The text on the shrine reads:

THIS REPLICA OF THE SACRED SHRINE WHERE OUR LORD WAS BURRIED FOR THREE DAYS BUT HE AROSE THE THIRD DAY AS HE SAID HE ASSENDE INTO HEAVEN AND SAT DOWN AT GODS RIGHT HAND NOW JN 5-28-29 ALL THAT ARE IN THE GRAVES SHALL HEAR HIS VOICE AND SHALL COME FORTH ALL THIS CRIPT IS LIKE THE REAL SE,PH,U,L,CHER HE IS NOT HERE THE STONE MUST FACE JUDGEMENT SOME WILL BEE THIS FORMS THE BACK OR FOOT OF MOUNT CALVERY HE IS RISEN WAS ROLLED SAVED SOME WILL BEE LOST THE CRIPT IS IN SOLID ROCK THIS MOUNT GOES UP AND AWAY BACK NORTH EAST ABOUT 200 FEET TO CALVERY

FROM THE GRAVE TO THE CROWN FROM THE

Ministering to his tiny congregation doesn't bring in enough to get by. He earns a bit by conducting revivals at other churches, but the invitations grow fewer and fewer as the days go by. He would be happy to preach for nothing, but that doesn't seem to help.

"I'm coming to the place where they don't want me. They want young men, just like the armed forces. They want people to come to preach who have been hooked on drugs and alcohol and have got off of it. A few years ago, they began to drop me, and now I'm down at the bottom. The next place is out."

He has time to paint now, to fulfill the passion that is next to serving the Lord. His paintings have begun to sell. Not many, but with his social security check it is enough to keep him going. His faith burns as brightly as ever. *For whosoever shall call upon the name of the Lord shall be saved.*

Overleaf: left, *The Only Hope of the World Today;* right, *What Next?*

TH
00·YEAR
DAY

400
1000
YEAR
DAY

3
0
1000
YEAR
DAY

2ND
1000
YEAR
DAY

4
00
AR DAY

1ST 1000
YEAR DAY

988 = 12·YEARS·UNTILL SUNDOWN

1ST SUN RISE 4000 B.C

2ND PETER 3-8-9 - 1 DAY WITH THE LORD.IS AS 1000
YEARS - THE WORD SAYS - GOD.CREATED HEAVEN AND EARTH
ND FINISHED ALL HIS WORK IN SIX DAYS AND RESTED
N THE SEVENTH DAY: GOD.HAS BEEN FOR ALMOST
SIX 1000 YEAR DAYS TRYING TO GET PEOPLE TO
LIVE RIGHT AND GO TO HEAVEN = ONLY 12 MORE
YEARS AND THE SUN WILL SET ON THE 6TH 1000
YEAR DAY = THE BIG QUESTION IS WHAT NEXT
WILL IT USHER IN THE 1000 YEAR·MILENIUM
OF PEACE ON EARTH REV. 20 - 1.2.3

RFP

"It never did seem much of a challenge
to do anything I set my mind on.
If I take a notion to move a mountain,
why, I just start movin' it."
CLYDE WHITESIDE

CLYDE WHITESIDE

ow a days you can learn things
from books that you didn't go out
and actually do—
But back then the way you learned
most everythin was by goin out
and doin it. . . .

A COMMENTARY
on mountain life today and mountain life in the old days is the only poem Clyde Whiteside ever wrote. His art isn't stringing together words. It's carving. From gnarled roots and fallen tree limbs he creates fanciful birds and beasts for his own Garden of Eden.

It all began when he was able to buy a little property, a wreck of a house and four overgrown acres of trees, briers, poison ivy, and rotting stumps. The land lay sprawled along Mashburn Creek, in the heart of North Carolina's Blue Ridge Mountains. Clyde Whiteside was twenty-one years old then, four years married to Ellen Pearl Whiteside, and making thirty-five cents an hour driving a truck for the Grovestone Sand Company.

In his mind's eye, he could see his land transformed by a waterfall, a pond, terraced hillsides beautiful with tulip poplars, hemlocks and fruit trees, box-wood and beech. It would be serene, a place where a person would feel at one with nature. He didn't foresee creating the grotesque creatures who live there now. That would come later. He had no idea that he would be working on his Eden for the next fifty years.

In New York and Beverly Hills, Wichita Falls and Chicago, when something needs to be built or fixed, you call in someone to do it. That's life in a city. In the mountains, you build it or fix it yourself, or at most, with the help of a few of your kin. Every mountain man and woman is handy at a hundred skills: laying shingles, repairing a carburetor, sewing a quilt, replacing a well pump, canning tomatoes.

Working alone, Clyde Whiteside renovated his tumbledown house, rewired it, installed new plumbing, rebuilt the chimney, and insulated the roof and walls. When he finished, it was a fine home, warm, dry, and solid. He built an electrical system powered by a six-foot wooden waterwheel and an old Dodge automobile generator. Then he turned to creating his dream landscape.

"I started workin' on it, and just kept workin'." He moved the creek four times before he got it the way he wanted it, flowing along a channel bordered by a stone wall and spilling down a waterfall.

"All the time I was puttin' in eight, ten hours a day in the mill, repairing textile machinery, and later, pouring concrete culverts when they put in the Blue Ridge Parkway, and after that, at a job in a factory makin' furniture. I'd come home and string me up a light outside to where I could see to work on into the night. Lots of people feel it's a burden to work, but I always enjoyed it."

He built windmills, whirligigs, weather vanes, and waterwheels. He shaped terraces, planted juniper hedges and more than a dozen different kinds of trees.

Especially apple trees. After all, this was the Garden of Eden. Just to make sure there would always be a snake around to tempt Eve and Adam, Clyde Whiteside made one. He chose a sapling that had been contorted into a corkscrew shape by the wild grapevine that clung to it.

He built a large pond, and three smaller ones that he filled with water lilies and goldfish. "My neighbors'd see me out there at all hours, haulin' wheelbarrows of dirt, movin' the creek, shovelin' and plantin'. They thought I was wastin' my time, just messin' around. Lollygaggin' is what they called it. To them it seemed like I was touched in the head, which I guess I am. They kept sayin' I'd be a-workin' on it till doomsday, or till I got sick and tired of foolin' with it. Well, I'll tell you one thing: I never started anything I didn't finish."

It was as though his garden made a mockery of his neighbors' patches of dust and trampled grass, and they resented it. Their children yelled insults and threw rocks. Clyde Whiteside just went on working. Slowly, he transformed his four acres into a green, growing, fanciful creation.

Exploring the woods, he began collecting oddly shaped roots and the limbs of fallen trees that leaped alive in his imagination as birds and animals. He'd bring them home, carve them, give them eyes of colored marbles, transform one into a goat's head and another into a wild boar's head. Provided with a long beak, a twisted branch became a comical bird. An S-shaped root became a sea serpent. One by one, he created his Eden's bizarre inhabitants.

Like many a mountaineer, Clyde Whiteside has made his home close to where he was born and raised. His wasn't an easy childhood. Before he was five years old, his millworker father died. His mother went to work as a housekeeper for a wealthy family. "They owned just about everything around our parts but the United States Post Office."

In the Whiteside home, money was hard to come by. If young Clyde wanted a toy, he had to make it. "Nobody showed me how to do it. I just learned on my own. Just kept tryin' till I had it.'

He quit school after the fifth grade and got a job sweeping out the local theater and changing the rolls on the player piano that accompanied the silent movies. He was ten years old.

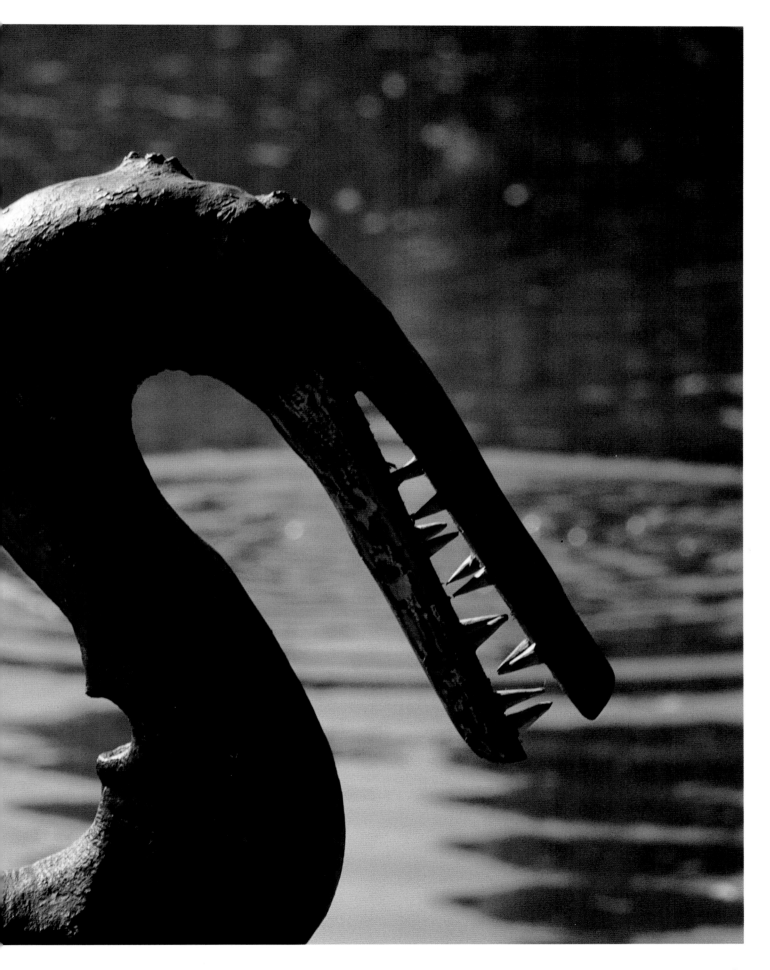

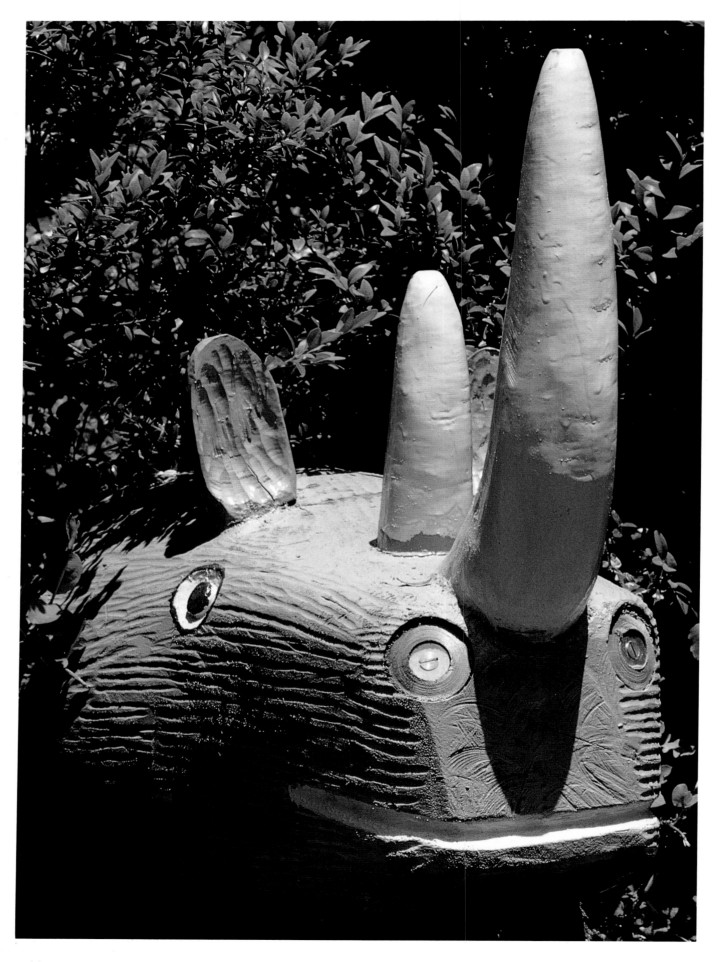

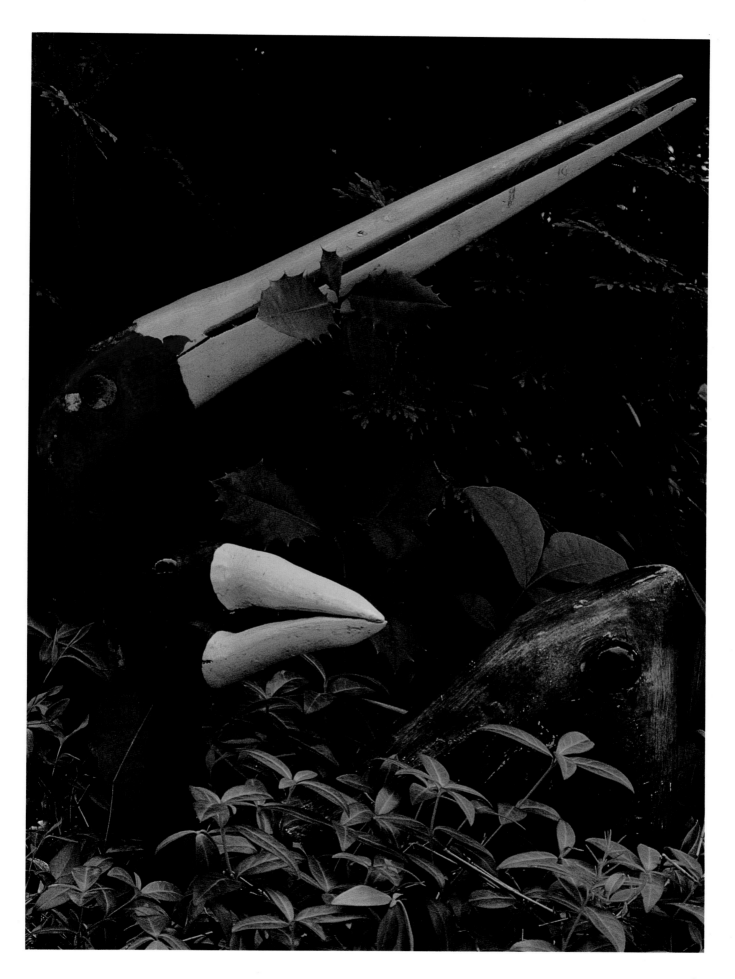

A neighbor, whose daughter he was later to marry, taught Clyde Whiteside how to whittle. Adam Wheelon made wooden buckets, chairs, and anything else he needed. Hanging around him, Clyde Whiteside learned how to farm, and he picked up the fine points of carpentry, blacksmithing, and rock masonry. He married at seventeen and for several years drove a sand and gravel truck and made bricks and stacked them. Then in 1940, when he was twenty-three, he joined the army. He served in the Military Police, escorting prisoners of war around the South and watching over them while they picked cotton. After the war ended, he worked at half a dozen different jobs, twenty years of everything from operating a wood lathe to construction work. Finally, he went to work as a repairman in a local hardware store, fixing broken toasters, stoves, fans, lamps, and electric coffee pots until he retired a few years ago. And all the while, every spare hour was spent creating his garden and fashioning the creatures who live in it.

"I made a snake and set it out there to scare the birds away from my strawberries. The birds just laughed, and sat on it while they picked away at the berries."

Clyde Whiteside finally completed his Garden of Eden. Well, not exactly. There are always little touches to be added, another tree, another whirligig, a tin fish to lurk at the edge of the pond, a wooden bird to peer down from a maple.

"It never did seem much of a challenge to do anything I set my mind on. If I take a notion to move a mountain, why, I just start movin' it."

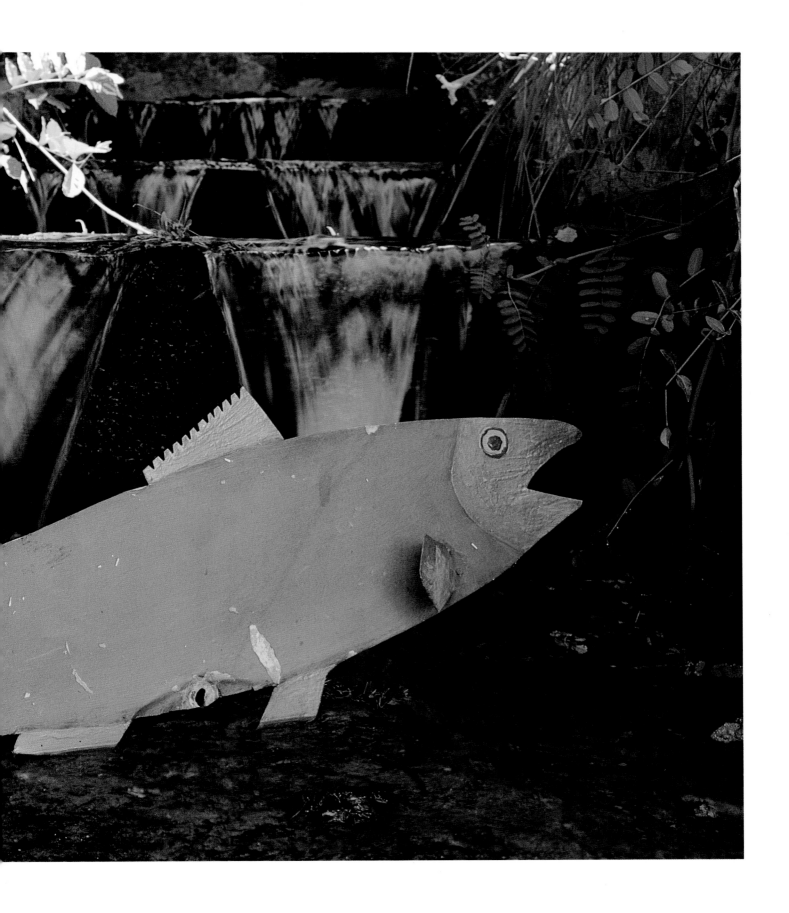

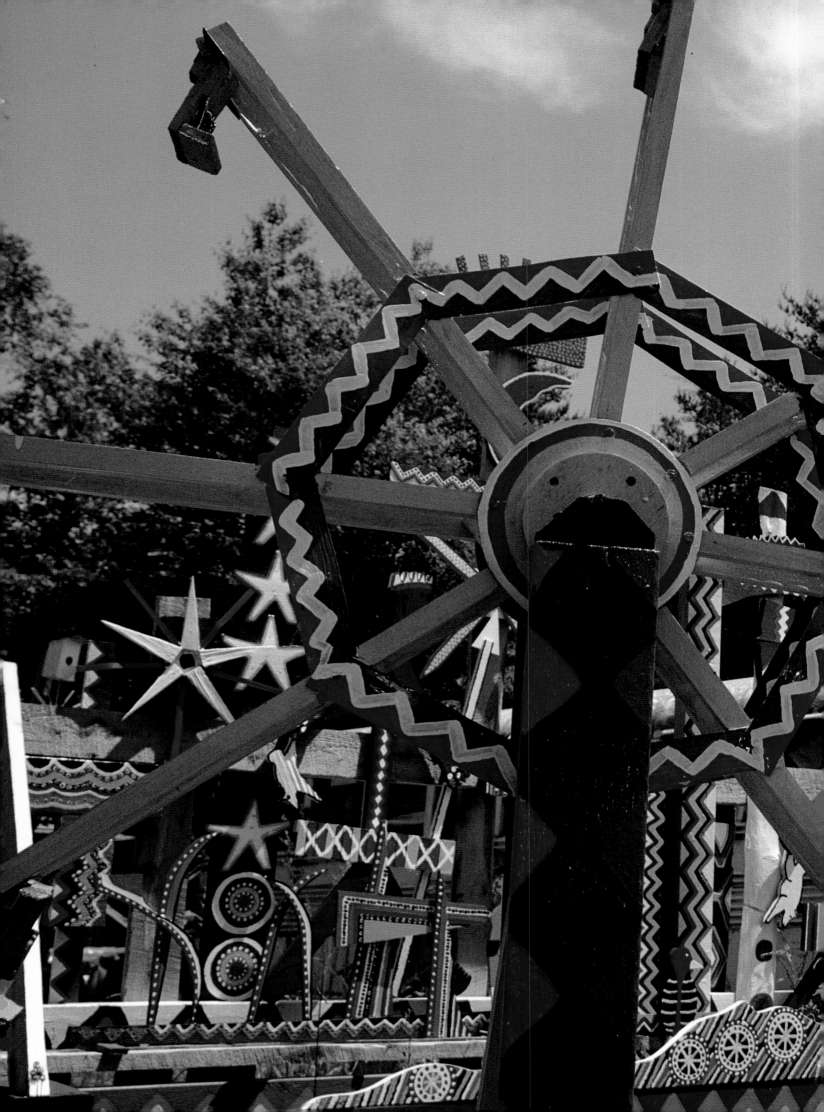

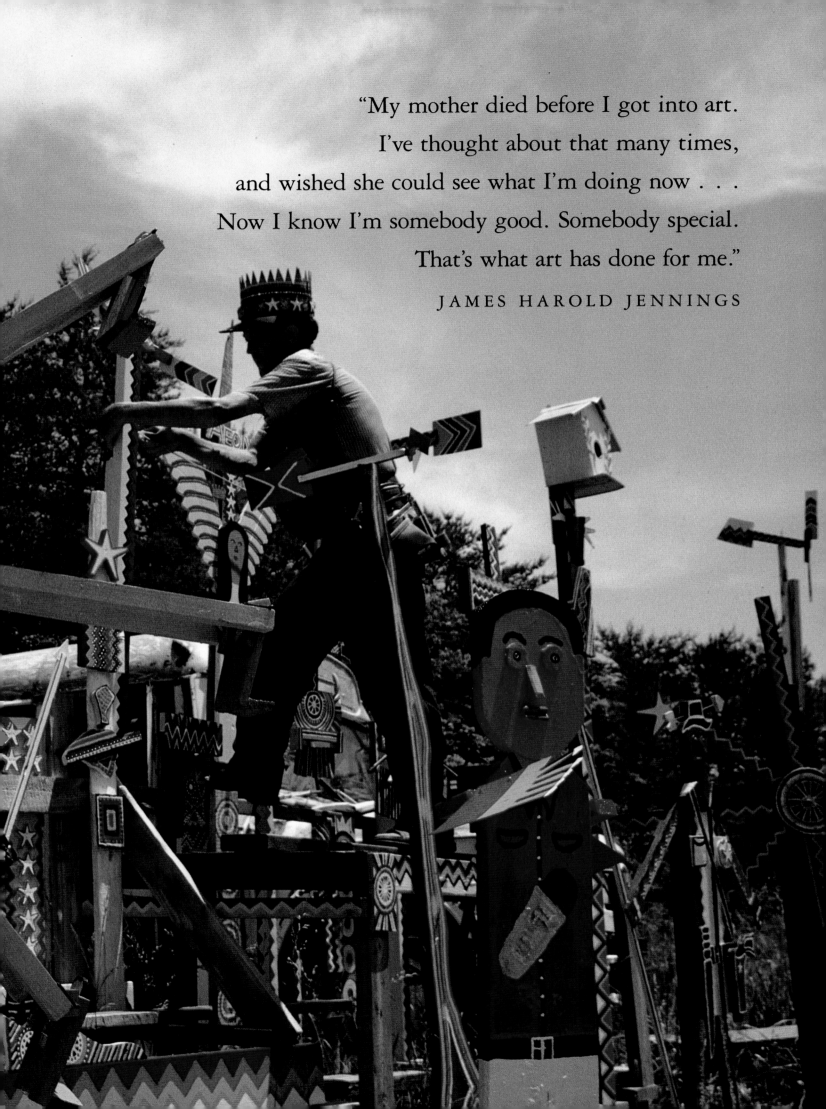

"My mother died before I got into art.
I've thought about that many times,
and wished she could see what I'm doing now . . .
Now I know I'm somebody good. Somebody special.
That's what art has done for me."

JAMES HAROLD JENNINGS

JAMES HAROLD JENNINGS

A FANTASTIC WORLD sprouts from an unkempt patch of land in the mountains of North Carolina. Coming upon it produces the same delight a five-year-old feels coming upon his first circus. The field is a carnival of color. Scraps of wood have been transformed into Ferris wheels, whirligigs, exuberant cowboys, birds and beasts, Amazonian women, Indians whose feathers spin in the wind—transformed through the magic of James Harold Jennings, artist of the sun, moon, and stars.

"People will say, 'Red, what you been up to?' When I tell them I'm an artist, they think I'm crazy. Say to me, 'What the hell do you know about art?' "

James Harold Jennings has soft, hazel eyes and wears his coppery, shoulder-length hair tucked under his cap or a gaudily painted tin crown. Slung from his waist are three leather tool holsters filled with pencils and pens, screwdrivers, pliers, his worn wallet and notebook, his pocketknife.

He manages happily without electricity, running water, a telephone, or a television set. "I just live sort of low, like the Amish in Pennsylvania. They still do like people used to do long ago. I admire that."

At fifty-nine years old, James Harold Jennings is an innocent, but nobody's fool. In an era of Americans playing it safe, striving to be like their neighbors, he is that rarest of human creatures, an original.

"Most of the folks around here, they don't go in for art at all. They don't believe in it. Well, I don't believe in them either. Because art is my life."

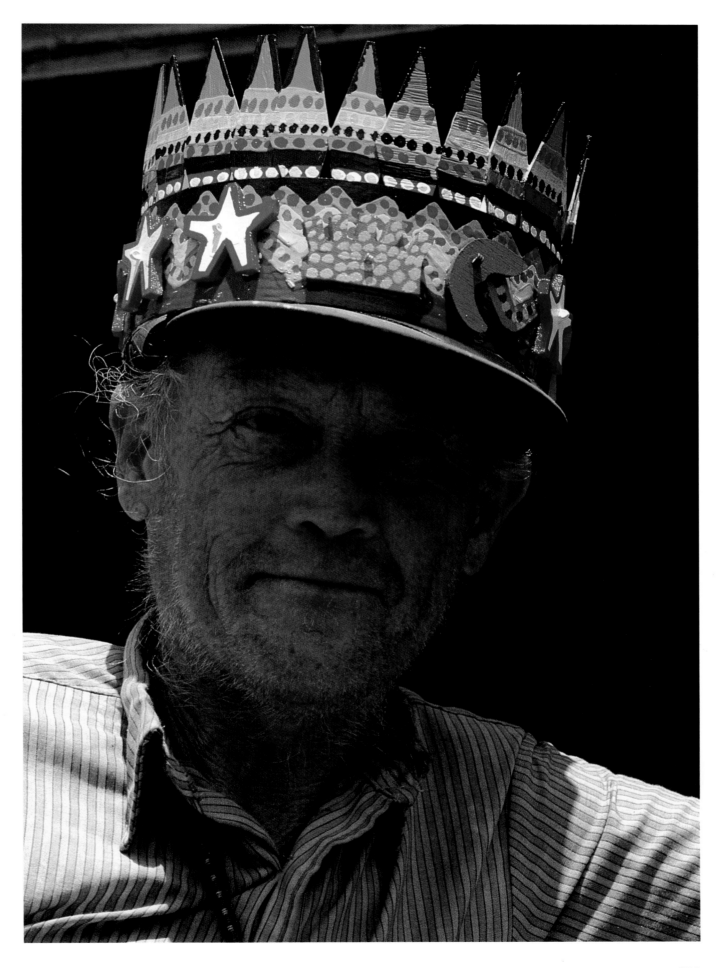

He lives on a bit of family land across the road from the deserted home where he grew up. He has moved into three old buses, one white, one blue, and one yellow school bus with "Woonsocket" printed on its sides. How it got from Rhode Island or South Dakota to North Carolina is anybody's guess.

The white bus is a storehouse for pieces of art he has finished. The blue bus, rigged with a tin can burglar alarm, is where he keeps his sleeping bag and clothes. It's filled with cans of paint, rolls of tape, bottles of glue, extra hack saw blades, and a clutter of hardware odds and ends. Also inside are stacks of *National Geographic* magazines and a shelf of books, among them his mother's dictionary and a slim volume called *The Magic of White Witchcraft*.

"I feel like the ghost of the spirits is with me all the time. Sun, moon, and stars are the powers I believe in. Sun, moon, and stars live on and on. There's death for everything, but I don't think there is death for them."

The yellow bus is where he cooks his meals in a skillet on a kerosene heater, and where he works when bad weather drives him inside. Surrounded by the graffiti of vanished children—"Lisa Loves Sonny," "Bubba's A Jerk"—are James Harold Jennings's bike and spare tires, an air pump, six-packs of beer, food supplies, and several works in progress, including a life-size Elvis with guitar.

James Harold Jennings's father died when he was three. School was difficult for a boy whose head was filled with dreams, who was trusting and open, who was more interested in the planets than in spelling and arithmetic. His mother, a grammar school teacher, educated him at home from the fifth grade on.

"Mama was a redhead like me. She taught me everything she thought I might need to get along in the world; how to write, how to figure, how to read and spell."

At the age of eleven, he went to work in the tobacco fields. "Those days, weren't nothing else to do but work in tobacco. That's all there was." He was paid fifty cents an hour, and he felt the world was telling him that's all he was worth. "I had no faith in myself. I felt cheap."

When she died, his mother left him a small inheritance. He added to it by selling bottles and cans that he picked up along the highway. Finally, he got a job as a projectionist at a drive-in theater. He stuck it out until they began to show X-rated movies and things got rough.

"Fights, whiskey, and drugs, that's what caused me to quit. I won't have nothing to do with those things."

At loose ends, he was consumed by the need to express the joy he felt in being alive. He started to build windmills and whirligigs, paint them in the brightest colors he could find, and put them up.

"In a while I had this whole little village. A kind of circus is what it was. Windmills squeaking, birds hollering and singing, Ferris wheels running, all sorts of things spinning and flapping. I had it looking beautiful out there. Kids loved to come."

Passing cars began to stop. People admired his works and asked if they could buy them. He sold off his circus piece by piece.

"It was sad, seeing it all took away. I didn't feel happy till I had it built back up again."

Outside the yellow school bus he hunkers in the sun, starting to create a piece inspired by an article he's read about a tribe of warrior Amazons. On plywood

he sketches a muscular, scantily clad woman astride a defeated man. Above them he prints what he's planning to call it: *Cindy Tames a Bully*. It will be a companion piece to another of his Amazon series: *The Devil Gits Helt Down and Sat Upon*.

James Harold Jennings is an elusive mixture of gaiety, iron discipline, and serious dreams. He has designed his life to eliminate most of the stresses that plague his neighbors.

"I don't drive a car. Riding my bicycle keeps me fit. I don't have rheumatism, arthritis, aches, or pains. I wake up with the sun, take a ride on my bike, come home and work right through till it's too dark to see. I eat my supper of pinto beans, maybe a couple of cans of Sweet Sue's chicken and dumplings, a couple of beers, and I go to sleep. Wake up, I can't wait to get going."

With a coping saw, he deftly cuts the figures of Cindy and the bully out of plywood and nails them to a pine base. Staring at the piece, he debates which colors to use. Closing his eyes, he presses them hard with his fingertips, seeking ideas from the whorls and speckles that vibrate in front of him. He decides on a brilliant blue, a daffodil yellow, a vivid green. He likes primary colors. He believes they radiate joy.

Gazing up from the figure he is painting, he nods his head toward an angel he's made. Above it, in wooden letters, is *Metempsychosis*.

"That's a dictionary word. It's connected with reincarnation. You don't just die, you know. People call you dead, but your spirit isn't dead. You come back as some other kind of living thing. Metempsychosis is what controls the destiny of the soul beyond death."

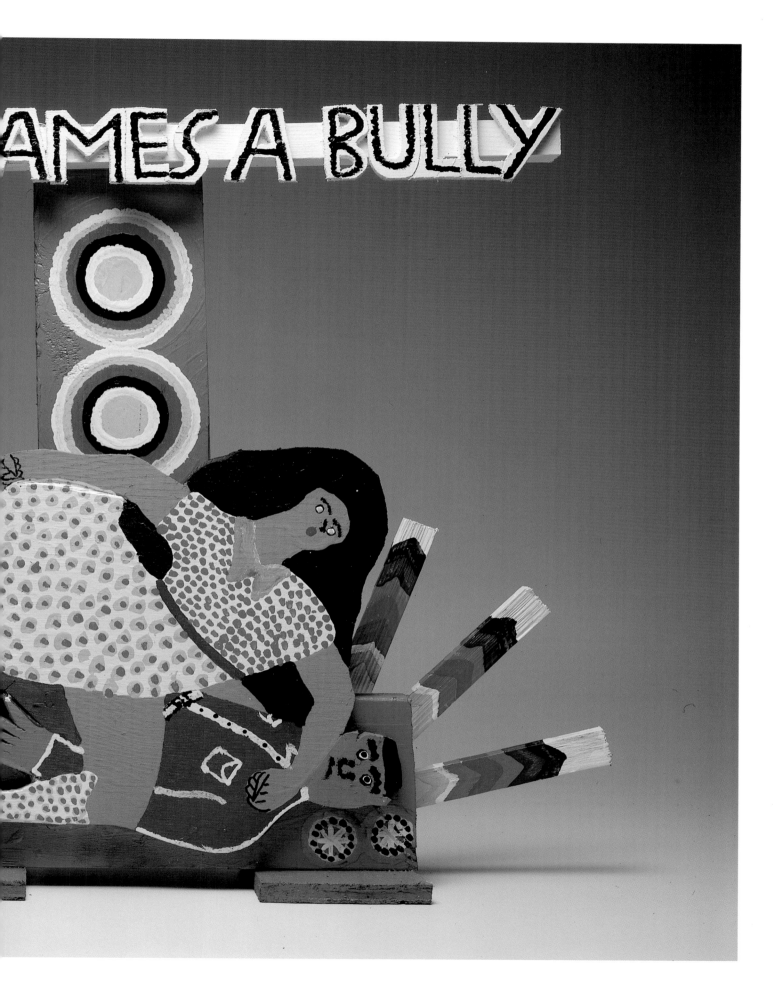

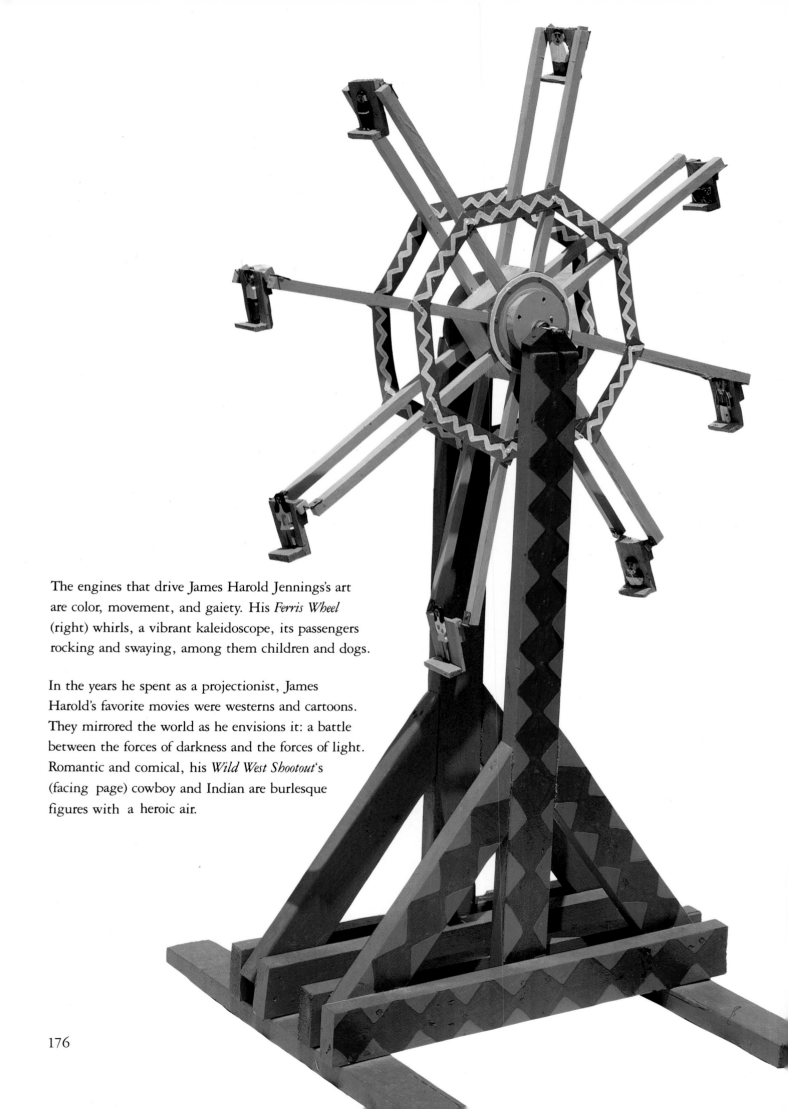

The engines that drive James Harold Jennings's art are color, movement, and gaiety. His *Ferris Wheel* (right) whirls, a vibrant kaleidoscope, its passengers rocking and swaying, among them children and dogs.

In the years he spent as a projectionist, James Harold's favorite movies were westerns and cartoons. They mirrored the world as he envisions it: a battle between the forces of darkness and the forces of light. Romantic and comical, his *Wild West Shootout*'s (facing page) cowboy and Indian are burlesque figures with a heroic air.

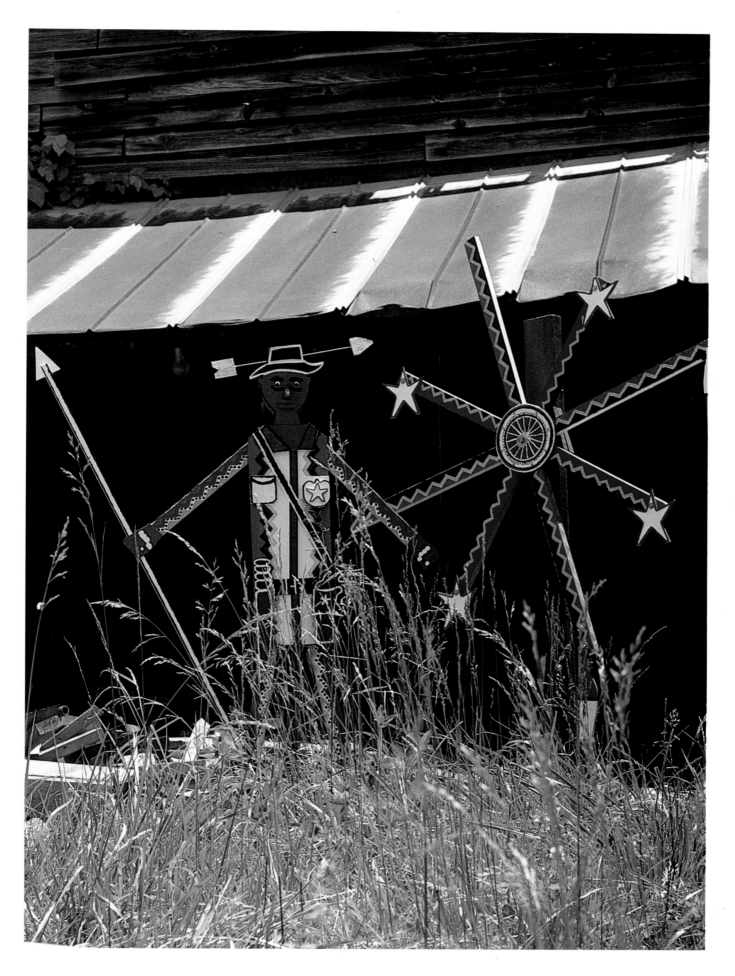

James Harold Jennings hasn't gone to church to hear a preacher rant about eternal torment and damnation since he was a boy. "It scared my nerves. Those preachers, they can hypnotize you. They can make you believe you are lost and going to burn forever in hell. It's not right for them to do that. That's not really what's going to happen."

His jaw hardens, his lips press thin. "In the old days, preachers preached against the evils of money. Now it seems to be all they're interested in." He says doggedly, "You can be a spiritual person without going to church."

Setting the painted piece aside to dry, he crosses to the poles, crossbars, and scaffolds that support his works. Climbing up, he adjusts the position of a

pistol-packing bandito. He likes to move his figures around, give them a change of scene.

"My mother died before I got into art. I've thought about that many times and wished she could see what I'm doing now."

By transforming his world, James Harold Jennings has transformed himself. He has at last learned his own value.

"Now I know I'm somebody good. Somebody special. That's what art has done for me."

A rare smile lights his face. Nobody can ever again make him feel he's nothing but a fifty-cent man.

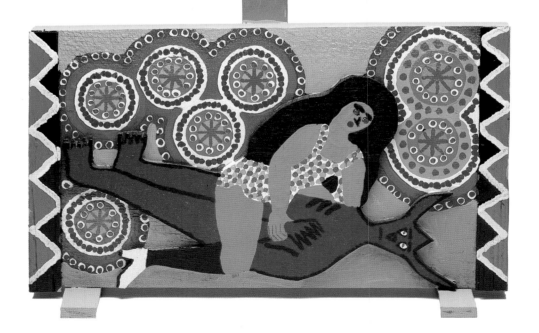

178

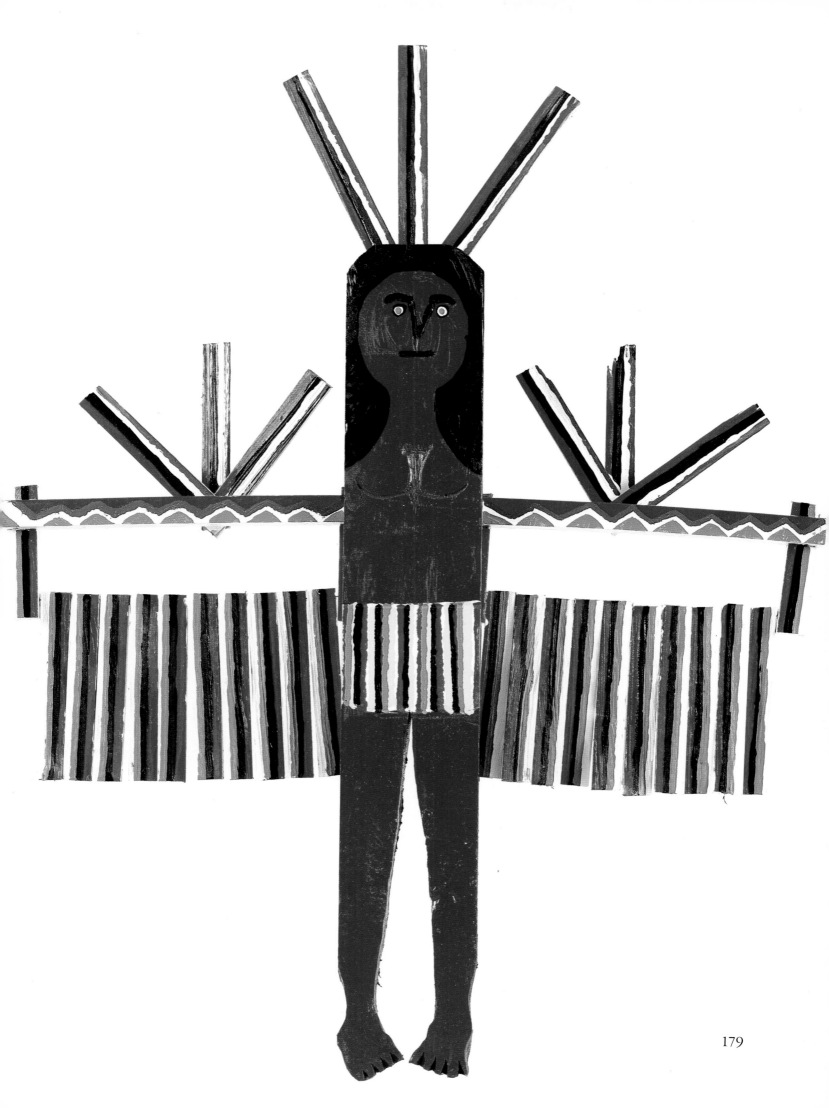

"I wouldn't want to live anywhere but the mountains. But it does me good to know that people out there somewhere are enjoying my work."

MINNIE ADKINS

MINNIE ADKINS

Aieouuuu! Aieouuuu! **T**HE BAYING of fox hounds, a kind of Kentucky country music, echoes across Newcombe Creek and up the slope of Turkey Knob mountain. The high-strung hounds dance back and forth along the wire fence of their pen, outside the small home in Peaceful Valley where Minnie Adkins was born and still lives.

In the shed that serves as her workshop, she adds the finishing touches to the fox she has carved, smoothing on the bright paint. Off a ways, her burly husband, Garland Adkins, hauls a log off of his pickup truck and heaves it on the pile of linn wood from which she creates her striking creatures: a savage-toothed bear, an elegant horse, a mother opossum and her cubs.

Setting down her brush, Minnie Adkins stands up and fishes her favorite knife out of the pocket of her jeans. She snaps it open and regards the sliver of steel. "I've wore out more knives than there's acorns on an oak tree." She shakes her head sadly. "A good knife is getting hard to find. Eyeballs are the best ones you can get hold of." She grins. "That don't mean they're for cutting out eyeballs. That's the name of the company makes them. Here, see, it says Eyeball on the blade."

Foxes play a big part in Minnie Adkins's life. She says that the times when she's most at peace are when she's whittling, studying her Bible, or fox hunting.

Fox hunting. It conjures up an image of scarlet-coated gentry out for blood, galloping across fields, vaulting hedges, racketing after a pack of hounds.

That's not how it's done in eastern Kentucky. To Minnie Adkins, fox hunting means spending a starry night on top of a mountain with her husband. Her face softens as she says, "We never killed a fox, never killed a one in our lives." Fox hunting means lying on a mossy ridge in the dark, gazing up at the Big Dipper, smelling the damp, green scent of the woods, listening to the song of the hounds as they chase across the hills.

"You can turn loose twenty dogs, and there's only three or four of them'll run all night. The rest will quit and come back to eat and lay down. After a while, the fox will circle around and bring the dogs back. If they get sidetracked and go after a deer, we might not see them for two, three days. Then they'll come back, the most of them. But we lose a young one now and then."

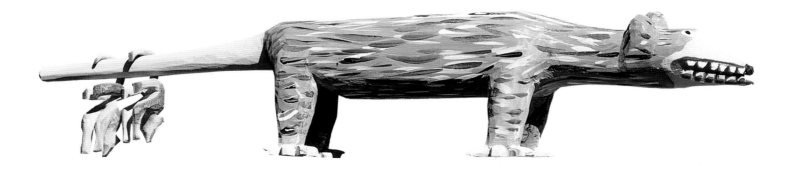

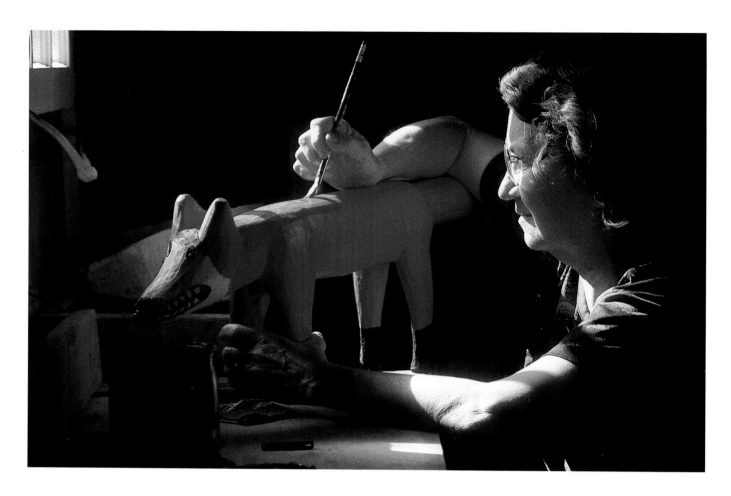

She clamps a rough-hewn log in her vise and sets to work shaping it with a drawknife, the pale shavings curling away. "Always seemed to me that at night the woods are most near to the way God made them. Nothing around but the owls and the insects, the animals and the wind."

Minnie Adkins has an infectious laugh. Warm and outgoing, she says whatever pops into her head. But behind the exuberance is another Minnie Adkins, the plain, tomboyish girl who never knew what it was like to be praised. "All my life I prayed that someone would appreciate what, you know, what I could do."

She is modest about her talent. "I just whittle, slop, and gaum. Most of my neighbors, even the most of my own family, don't think much of my work. Garland says it's because they're jealous, but I believe it's because they don't think it's a woman's place to be doing what I'm a'doing. Way they see it, the woman's supposed to obey the man, and not be

doing something to bring attention on herself."

It goes deeper than gossip and jealousy. Mountain women like Minnie Adkins have to contend with preachers who thunder that female subservience is the will of God.

The chunk of wood in the vise is taking on the shape of a sow. Exchanging her drawknife for a chisel, she begins to round off a haunch. "Early on, when I was just getting going good, I took my pieces to the county Tobacco Festival. They were giving prizes. I'd knowed the judge and his wife all my life, and they never even come over to see what I was making. One highfaluting lady looked down her nose at me and says, 'I think you need some art lessons.' "

Minnie Adkins takes up her knife, her strong hand guiding it as she carefully etches a detail. "Now that people are beginning to look at my work, and even

buy it, some of my friends act so peculiar. I've got one, if we're talking on the telephone, all I have to do is mention something good that's happening, and she's ready to hang up. She don't want to hear. She just resents it completely. That hurts me so bad when that happens."

She can't remember when she started carving. It seems to her she's been doing it since she was born. Too young to be trusted with a knife of her own, she wheedled her favorite uncle into lending her his, and she began to whittle little horses, roosters, and pawpaw whistles.

The daughter of a tobacco farmer and part-time preacher, she did the same chores as boys. "My father was a man it didn't do to fool with. When he said something, I knowed to do it. He'd tell me to pack in the stove wood or gather eggs, and I'd jump to it. What I loved was riding the drag behind the horses, with a big old rock to weight it down to where it would scrape the field level, bust up the clods before my daddy plowed. We never heard of a tractor. We did everything with horses and mules."

Growing up was sweaty work. Laundry was done with a washboard and a kettle of boiling water. When the well got low, Minnie Adkins would carry the washtub to the creek. When her father hauled logs for the sawmill, it was her job to yoke the oxen, Mollie and Buck. By the time she was nine, she was handling a mattock and an axe.

By the age of eleven, Minnie Adkins was pretty good with a shotgun, though its kick sometimes knocked her tail over teakettle. She was a real hand at making a slingshot from a Y-shaped branch, a strip of inner tube, and a scrap of leather. "It would tickle me so good for a pair of shoes to get wore out to where I could get the tongue to use for the part where you set the stone."

She didn't much care for the company of girls. She wanted to play football and go hunting with the boys. It hurt when they snubbed her. But all that changed when she was sixteen, and Garland Adkins's truck got stuck in a mud hole. He came to her house to borrow a shovel.

She'd been stuck on him for years, but he didn't know she even existed. She was skinny, and she'd heard he liked them curvaceous. She still isn't sure why he started courting her.

Garland Adkins drove trucks, worked on a bridge-building crew, driving pilings and pouring concrete, and jockeyed a giant loader at a strip mine. Minnie Adkins worked in a factory that made trailer parts. She spent eight hours a day glazing windows and putting rubber seals on them. For a time, she ran a drill press. "Every machine they put me on, I was a demon. Wasn't nothing could beat me."

Garland Adkins was back running a loader when the coal company he worked for shut down. "We were hurting for money. Garland don't like for me to say that. He don't see no need for people to be knowing our personal business. Anyhow, this time I'm telling about, things were real bad. I sold my Avon bottle collection, and I was doing everything I could think of to bring in money. I whittled some little roosters out of basswood and took them down to the flea market. I was selling them for fifty cents apiece, but what I was making didn't add up to much."

Minnie Adkins accompanied her husband when he went to sign up for unemployment benefits. In town, she stopped to stare in the window of a small arts and crafts gallery. There were some carvings on display. Inspired, she headed home and took out her whittling knife.

"The spirit got in me. Or maybe it was in me all the time."

Above: Appalachian mountain black bear

186

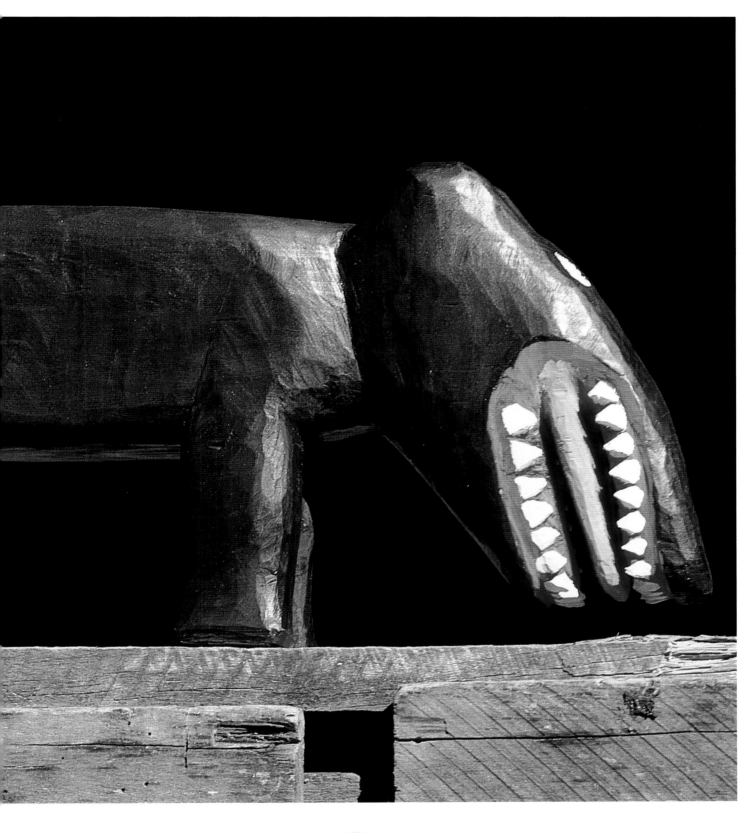

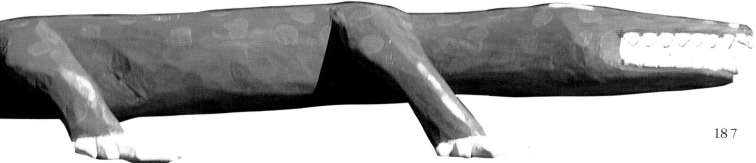

"I loved anything that pertained to a knife. I could beat all the boys at playing mumbletypeg. Oh, I was wild, skinning up trees, riding bareback on my pony. I loved horses better'n anything on four legs. Better'n anything on two legs, far as that goes. I could put on a set of harness good as anybody. I still love to ride bareback. I can't ride in a saddle to save my life."

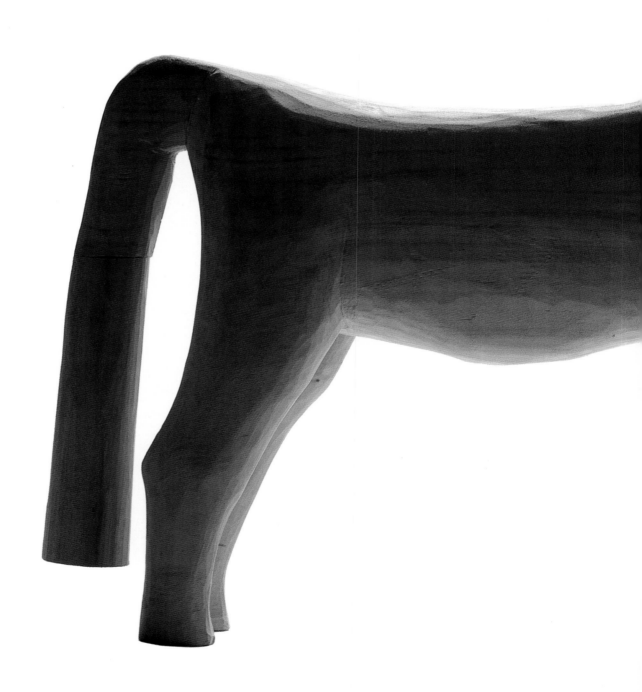

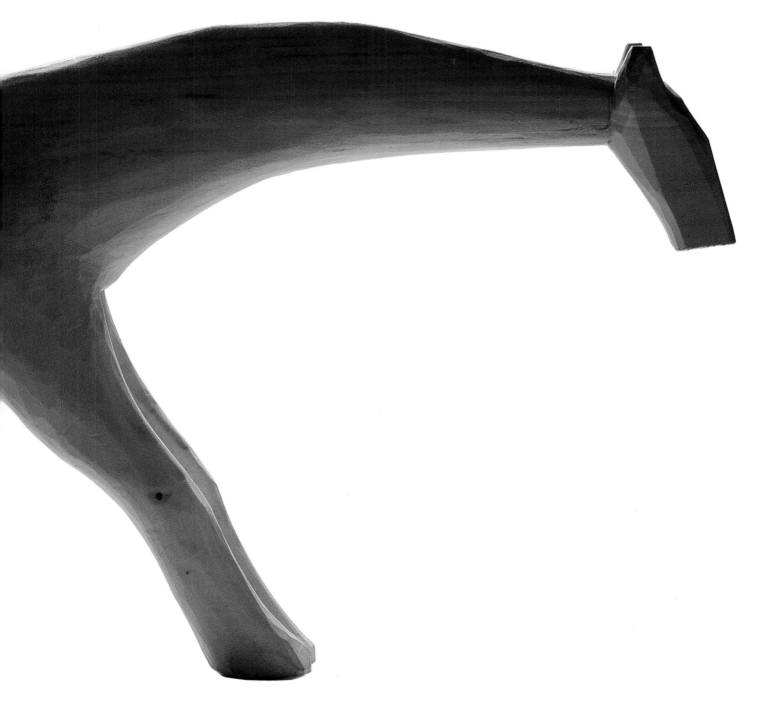

She carved small figures at first. She couldn't afford to buy paint, so she carved a larger figure of an old lady and traded it for some. From then on, she never stopped carving.

Minnie Adkins was saved at the age of fourteen, baptized in the creek by a hellfire preacher. Until a few years ago, she belonged to the Rocky Branch Enterprise Baptist Church. She doesn't belong to any church now. "I don't believe in denomination. My religion is private between me and the Master."

Minnie Adkins's *Garden of Eden* swarms with birds and beasts, delicately carved trees and flowers. "I wanted to do the Garden as it looked before Adam and Eve knew sin. It's so beautiful where the Bible says, 'And out of the ground, the Lord made to grow every tree that is pleasant to look upon.' And I wanted to show there was trouble a'coming. See, there's the snake, and there's the apple."

The animals in her *Garden of Eden* are miniatures of the larger ones she carves. By putting foxes, pigs, and roosters in Eden, she transforms the Old Testament world into a familiar scene. She makes herself at home with the Bible story and shapes it to her feeling that her relationship with God is deeply personal.

Her favorite Bible passages have led her to carve two other intricate pieces: *Noah's Ark* and *Daniel in the Lions' Den.*

"Daniel was the king's favorite, but he was an outsider, a child of Judah, an Israelite in captivity. All the big shots in the kingdom were jealous of him. There was this law that anyone caught praying would be thrown to the lions. But Daniel, he went ahead and prayed anyhow. The king wanted to save him, but the princes and judges insisted that the law was the law. So Daniel got thrown into the lions' den to be eaten. In the morning, when the king came, there was Daniel, not a tooth nor a claw mark on him. He said, 'The Lord worketh signs and wonders in heaven and earth. My God hath sent his angel to shut the lions' mouths.' He had faith, Daniel did. He had faith in the Lord."

The light is fading. Minnie Adkins closes her knife and slips it back in her pocket. Stepping out of the shed, she gazes up at Turkey Knob.

"I wouldn't want to live anywhere but these mountains. But it does me good to know that people out there somewhere are enjoying my work. When I'm a'makin' it, I think about all the different places it might end up. I'd just love to meet everybody that has a piece I've carved."

Below: *Garden of Eden;* facing page: *Daniel in the Lion's Den*

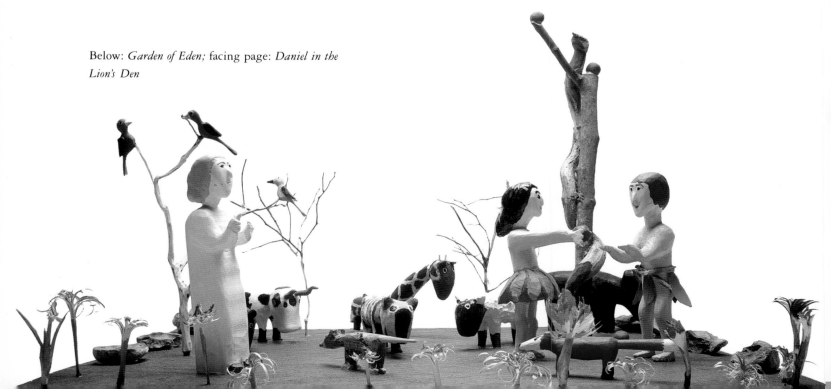

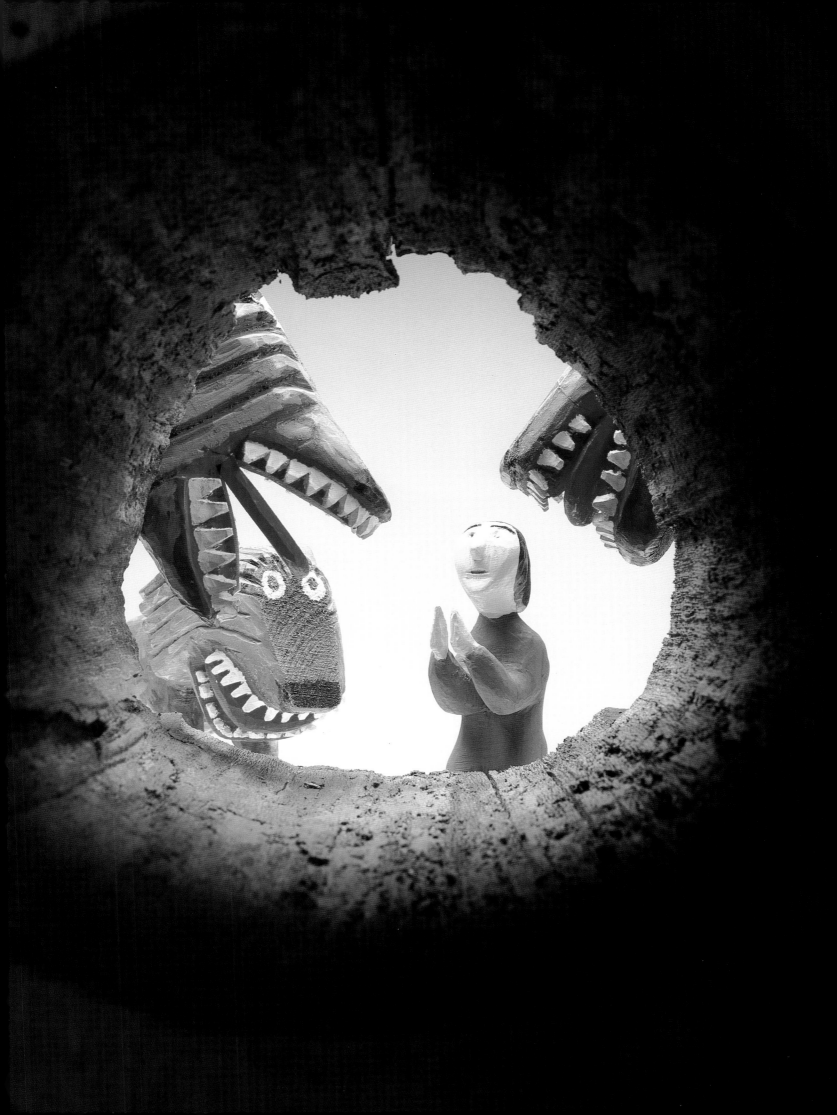

"You pound on cold iron, and your hammer bounces,
it fights you every inch of the way.
When it's red hot, it responds to each blow.
It's as though you and the iron can speak to each other.
You can do very delicate things."

VERNON RAAEN

HELEN RAAEN AND VERNON RAAEN

ATENNESSEE MOUNTAIN morning, the sky cornflower blue. Helen Raaen stands on a high ridge. Her fragile look is deceptive. Straight-backed, slim, every inch a gentlewoman, she raises her shotgun to her shoulder, resting her cheek against its checkered walnut stock. A bird arcs across the sky. Then another. Sighting along the blue steel barrel, Helen tracks them. *Crack! Crack!* The clay discs disintegrate, fragments spraying through the air.

Skeet shooting is the way Helen Raaen and her tall, scholarly husband, Vernon Raaen, relax from their art of creating original edged tools. Guns have always been prized by Vernon Raaen. He deeply admires the artistry of carved wood and chased metal that decorates the best of them.

"I started hunting at age seven or eight, with some watchful care from my father. I had a single shot .22, and inlaid its stock with an eagle, using bits of wire, the way the Indians used to do. My Uncle Aaron said I was ruining a perfectly good gun, but my father approved. He loved to tinker, twist metal into all sorts of strange and useful things."

Vernon and Helen Raaen used to hunt quail. They scared up a covey one day when it had been arranged that Helen would shoot first. "We didn't have a dog, we just kicked them up out of the tall grass. Helen didn't shoot, and she didn't shoot, she didn't shoot. I asked her why. She said, 'Oh, weren't they beautiful! They were too beautiful to kill.'"

The daughter of a salesman, Helen Raaen spent most of her childhood between Terrapin and Nobusiness mountains in Virginia, on her grandparents' dairy farm. She helped her grandmother make butter in a wooden churn and gathered chestnuts with her grandfather. She'd sit on his lap at dusk, listening to the call of a whippoorwill. She remembers walking barefoot, remembers the slippery-smooth feel of the soft Virginia clay after a rain.

"My favorite uncle was a bachelor, a Fancy Dan who drove a racy, two-seater Studebaker with celluloid windows. He'd get all spiffed up on a Saturday evening, and when I asked where he was taking off to, he'd tell me he was going to ride the billy goat backwards and climb the greasy pole. It was years before it dawned on me that he was off to see a ladyfriend."

Preceding pages: kitchen tools. *Page 192:* chopper with spalted black birch handle; below, chopper with teak handle, cheese fork and knife. *Page 193:* free form chopper with apple wood handle.

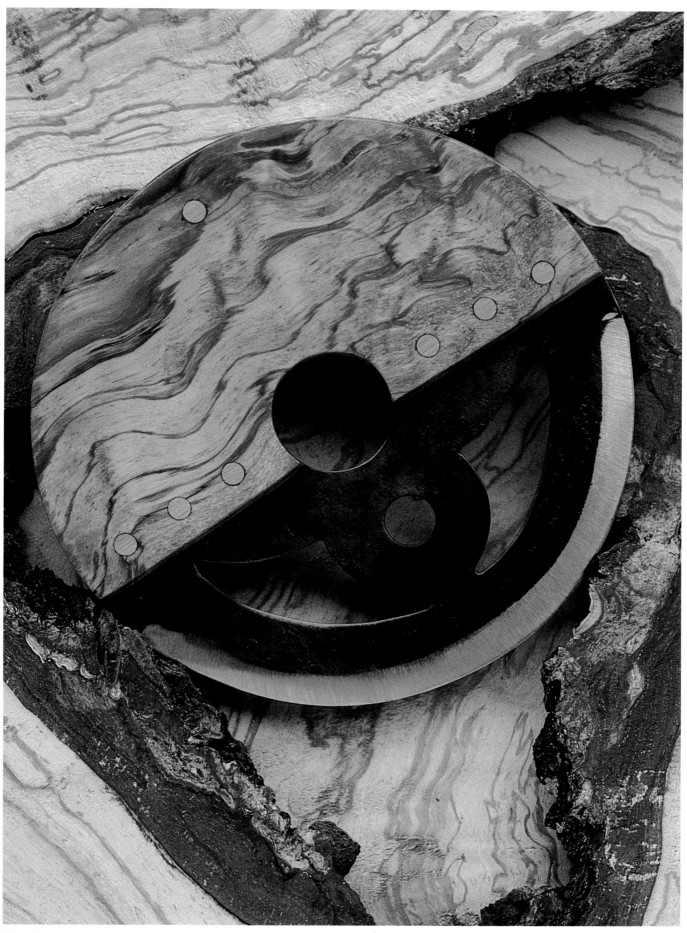

Mezzaluna chopper

Time arcs back in a trapeze swing, and memories of
Helen Raaen's country childhood come flooding in.
She remembers riding on her grandfather's horse-
drawn mower, the afternoon heady with the smell of
new-cut hay. She remembers the scary shiver that
went through her as, arms outstretched for balance,
she made her careful way across the single-log bridge
over the creek. She tells about catching her first fish,
a six-inch hornyhead, the kind that were supposed to
be able to sting, how she felt terrified trying to get
the hook out as it flopped on the grass. She recalls
climbing the huge steam engine that was used for
threshing grain. And the bloody hog butcherings,
and the scent of mimosa, and her grandfather's
blacksmith shop where he let her pump the bellows
and watch him shoe a mare. How she stood there,
wincing as he drove in the nails and baffled that the
horse seemed to feel no pain. She sees again the
Christmas tree lit with real candles, turning the
parlor into a magical dream.

Helen Raaen waited tables to help put herself
through college, concentrating on chemistry, her
second choice. Her first choice was medicine, but in
those days nice, southern young ladies studying to be
doctors were about as common as unicorns. It was
during the Depression, and there were no research
jobs for a woman with a masters degree in chemistry
and a passion for laboratory work. The best she could
find was a teaching post at a small Alabama college
for women. Then came the war. Corporations were
desperate to fill the places of men who'd been called
to arms. She got her big break, a chance to work as a
chemist for Dupont.

When the war ended and the men came home, Helen
Raaen found herself out of a job. It took dogged
searching to find a place as graduate assistant in the
chemistry department at the University of Min-
nesota. That's where her path crossed Vernon Raaen's.
He was fresh out of the army when they fell in love.

Quatraluna chopper with dogwood handle.
Its twisted shape came from the tree being choked by
honeysuckle vine. Overleaf: draw knife

196

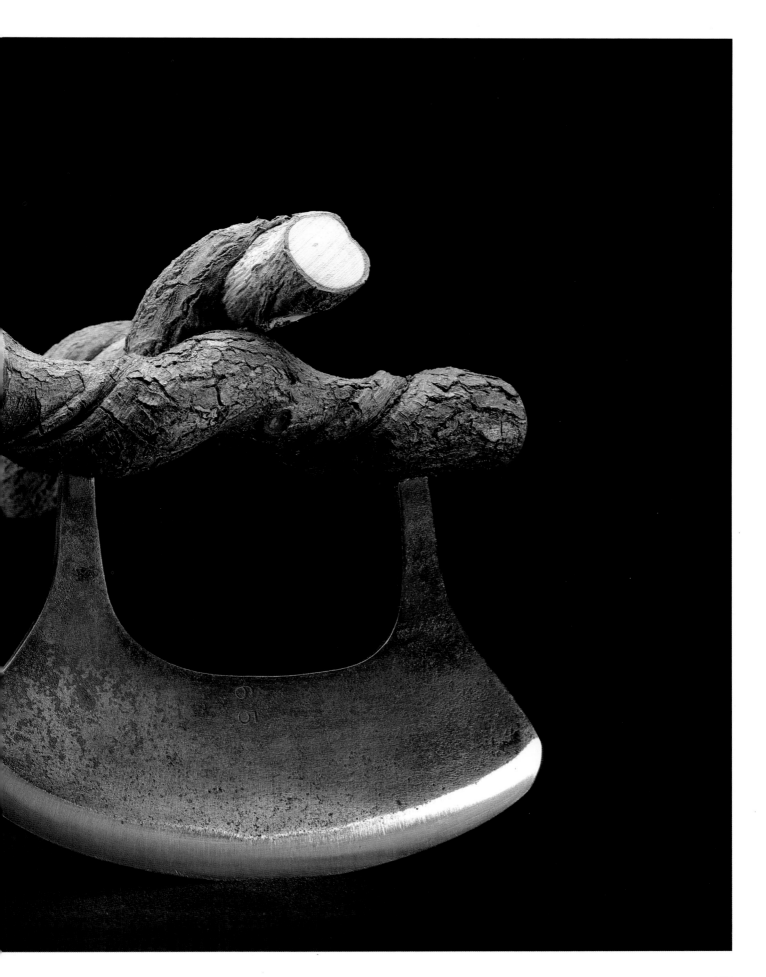

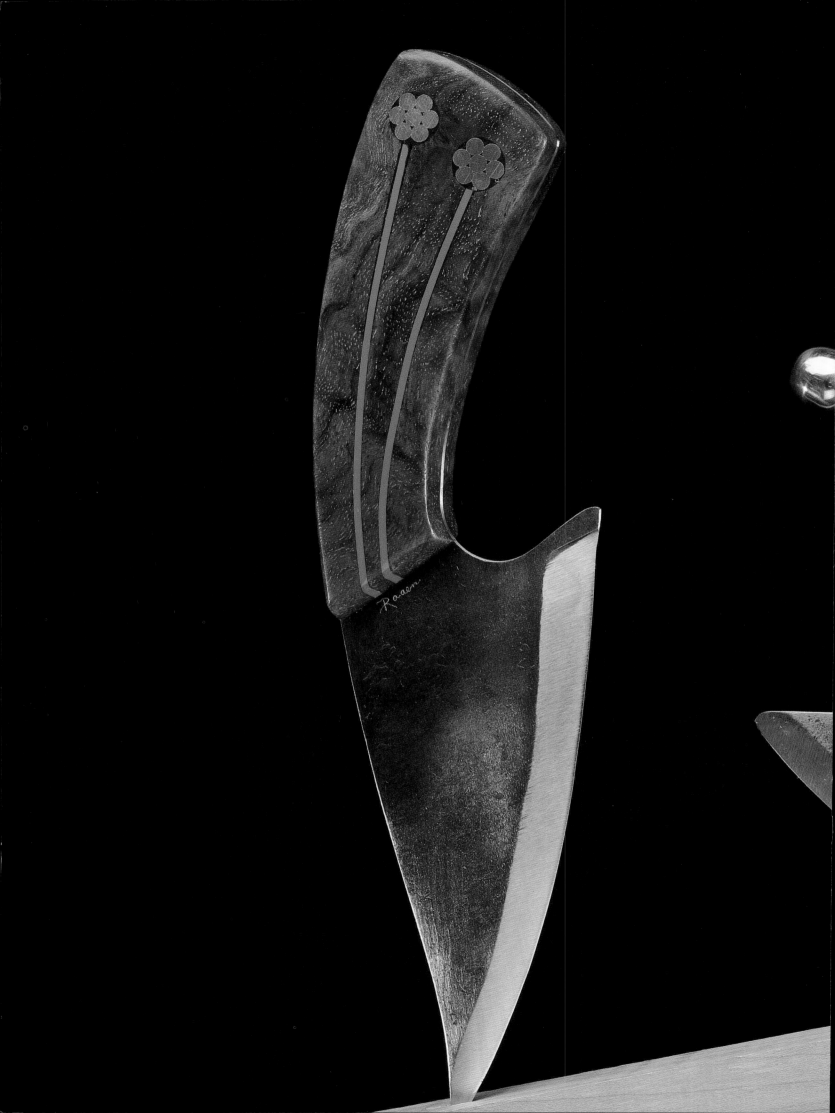

Vernon Raaen was a farmer's son. One of his grandfathers had a blacksmith shop on his farm, and the other was skilled at carving and making furniture. Handling tools, learning to care for them and respect them, and learning to shape wood and metal entered early into his life.

"My father would have been able to survive quite well in the wilderness with nothing more than an axe. He built all our outbuildings. There was no blacksmith shop at home. His metal work was done in the kitchen wood stove. When the iron got red hot, he'd rush it outside to a section of railroad track rail that served as his anvil, flattening, bending, and turning some piece he needed to repair one of the farm machines."

Research jobs in chemistry brought the Raaens to Tennessee, where they began working at the art that absorbs them now, making edged tools. When they retired, they began to work at it full time. They advanced from making to creating when they began to envision pieces different from any ever made before.

At home, Vernon fires up the outdoor forge. Helen has created the design for a bird knife and traced it on cardboard. Now a painstaking process begins. A pattern of blade blanks is scribed on a large, masonry saw blade. Masonry saw blades, sawmill blades, and the knives used for slitting thick piles of textiles are sources of fine, high-carbon steel.

Cut out with a torch, the blade blanks are ground smooth, heated in the forge, and flattened on the Raaens' treasure, a small, seventeenth-century anvil called a bickern. They traded knives for it with a traveling blacksmith.

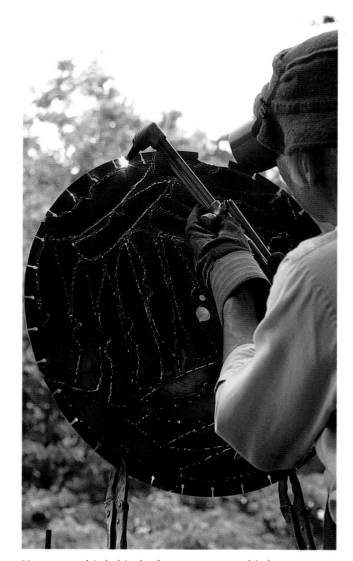

Vernon cuts blade blanks from masonry sawblade.

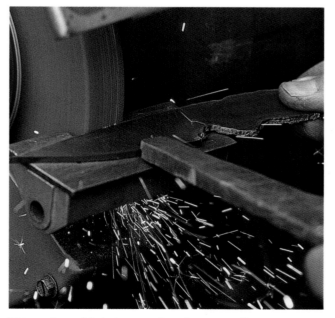

The torch-cut blade is ground to the pattern line.

Facing page: chef's knife

Vernon Raaen speaks of metal as though it were alive and an old friend. "You pound on cold iron, and your hammer bounces. It fights you every inch of the way. When it's red hot, it responds to each blow. It's as though you and the iron can speak to each other. You can do very delicate things."

The blades are heated again and then cooled slowly in ashes, a process that makes them less brittle. Holes are drilled for the pins that will hold the handles. Then the blade blanks go back to the forge to be heated cherry red before they are plunged into a bath of motor oil and kerosene. Vernon Raaen thrusts the blades deep below the surface to avoid the flash that sets the oily mixture ablaze.

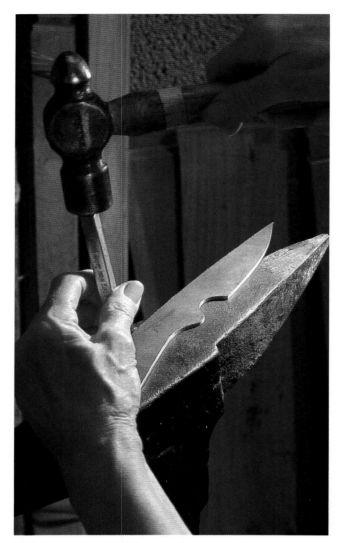

Pinholes are started with a punch.

Cooled, the blades are black with carbon and so brittle they can break like glass. Vernon carries them to the kitchen and sets them in the oven at a moderate, cookie-baking temperature to relieve the brittleness. Sanded and given final temperings, the blades emerge a subtle straw color overlaying blues and greens, giving the metal a handsome, rainbow hue.

The Raaens debate which woods to use for the handles. Their storeroom is stocked with flitches. A few exotic woods, like padauk and bocote, are from foreign lands, but most are native to Appalachia. There are thick boards of apple, birch, butternut, and black cherry. There is a section of a chestnut tree felled by blight more than fifty years ago.

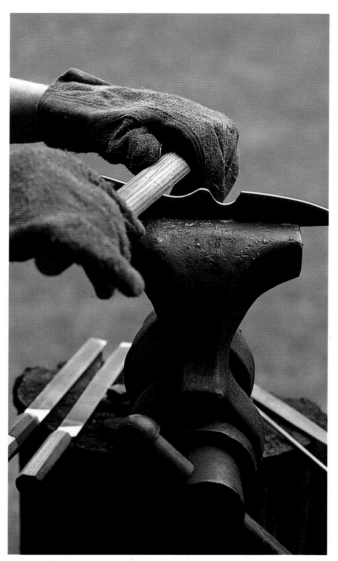

Helen refines the blade shape.

202

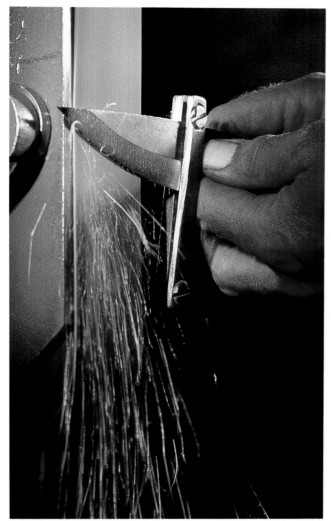

The blade edge is ground.

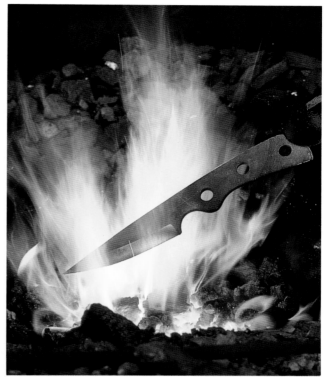

The hardening begins.

"The trees we cut," Vernon says, "are usually ones that have been damaged or are sick. As a rule, we take only what we know won't survive. Ironically, stressed woods are often the most beautiful."

Maple and mulberry, dogwood, holly and hickory, persimmon, redbud, and walnut, the Raaens use them all for handles, as well as the hornbeam that grows along a stream on their farm. They search western Tennessee for old fence posts made from Osage orange, a wood the Cherokee Indians favored for making bows.

The wooden handles are fastened to the blades by the Raaens' trademark rosette pins, welded flower clusters of thin brass rods.

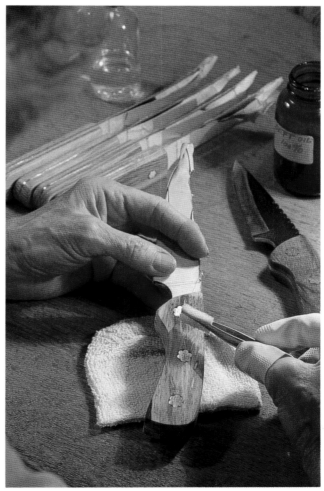

The handle is finished.

The Raaens turn out a colorful assortment of edged tools of their own design, each of them numbered and signed. There is a graceful chopper with a tiny heart cut in the blade, a knife for trimming the lead used in stained-glass windows, a reed scraper for wind instruments, and a dagger similar to the Kotanga, which ancient Japanese warriors used for eating and kept sheathed in the handles of their samurai swords. The Raaens create chef's knives, paring knives, a half-moon chopper they call the Mezzaluna, and a double-edged carver inspired by the knives of the Tlingit Indians of Alaska and British Columbia.

Sitting at her design table, Helen's eyes take on a faraway look. "Oh, it's marvelous to sit down with a pad and pencil and create a knife, and then go and make it, and find that it feels just the way it ought to feel and it's beautiful to the eye. It fulfills all your expectations. You get that same feeling of elation you had when you first imagined it. That's a thrill."

Mezzaluna chopper

"It didn't do to be careless when you were shooting coal.
Drill a hole with a breast auger, charge it with dynamite,
set the fuse, back off and yell, *Fire in the hole!*
Then you blew her, and Lord help any poor miner
who wasn't hunkered down."

OSCAR SPENSER

OSCAR SPENSER

WE ALL CARRY our share of blindness. We are born nearly blind, and in a day or two our eyes grope into fleeting focus. We see a moving shadow, a dim shape.

Then swiftly vision clears and sharpens. At less than a year old our eyes rove everywhere, hungry and alert, a penetrating gaze discovering with delight the colors and shapes of uncountable new worlds. The eyes of a child are the eyes of a Magellan.

But somewhere along the way we begin to go blind again. The familiar things are noted mechanically, our eyes sliding past. We walk without cane or tin cup, but blind.

And there are those who come to startle us out of our blindness, crying, *Look!*

From the golden toad in a Mayan artifact to the marble serpents that entwine a sculptured head of

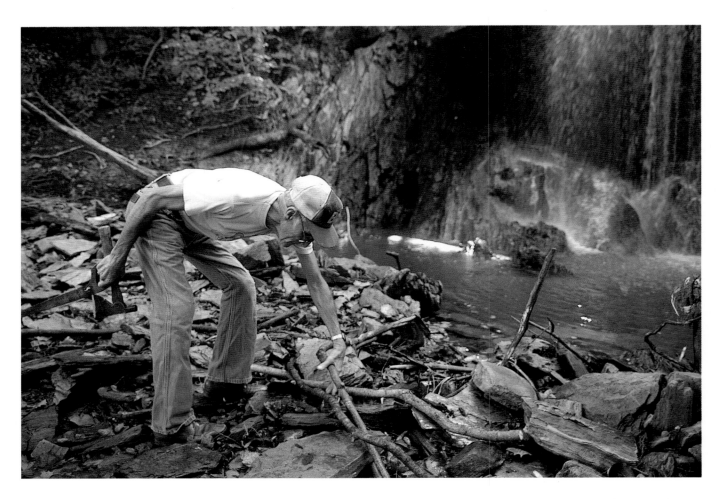

Facing page: Laid out on his work bench, the skin and
rattles of snakes Oscar Spenser killed in the hills.

Medusa, or a greyhound in the Bayeux Tapestry, or a
hare in a drawing by Dürer, we are fascinated by the
creatures of nature beautifully rendered in art. So it is
with the works of Oscar Spenser. He presents us with
the gift of a chance to contemplate nature's amaze-
ments in a way that nature rarely allows.

Back when a miner dug out coal with a pick and
shovel, Oscar Spenser lost a leg to a faulty trap door
in a Virginia mine. He turned to house painting,
breeding rabbits to sell at the flea market, and
scouring the slopes of Virginia's Blue Ridge Moun-
tains for the sinuous sourwood, sassafras, and
dogwood branches that he transforms into life-size
snakes.

"There's timber rattlers all over this part of the
country. I've shot a'many. Way I started carving
them—I got to pondering on snakes the day I was
out hunting sang and a copperhead hit me." A
deadpan pause. "Right on my artificial leg." He
grins. "It just straightened his mouth out. He
couldn't get in his fangs at all."

When he got home that day, he bent an old iron bar
crooked and ran it up a length of a black rubber
hose. "I studied out a piece of wood, and carved a
head and tail. Laid it in the grass, and called my wife
to come and see what was in the yard." Remembering
it, he starts to laugh. "She took one look, and yelled,
'Get you a hoe and kill that thing!'"

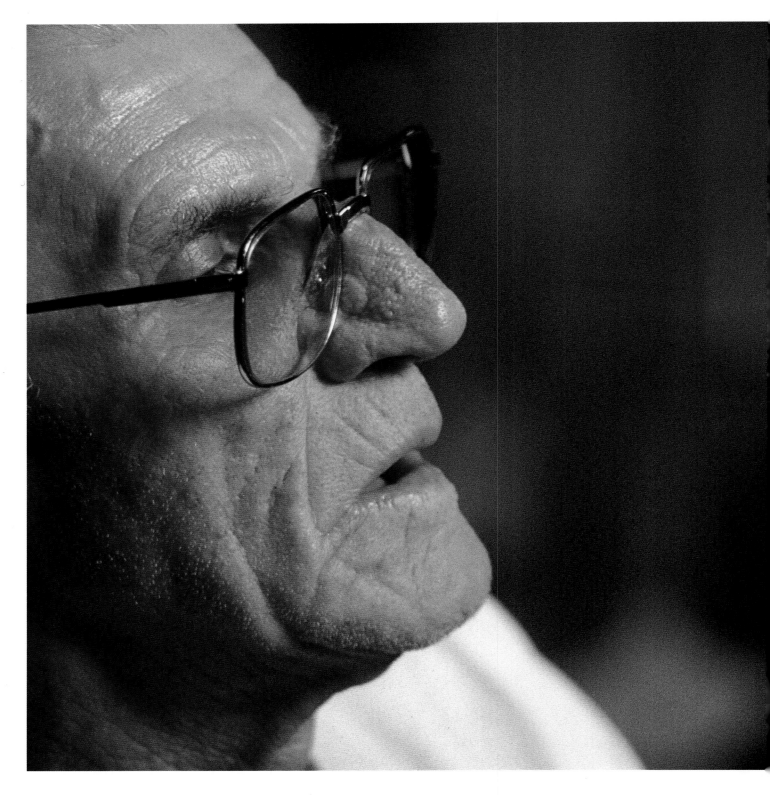

In his cellar workshop, Oscar Spenser lays a branch on the table to make sure its head raises up. Peeling off the bark with his pocketknife, he shapes the head and tail. If he's making a rattlesnake, he uses a real rattle whenever he can. Clamping the branch in a vise, he smooths the knots with a drawknife and a rasp, fixes on glass bead eyes, and splits the plastic insulation off an electrical wire to get at the thin strips that will make the tongue.

Oscar Spenser was born and raised in the Virginia coal fields. At the age of eighteen, he went to work in a mine. In the 1920s, they still used mules to pull the coal cars. There were stalls for the mules

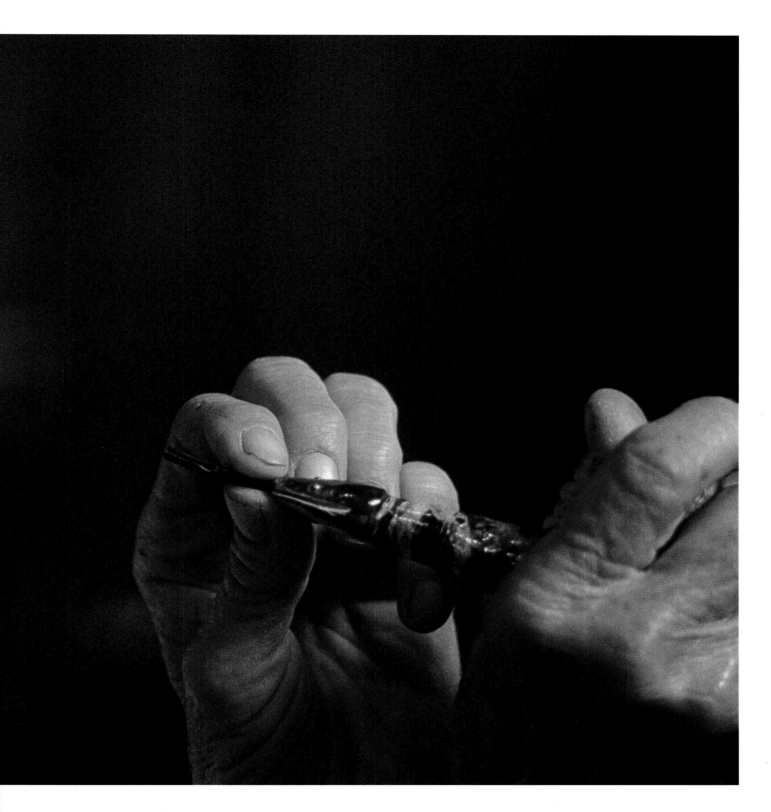

underground, cut out of solid rock, "Once they got down there, those mules never saw daylight again."

Frequently a miner had to cut away a shelf of slate to get at the seam of coal. He didn't get paid for slate and could work all day without having a dime to show for it.

Digging coal was torturous work. Often the roof was so low a miner had to lie on his back. If it was high enough for him to work on his knees it was considered a pretty good face. "Many's the time I worked kneeling in water. Come the end of the day, my feet would be swollen up."

213

It didn't do to be careless. Oscar Spenser had to watch his step when he was shooting coal. "Drill a hole with a breast auger, charge it with dynamite, set the fuse, back off and yell '*Fire in the hole!*' Then you blew her, and Lord help any poor miner who wasn't hunkered down."

He was twenty years old when he lost his leg. The company was experimenting with something new, power-driven cars the miners called electric mules. "My brother was a motorman and I was braking for him. They had these big old heavy doors that helped direct the air from the fan. When the car hit a trip rail, the door was supposed to open and stay open until you hit the next trip rail. One snapped back before we got through, and tore up my leg."

He was half a mile down, four miles in from daylight. It took a long time to get him out and to the company hospital. The facilities were primitive. The doctor was senile. Those were the days before penicillin. Gangrene set in, and Oscar Spenser lost his leg.

"Wasn't no union. I drawed eight dollars on it, is all I drawed."

He wanted to sue, but he couldn't find a lawyer willing to represent him. They all said there was no way he could win against a coal company. It would be like trying to sue God.

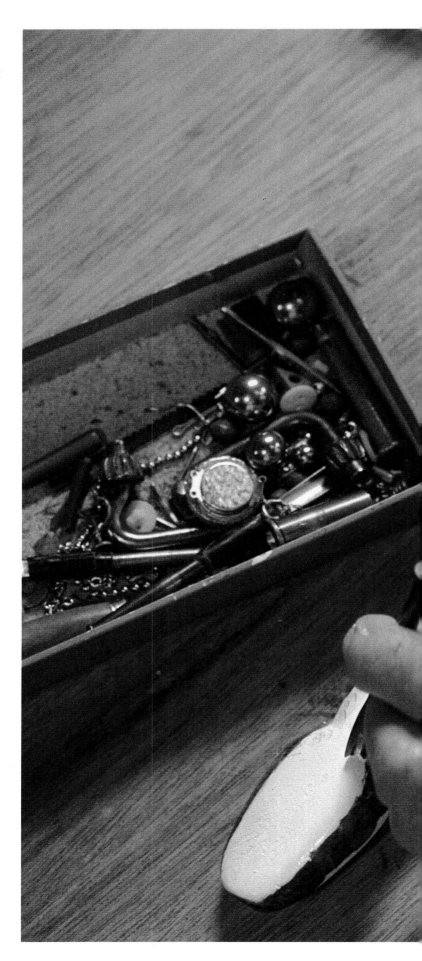

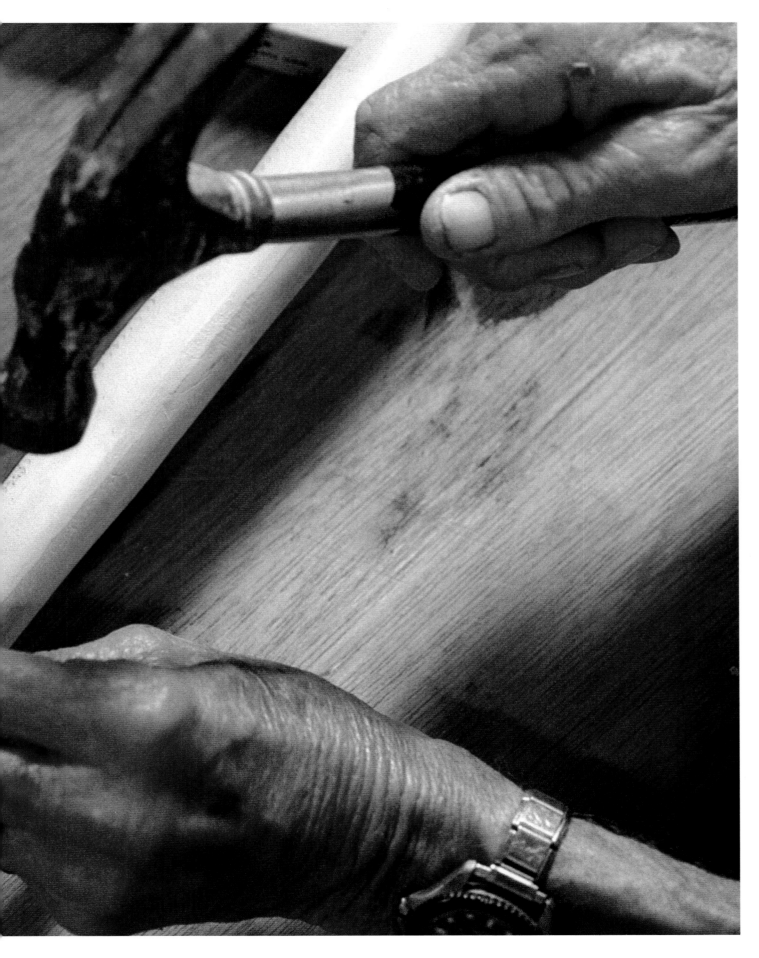

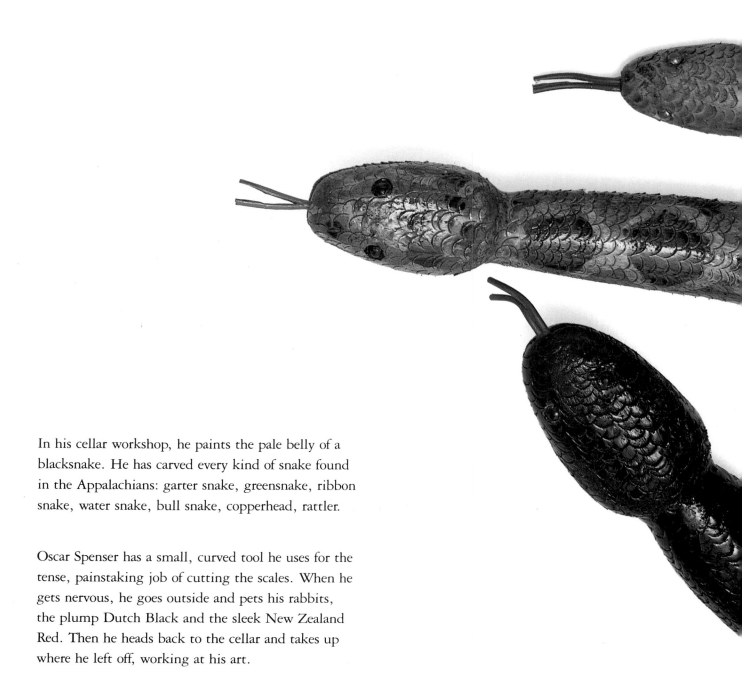

In his cellar workshop, he paints the pale belly of a
blacksnake. He has carved every kind of snake found
in the Appalachians: garter snake, greensnake, ribbon
snake, water snake, bull snake, copperhead, rattler.

Oscar Spenser has a small, curved tool he uses for the
tense, painstaking job of cutting the scales. When he
gets nervous, he goes outside and pets his rabbits,
the plump Dutch Black and the sleek New Zealand
Red. Then he heads back to the cellar and takes up
where he left off, working at his art.

"I'm a crooked feller, so I take to crooked branches.
At the flea market, they call me Old Snake."

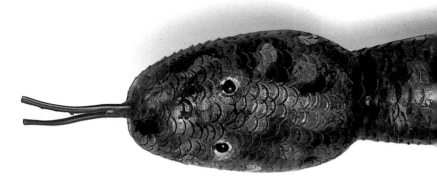

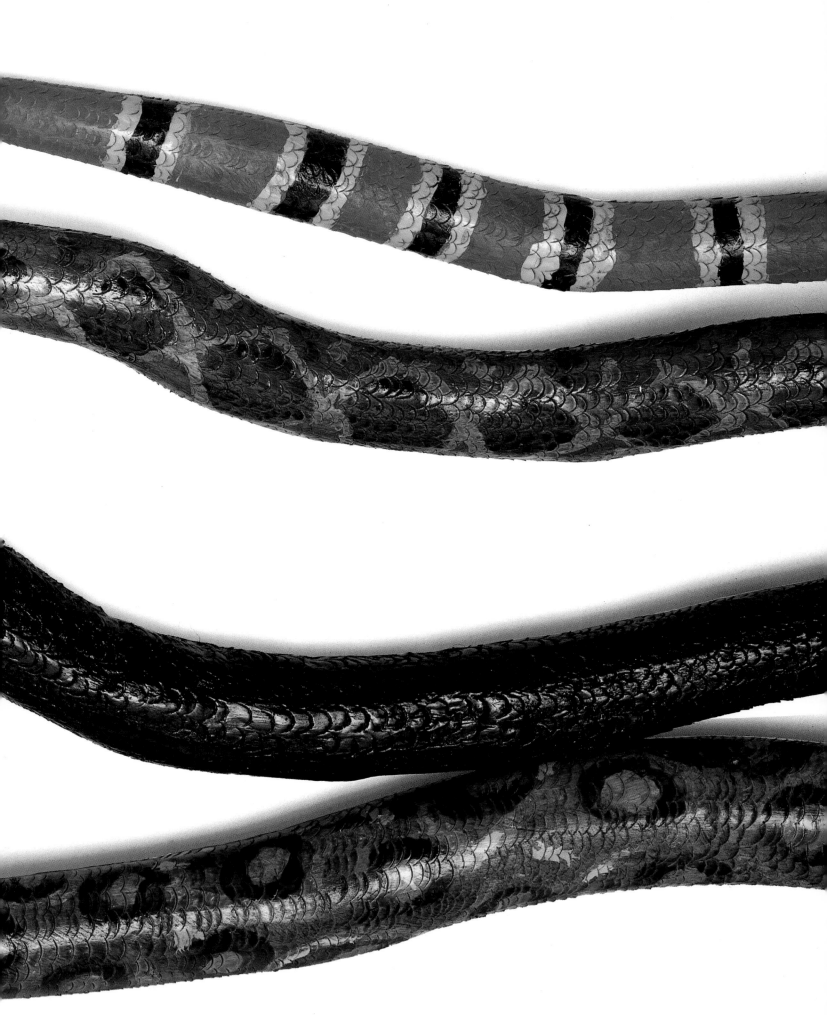

"All my pieces, I couldn't have made them no better,
and I couldn't have made them no worse.
Even if you didn't like it, I wouldn't change nothing.
I want it this way to keep me happy inside."

CHARLIE LUCAS

CHARLIE LUCAS

BLACKBIRDS and yellowhammers swoop among slash pines that are strangled by kudzu. The terra-cotta road curves into the dusty, Alabama community of Pink Lily, a scattering of ramshackle houses, weathered sheds, and parched fields.

One house leaps at the eye. Its mailbox is held by a jaunty scrap-metal man. On the porch are an alligator created out of a crankshaft and a fiddle player whose head is a shovel, his body a rusted car muffler. Across the road are two more scrap-metal men, one with car-spring legs, one brandishing an axe. On a strip of whitewashed fence, a lunatic scrap-metal bird perches beside a battered scrap-metal airplane. Nailed beneath them is a sign—"Tin Mens"—Charlie Lucas announcing himself to the world.

At the edge of a scraggly field is a junk pile. Axles, dented exhaust pipes, bicycle wheels, smashed radios and lamps, the stripped chassis of an old washing machine, coils of the metal strapping used to pack lumber and heavy machinery for shipping, and God knows what else.

"It's just castoff stuff people throw away." Charlie Lucas grins his boyish grin. "Like people who've been cast off, and everybody thinks they're worth nothing. I've been there. Beat up, broken, down at the bottom. But I had this dream in my head, and that made me more than a piece of junk."

The shouts of his children ride the air as they scuffle around the makeshift basketball court under the eyes of a towering scrap-metal dinosaur. His skinny son careens his bicycle down the path. A daughter with skin the color of maple sugar appears in the doorway of the house.

Charlie Lucas takes it all in with the ghost of an absent smile, as though he's amused at the whole human circus. In his mid-thirties, there is a poise about him, a dignity, the grace of a man who has learned the hard way his role in this life.

He is king of a childhood domain. Under the trees, out in the brush, down by the shed near his welding torch and mask stand his subjects: fantasies, animals, women, and men. A life-size horse moulded out of metal strapping. A demon with mouth and eyes stitched by acetylene fire. A muscular giant fifteen feet tall.

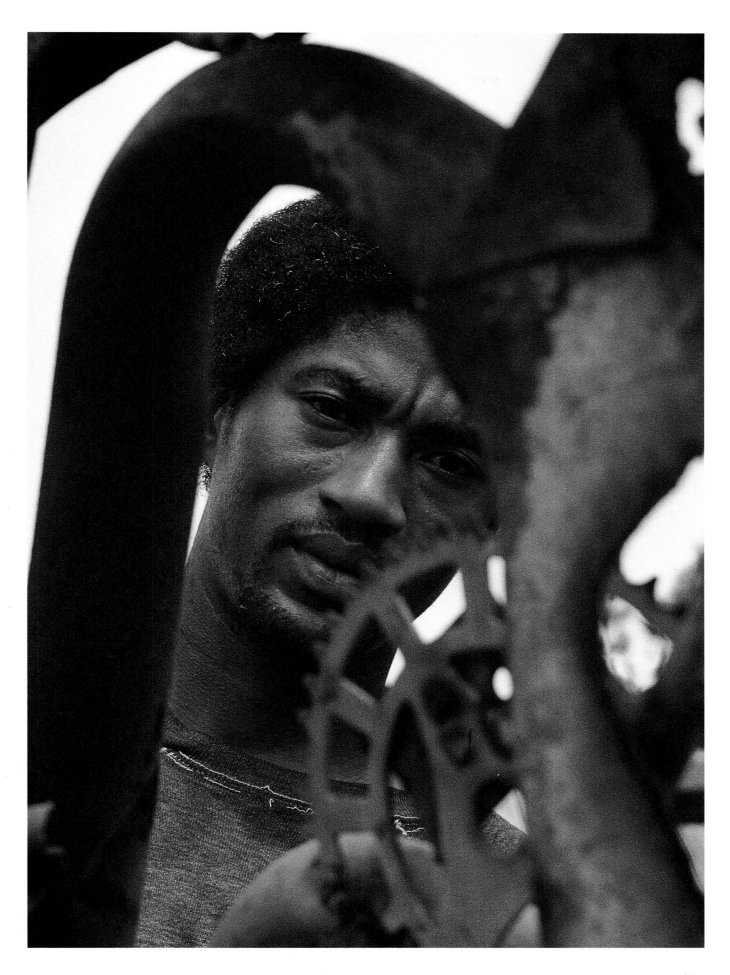

The son of an auto mechanic, Charlie Lucas started using tools early on. With fourteen children sharing one rattletrap bike, he had to wait until night to get his turn. With no money for toys, he had to make his own. "I was always running off with my daddy's hammer and saw. I'd leave them laying around, and I'd get whipped." He laughs. "Oh, but I had a good time doing it."

His father took time to explain transmissions, clutches, and starters to his kids. "He taught me some wonderful things. He could strip down a car with just a screwdriver, a pair of pliers, and a 9/16 wrench. Something I got from him is my love of taking engines apart and putting them back together again. I can close my eyes and know exactly which part goes where."

When Charlie Lucas was eight or nine, he was left in charge of his little brothers and sisters when his parents went off to work. He'd take them over to his grandfather's place. "He was a blacksmith, just an old man who worked all his life for thirty-five, forty cents a day. Any time we went there, he'd be working. Talk to us, he wouldn't stop. Oh, we kept him busy, messing with his coal. Everything he had around there, we'd mess with it."

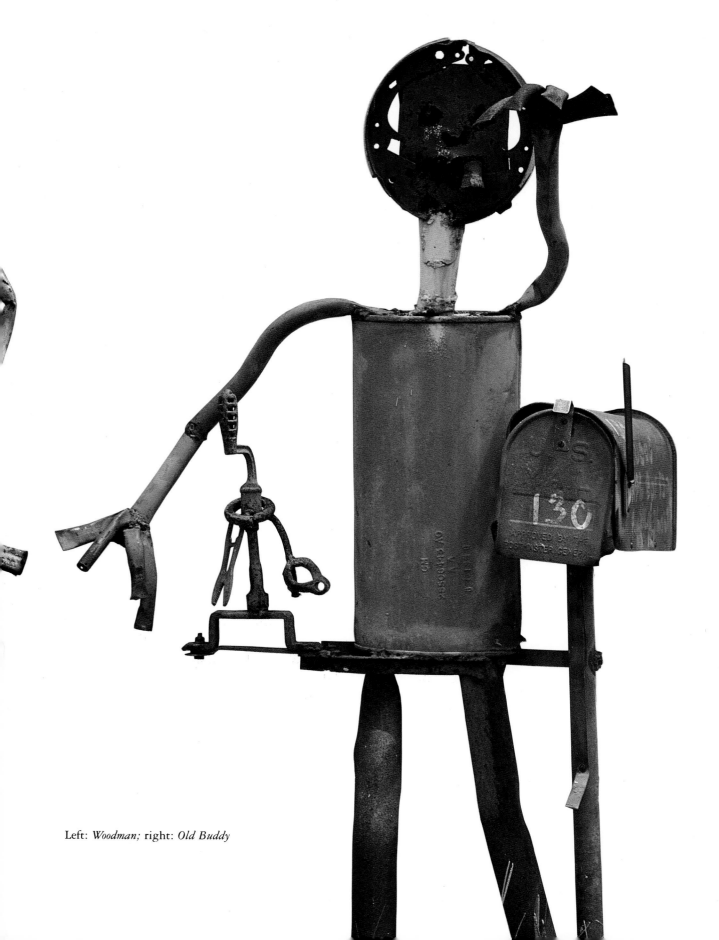

Left: *Woodman;* right: *Old Buddy*

Blacksmithing fascinated the boy. It meant dealing with fire, dealing with iron, seeing it change. Nine is a marvelous age for learning. Charlie Lucas was wide open. He never thought about what he couldn't do. He'd try anything, go anywhere, just open the door and walk in. Between the forge and the anvil, a sense of wonder about shaping metal was born in him.

His work history is a crazy quilt of skills. At fourteen, he went into construction. "Laying cinder block, framing houses, and all that good stuff." Then he went to driving trucks. Curious, restless, he was always longing to see what was going on in the next world. "A lot of people mistake the next world as maybe in another universe. I say it's somewhere over that mountain, or in the next town."

He took off for Florida and worked in a Miami factory breading shrimp. It didn't take long for city life to start grinding him down. "Florida was just too fast a living for me. I'm used to seeing the mailman every day. Down there, you were lucky if you even saw your mail. Or knew the names of your neighbors. Live next door to them, and you don't know them from Adam and Eve. Walk the streets, you're looking to get run over by an eighteen-wheeler or a bulldozer knocking down a building. In the country, you don't have to worry about nothing but trees."

Charlie Lucas headed back home to Alabama, worked on a farm for a time, and then got a job in a hospital as a janitor-plumber-fixit man. "You name it, I did it."

That was when it happened—the accident that led to back surgery, two discs removed, and an aftermath of exquisite pain. Pain like an evil, nightmare creature, gnawing at him day and night.

"It knocked all the juice out of me. I used to run and jump, and I couldn't do that anymore. Couldn't even walk good. It's a bad feeling, because you . . . inside, you're still thinking the way you used to be. I see myself as I was at fifteen, and then I limp around, and some friend hollers at me, 'Hey, old man!' "

He was in traction for five months and in bed for almost a year. He lay there, thinking about his past and his future, weaving fantasies. He wanted to put his life back together and not just gravitate to another job. He couldn't see himself sitting around watching soap operas and waiting on his disability check. While he was still in bed, he started bending and twisting aluminum wire, fashioning people and beasts, shaping scenes from his life.

When he finally got back on his feet, Charlie Lucas started making larger pieces. "My neighbors, they'd ask what I was doing hoarding junk. I'd make a piece, they'd look at it and say, oh, that ain't nothing but just old car hoods, bumpers, and stuff. You know, I'd smile at them, because I don't worry what people ain't got it in them to see."

He measures one if his works with a narrow gaze and a faint grin. "These here two, that's me and my wife. The steering wheel, that came from a bicycle. My face is a radio, see, my wife's talking, I'm tuning it

in. She's a strong woman, and I'm a stubborn man. She wear the motorcycle helmet, and I wear the hard hat. That let you know, hey, we've bumped heads."

Fighting the pain, Charlie Lucas forced himself to look on his accident as God's plan. "He slowed me down to where I could stop running and turn my hand to what I was meant to do. He gave me the gift to where I could look at a piece of junk that somebody had thrown away, and see something in it. Something wonderful."

"Folks ask me, have I got a book with an emu in it. Tell 'em, no sir. They say, you never seen an emu, how you know what one looks like? It's just . . . birds come to me. Like dinosaurs. I never seen a dinosaur, it just come out of me. I can lay down and one night just go into the world where the dinosaurs at. Looking inside my head is what other folks be doing when they look in a book."

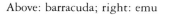

Above: barracuda; right: emu

He'd always done repair work on his friends' cars, and there were discarded parts lying around. A muffler inspired his first life-size figure, *The Spring Man*.

"It was spring, and I built him to help me clean up the yard. He's on car springs, see, real flexible, so's he can bounce. He's supposed to be jumping around, picking up dead leaves, broken branches, and stuff." Deadpan, Charlie Lucas shakes his head. "He never has done a lick of work. I tell him he's suppose to be doing it, but he don't listen. He just look at me, give me a sweet smile, and just leave it alone." He shrugs, his eyes glinting with humor. "Oh, well. I gave him a bow and arrow, case he want to go hunting, and a hat so he don't get too much sun. I even gave him a nice heart. He ain't worth much as a working man, but he's been a good friend."

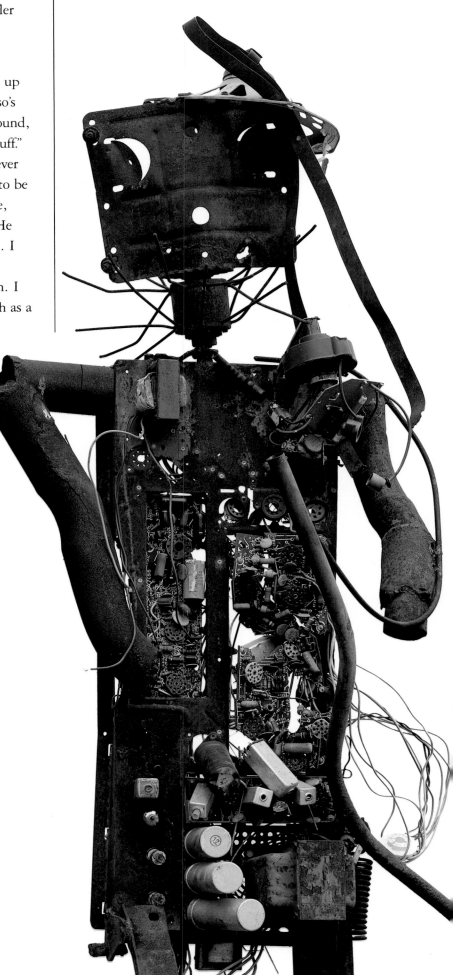

Radio Man

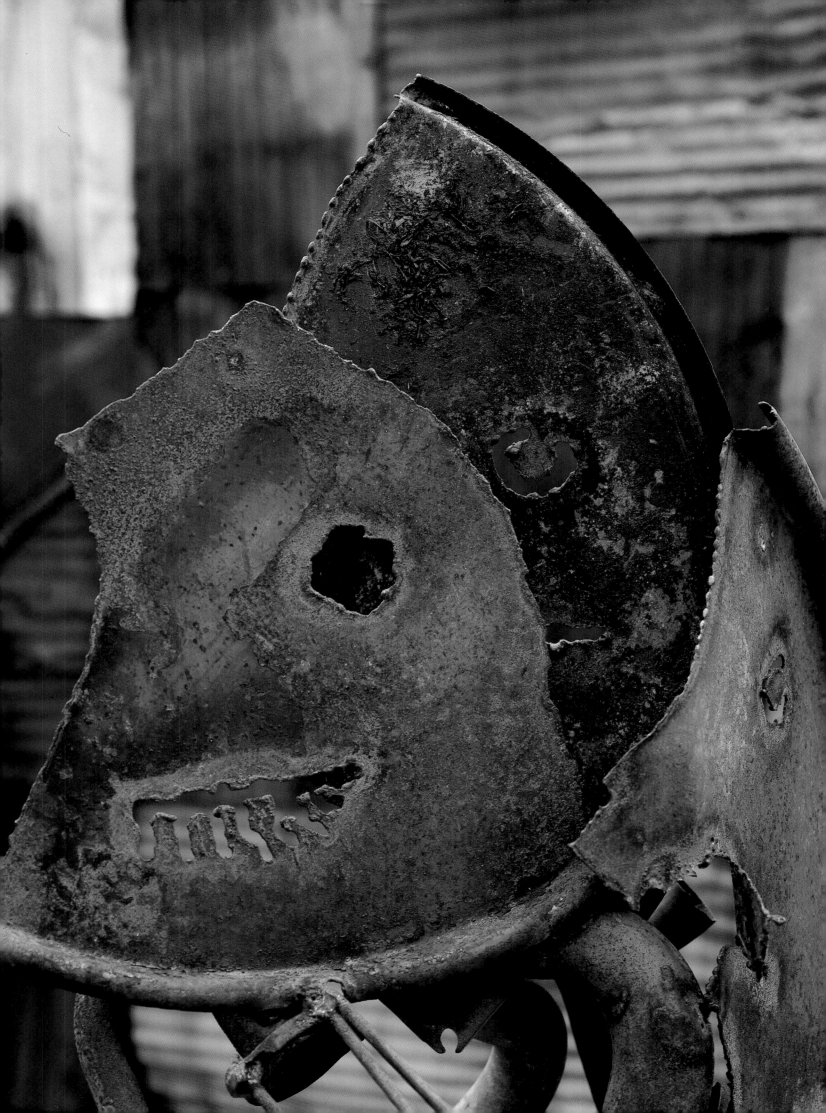

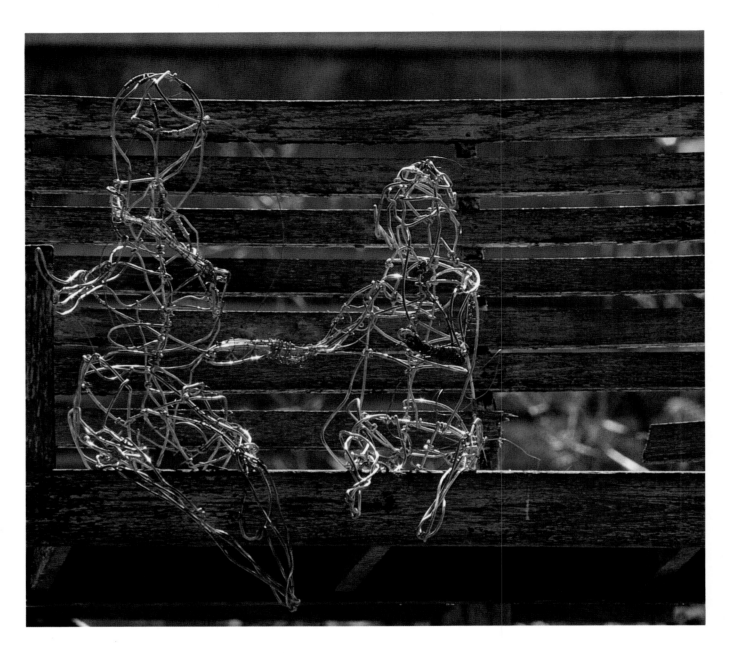

Married when he was nineteen, Charlie Lucas compares marriage to getting an education. "Husband and wife go to school to each other. And the kids too. I got six of them. You think you know them, and then they'll come up with something take you off your feet."

He looks on his works as gifts to his children, something to stir their imagination. Already, two of them paint, and the baby, his nine-year-old son, is welding. "I showed him how to do it one day, and he understood totally what I was talking about. He just started burning the rod. I don't mess with him too much because he's delicate, and I don't want to crowd him. Me and him talk about a lot of serious business together. I see him as my new baby brother in some respect. He can share what he's learning about being a little bitty boy, and I can share some of the things I'm learning with him."

He gestures toward two wire figures sitting side by side, their pose one of touching intimacy. "That's me talking to my son. We was having the birds and the bees talk, and he explained the whole thing to me, proud that he did. I was sure glad he took over 'cause I was getting confused with explaining it."

Above: *Talkin' With My Boy 'Bout the Birds and the Bees;* facing page: *Dinosaur*

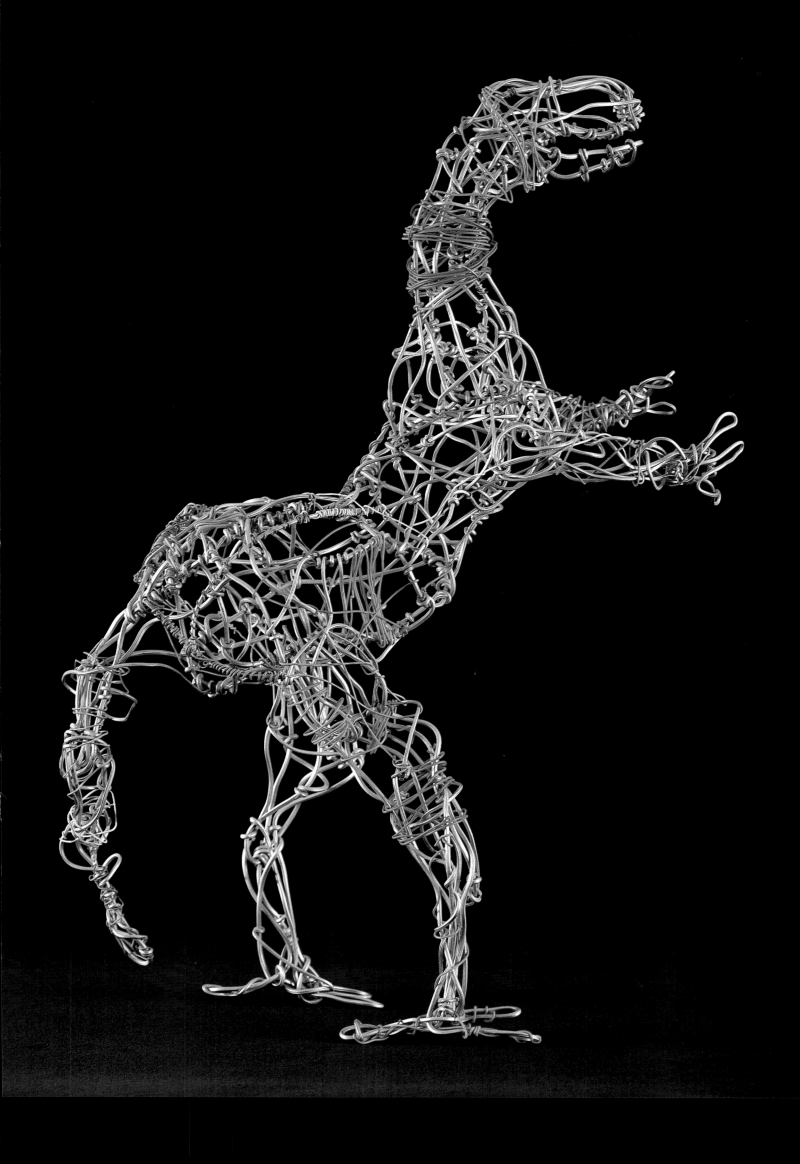

Standing fourteen feet tall, *Old Big Man Wrapped Up in the Spirit* towers over the life-size *Horse*.

There is something in Charlie Lucas that is more than just food on the table, something profoundly spiritual. He stands, his fingertips grazing his scrap-iron horse with its amazing evocation of muscle and sinew, saying softly, "I want my soul to be a good soul when I show people what I do. I'm not doing it for money. If I never sold a piece, I'd do it just to keep my soul straight. I don't want to see myself printed out like a machine. All my pieces, I couldn't have made them no better, and I couldn't have made them no worse. Even if you didn't like it, I wouldn't change nothing. I want it this way to keep me happy inside."

Facing page: *Baby Giant* is as tall as a ranch house. "Call him that because I'm planning to make me a Daddy Giant a whole lot bigger."

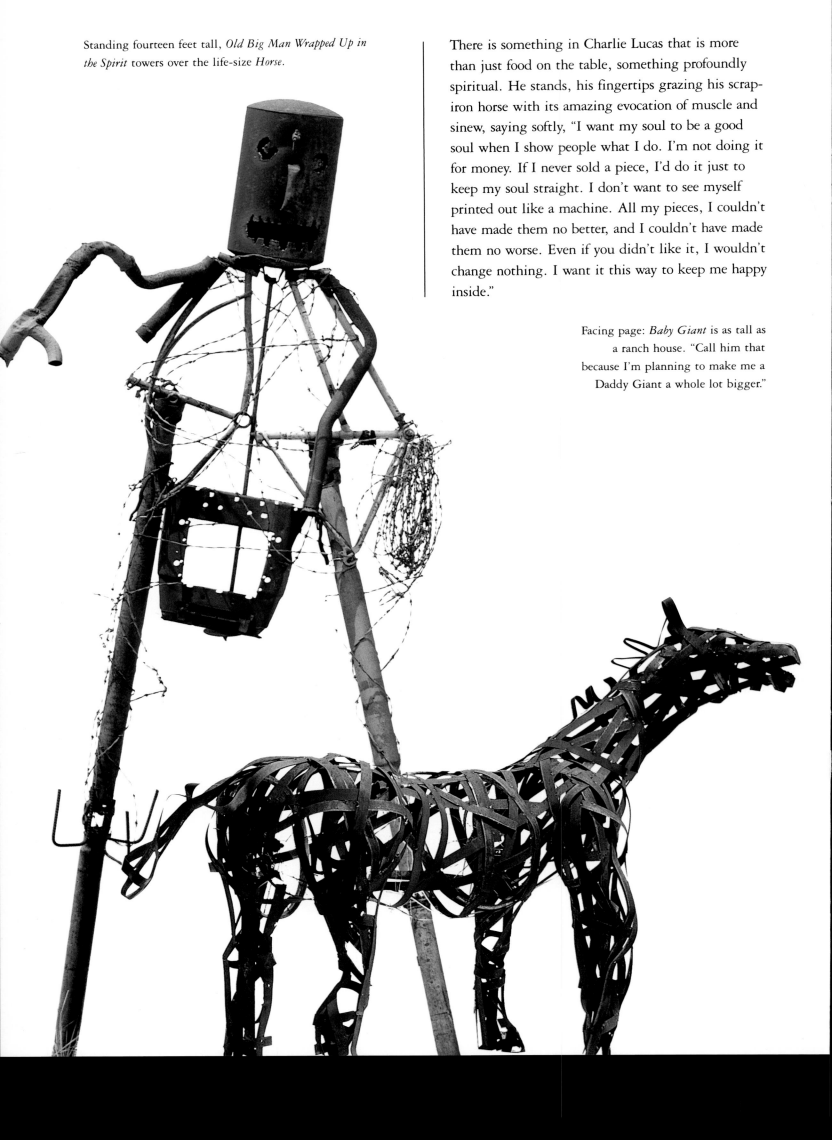

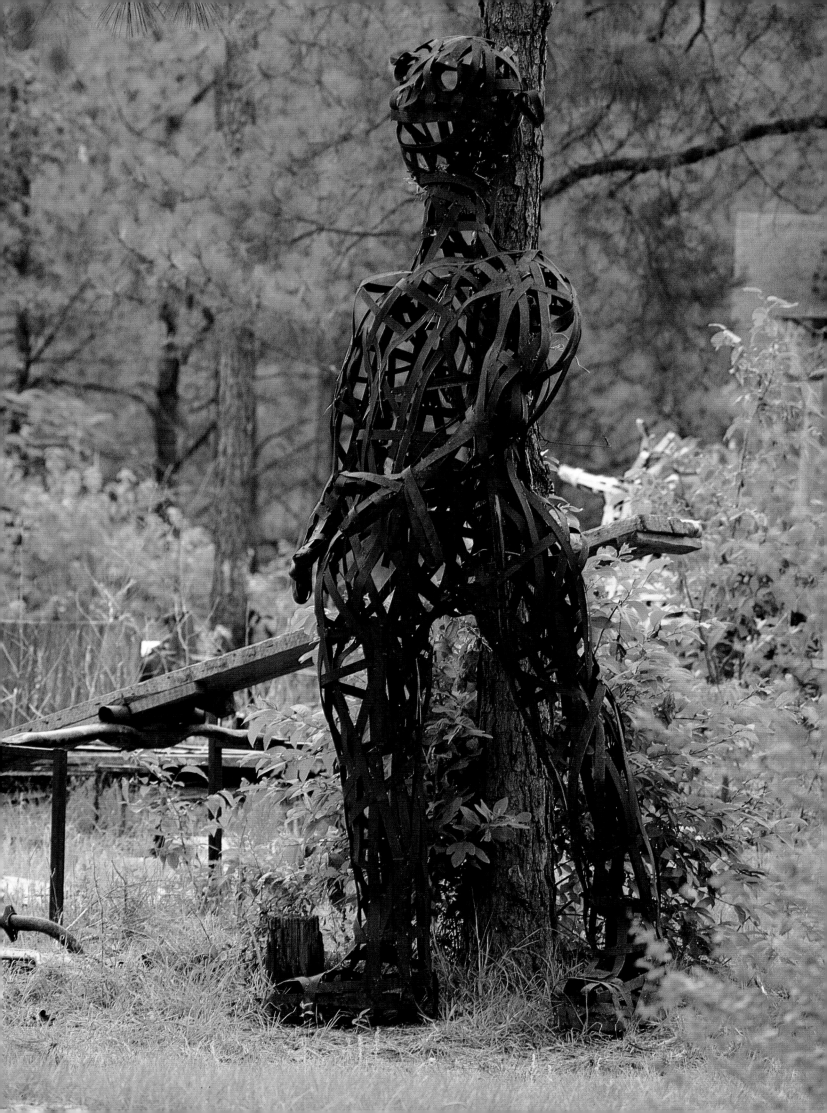

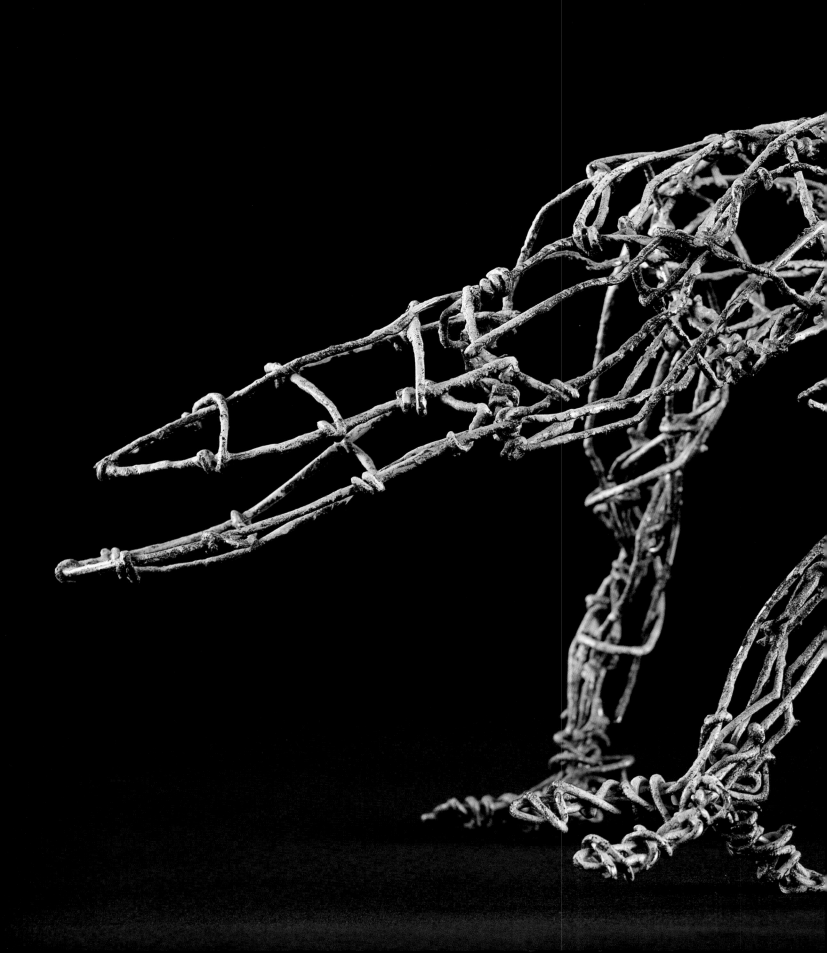

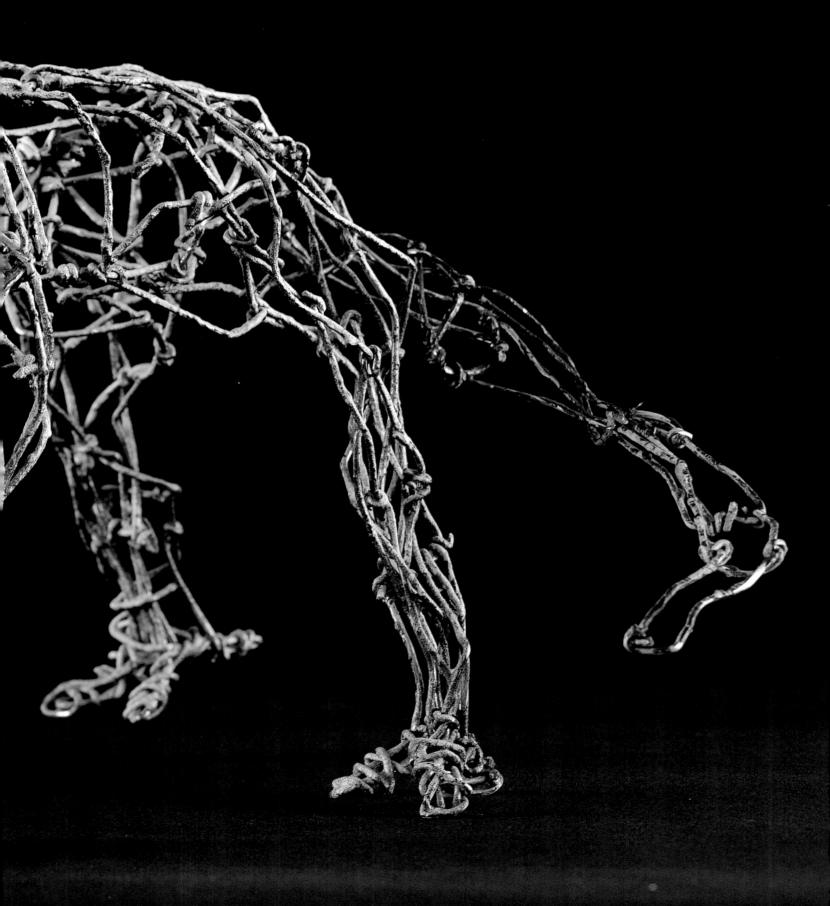

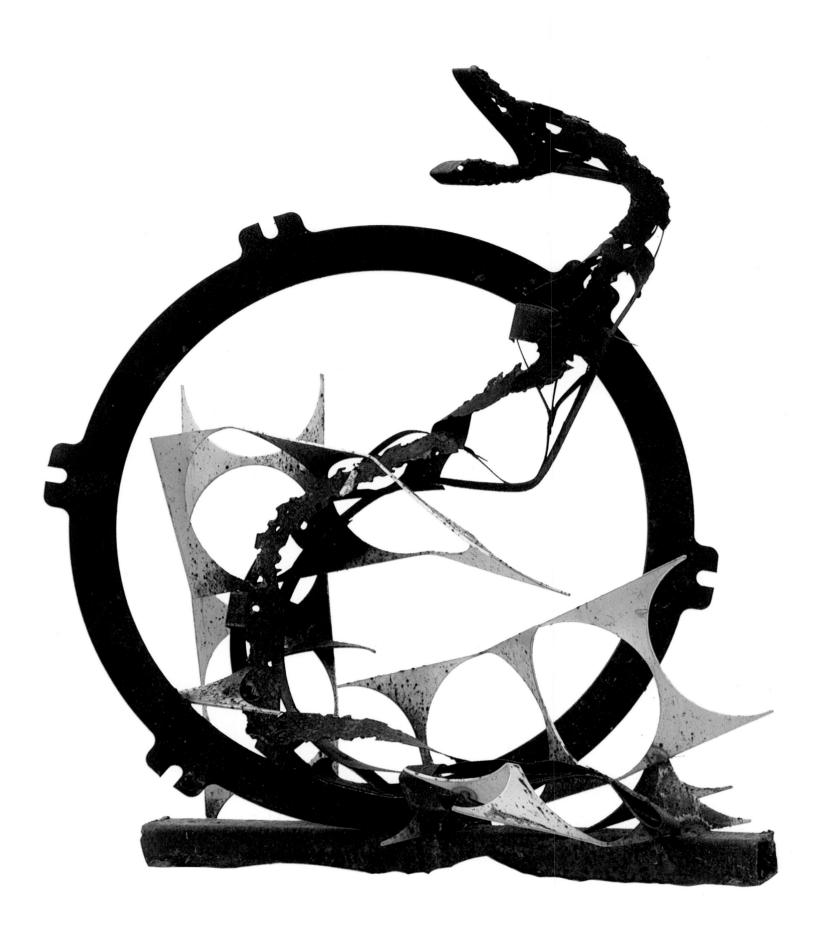

Preceding pages: *Baby Dinosaur*

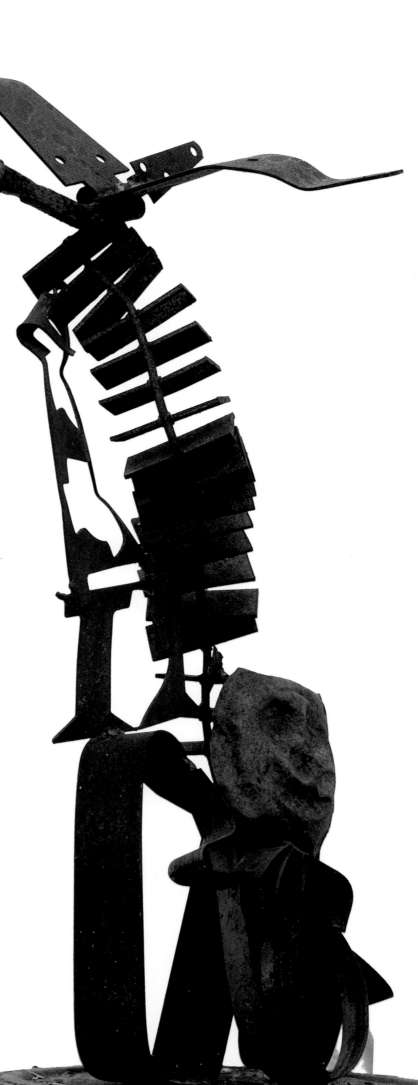

"In *Crawling through the Thorns* (facing page), that snake there, that's me shuffling around on my knees when I'm welding and my back is hurting. Making it through the hard way, making it through the sticky part, crawling around through the thorns has been something I know about."

As a piece takes shape, Charlie Lucas steps back and looks at it, touches it, holds it, envisions an arm, a thigh, an impish face.

"Touching, that when it mostly come to me. That piece just lean right where it need to be, and you can feel it, like touching a person. You feel all the muscle and strength of it, and everything just come to you as you be doing it. Just by touching, I feel it's somebody I know. It's friends of mine coming out of me. I mean, if I went to singing, this would come out."

Creating a jubilation out of scrap metal, Charlie Lucas is singing.

Jacob's Ladder

"I was already picturin' when I went down
to the schoolhouse. I wouldn't go to class. I'd rather spend
my time in the woods tracking game."

CHARLEY KINNEY

NOAH KINNEY AND CHARLEY KINNEY

APPROACHING the Kinney place, the rutted road passes a scene of destruction. The hillsides have been brutally timbered off. Battering down everything in their paths to get to the giant oaks and poplars, bulldozers have left the slopes littered with a wreckage of uprooted maples, splintered dogwoods, smashed hickory trees, and raw, ugly stumps.

His gaze taking it in, Noah Kinney's lean face sets in anger. "That was all virgin timber they took out of there. It'll take two hundred years to grow back them trees. The county board don't give a damn, wasn't nobody to control them, they done as they pleased. Yessiree, they was just out for the almighty dollar. And I'll tell you this. You go to the boys that cut that timber, they won't have five dollars to their name. It's already been blown away."

Charley Kinney's bright blue eyes peer out from under a hat with a speckled guinea-hen feather stuck in its band. "The woman owns that land inherited it. She lives up in Pennsylvania, and what I mean, she's got all kinds of money. Wasn't no need to sell off them trees, it was just pure greed. If her daddy knowed what she done, he'd be whirlin' in his grave."

Noah Kinney jerks his head toward the hillside. "See them stumps? When the roots die and there comes a rain, won't be nothin' to keep the water from runnin' into the holler. It'll come pourin' right down on my house."

Charley Kinney stares at the sparse thickets left standing. "The squirrels that's left are pitiful. With them nut trees gone, they ain't got nothin' to eat."

Scattered across the thirty-five-acre Kinney spread at Big Salt Lick in Kentucky are Charley's little house, the home where Noah lives with his wife, Hazel, a large old tobacco barn, a henhouse, and half a dozen sheds, one of them Noah's workshop. Across the creek is the homeplace, a log cabin where Charley was born. It was built a long ways back. No one knows for certain how old it is. At least a hundred and fifty years is a good guess.

In their younger days, the brothers raised corn and tobacco. Now they raise guinea hens, chickens, and ducks. Noah carves. Charley paints and makes puppets. Charley plays the fiddle and mouth harp. Noah plays the guitar. Noah has a gentle smile. Charley has the snaggletoothed grin of a free spirit who has been up to mischief. Noah's carvings reflect his good-humored, easygoing affection for all living things. Charley's paintings are wild, flung off with abandon, like a devil-may-care plunge into a swirling creek.

Charley is in his eighties. Noah is the kid. "I don't look a day over seventy-five," he announces cheerfully, "but I'm seventy-six."

The Kinneys are determined to protect what wildlife is left. A few years back, when the pickings were slim for the squirrels, they took to putting out corn. There's a law to stop hunters from using food to lure game into the open for an easy kill. A warden came by to warn Noah Kinney to stop feeding the squirrels. "I'm not about to do that," Noah told him. "You can just take me to jail, buddy, and my brother'll feed 'em till I get out."

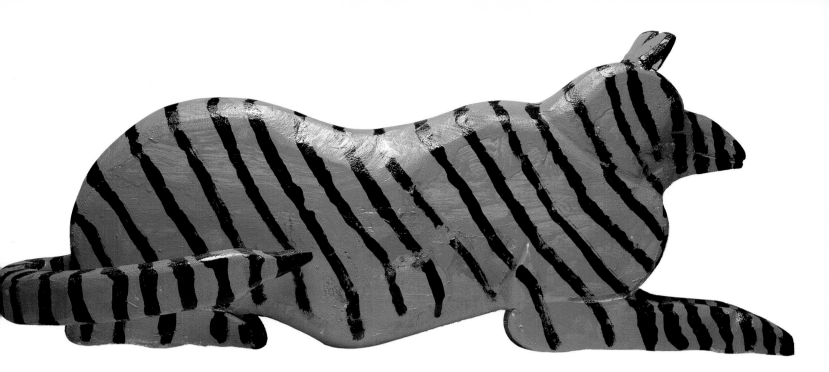

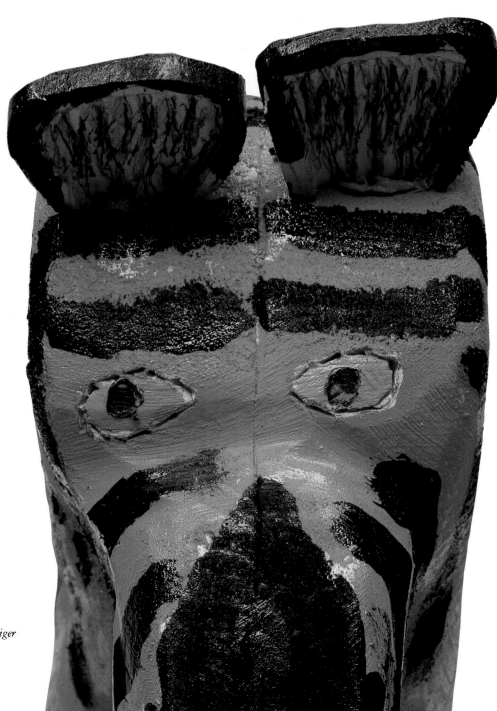

Noah Kinney: *Tiger*

Hazel Kinney rides herd on both of the brothers, sees to it that they eat properly, and looks after their health. She met Noah when she was out picking berries and strayed onto Kinney land.

"I heard somethin' thrashin' around in the woods," Noah Kinney recalls, "and went to have a look. Seen this pretty girl walkin' through the brush." He grins. "Good-lookin' as I am, you'd think she would have waited for me to catch up to her. But directly I started comin', she took off in the opposite direction lickety-split."

Hazel Kinney laughs. "He courted me with apples and grapes. Every time he come, he'd bring a paper for my father. We done our courtin' while daddy had his nose buried in the news."

Hazel Kinney's wedding dress adorns one of the three life-size female musicians Noah Kinney has carved out of poplar. The other two wear dresses he found at a yard sale. They are three prim, yet slightly disheveled schoolteacher types carrying rakish guitars. Noah calls them *The Kinney Band.*

Noah and Charley Kinney's father played the fiddle. He fashioned one out of a cigar box, telling young Charley, "When you play me a tune on it, my own fiddle's yourn." The brothers weren't yet in their teens when they started performing at corn-shuckings, apple-slicings, and square dances, picking up a dollar for whanging out the folk songs they'd been handed down:

Old Dan Tucker's a fine old man,
Washed his face in a frying pan,
Combed his hair with a wagon wheel,
Died with a toothache in his heel. . . .

They don't travel around to play these days. The neighbors come to them. On a Saturday, the yawp of Charley Kinney's fiddle and the twang of Noah Kinney's guitar bring grins and whoops, hands clapping to rollicking breakdowns:

Goin' down to Cripple Creek, goin' on the run,
Goin' down to Cripple Creek to have a little fun!

Their faces expressionless, mountain style, Charley's sassy bow dances over the strings and Noah picks the harmony.

Black-eyed Susie's 'bout half grown,
Jumps on a man like a dog on a bone,
Hey, black-eyed Susie.
Hey, pretty little black-eyed Susie,
Hey!

Noah Kinney's first carvings were of the animals in the hollow, and of a few historical figures, Teddy Roosevelt, Lincoln, and Washington. A piece that came from his heart is of three friends tending the steam-powered grist mill that used to operate a few miles down the road. It is extraordinary in its remembered detail and in the distinct character he has given each of the men. It perfectly captures a vanished world of mountain life.

Noah Kinney: *George Washington*

240

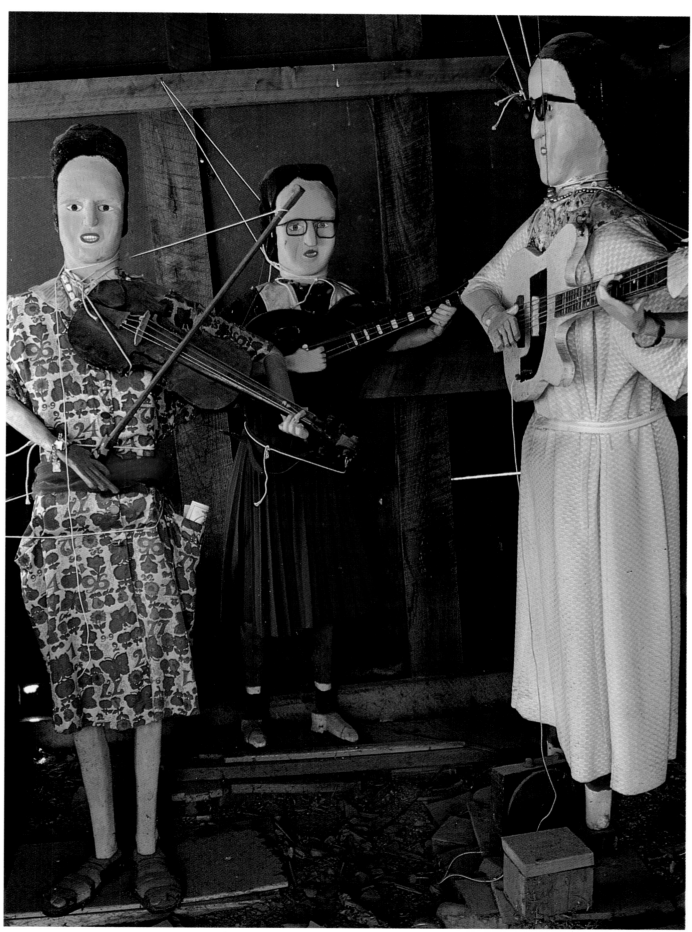

Noah Kinney: *The Kinney Band*

A visit to the Cincinnati Zoo started him carving beasts of the jungle: a giraffe, and elephant, a Bengal tiger, and the one he's working on now, a crouched lion as large as a beagle hound.

Noah Kinney is finding it hard to get hold of the yellow poplar he likes. For a while, he had a good lot of it when a pharmacy that dated from the Civil War was torn down in a nearby town. That's all been used up now. He's hunting for more, but well-seasoned poplar is hard to come by. When he gets his hands on some, it's no more than an inch or two thick. He has to glue two or three slabs together to get the thickness he wants. He roughs it out with a saber saw before he starts to carve. Arthritis in his hands has slowed him down. "Arthur," he allows dryly, "he's the worst one of them Ritis boys."

Part of Noah Kinney's art is the way he manages to imbue every one of his animals with something of himself. His elephant has a droll, quizzical air. His tiger is amiable. His lion is a wise, grizzled veteran who has come to terms with life. They all have an honest, rough-hewn look that, like Popeye, says, "I yam what I yam."

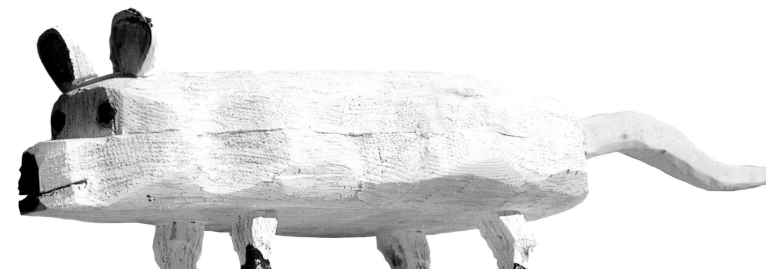

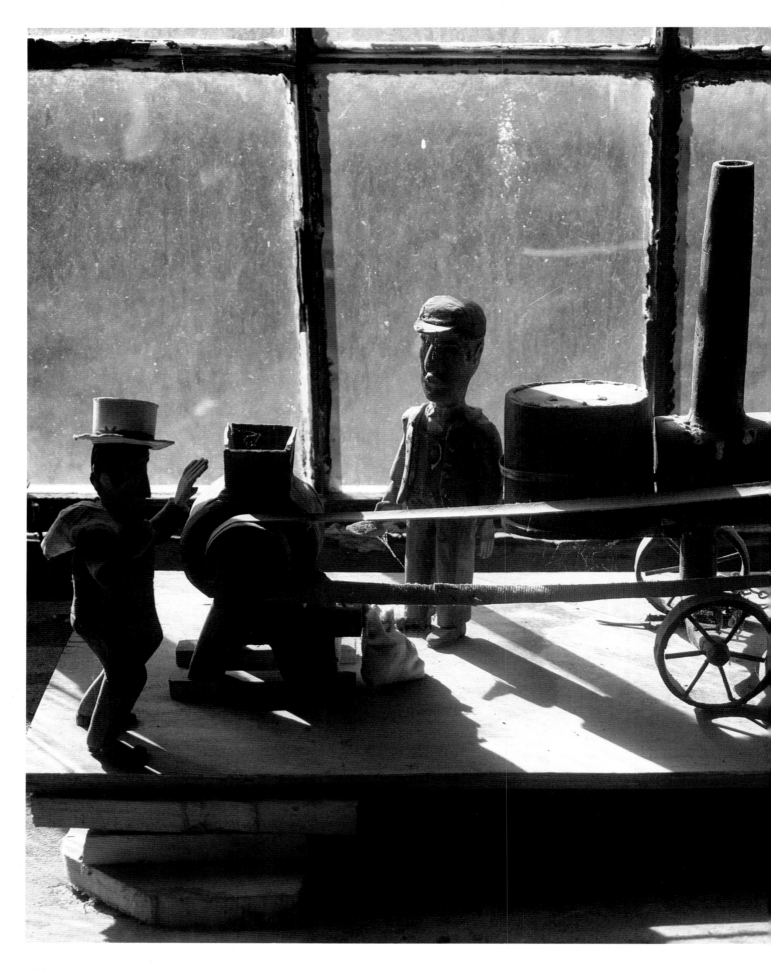

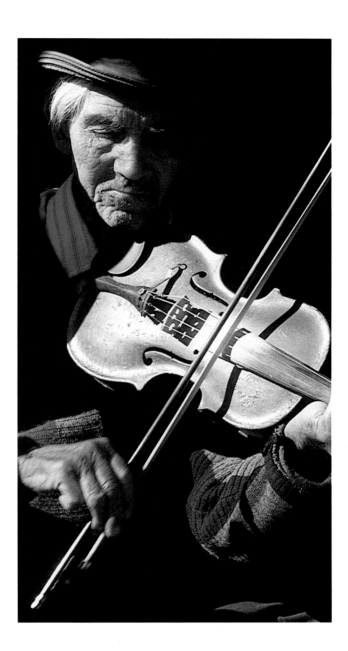

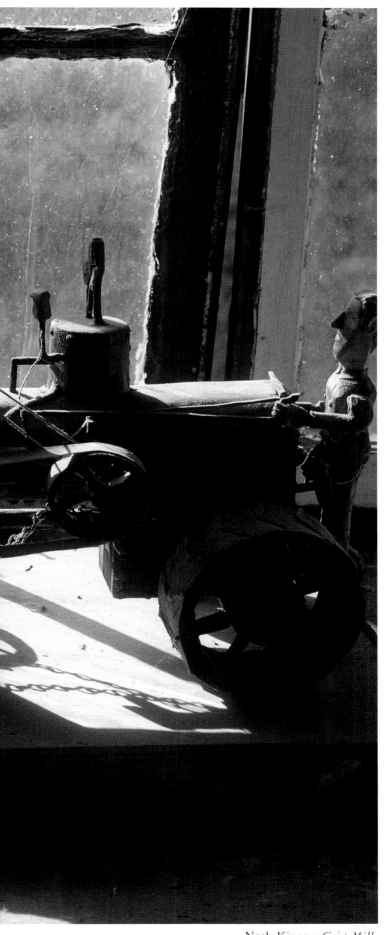

Noah Kinney: *Grist Mill*

Charley Kinney started making puppets when he was young. There were no movie houses, and television hadn't been invented. In his early years, there wasn't even a radio, and later on when there was one its batteries were usually dead. Dances were held maybe twice a month, and none during the winter. His chief source of entertainment was the woods, but when the cold hit zero and the mountain winds howled, he had to find something to do indoors. He dreamed up people to dance to his fiddle and proceeded to make them. Three feet tall and loose-jointed, they are fashioned out of wood, cardboard, and cloth stuffed with rags. Gaudily dressed, they look like people found in any honky-tonk on a Saturday night.

245

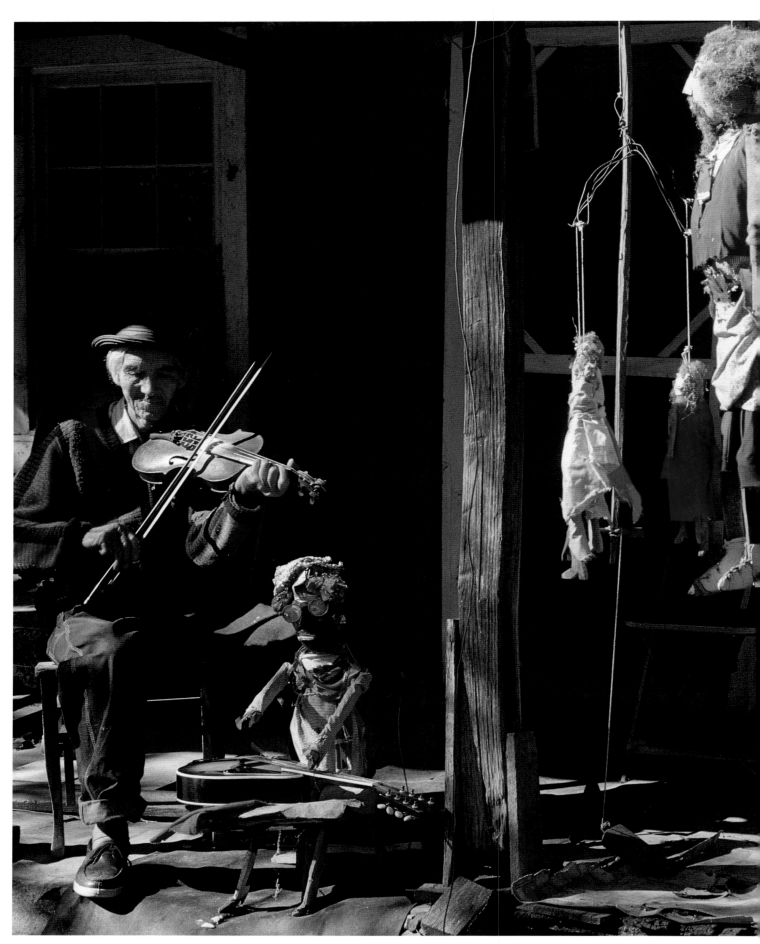

Charley Kinney with the dancing puppets he calls "my peoples."

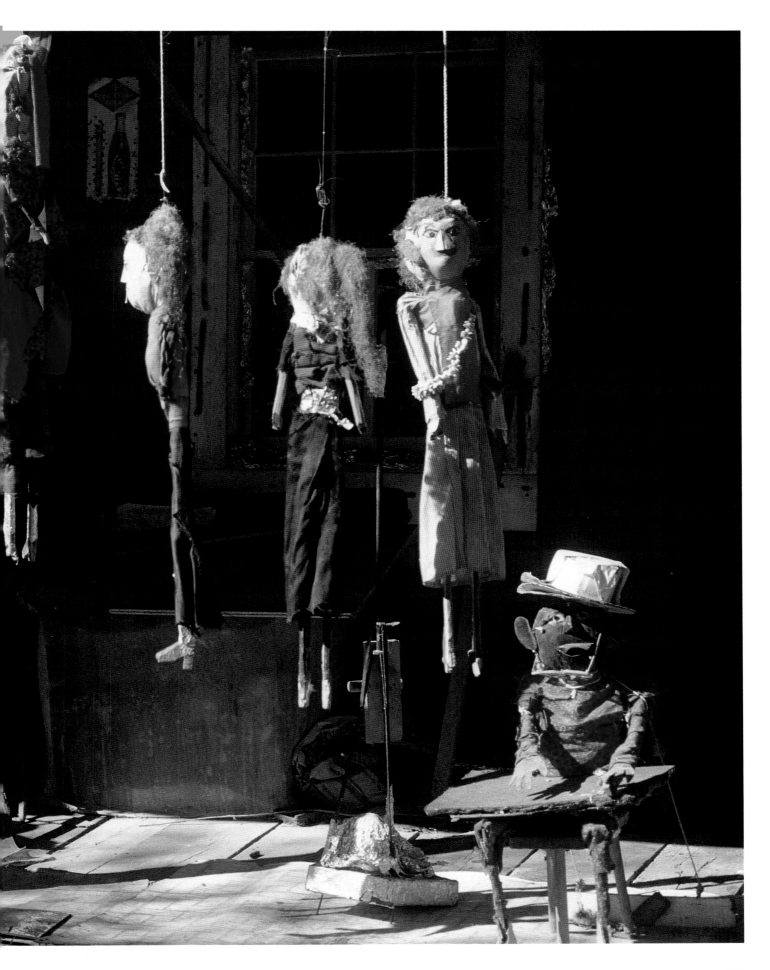

Charley Kinney decks them out with an assortment of props. One wears a crooked pair of wire-rimmed spectacles. Another looks out from under a floppy, flower-trimmed hat. His art is in creating sharply different personalities: a grinning good-ol'-boy, a shifty dude, a tipsy grandmother, a spinster out to scandalize the town.

One by one, Charley Kinney sets the puppets into motion. He hooks them up to a crossbar worked by a foot pedal. As he fiddles away, he stomps on the pedal, making a puppet play a mandolin or flinging another into a splatter-foot clog dance.

Charley Kinney has never married, and he insists it is because he likes living as his fancy takes him, being independent as a hog on ice. "I don't want to get hooked up to some woman that'd try to change my ways." His nervous suspicion of the opposite sex is reflected in his painting of a rattlesnake entitled *Femal*.

His paintings radiate a fierce glee. The subjects range from a bear hunt to a hog butchering to satanic scenes filled with frenzied fiends, skeletons, and hants—a mountain word meaning restless spirits come back from the dead.

Now and then, in his paintings, a rebellious damned soul challenges his fate. In *The Old Devil Burning the Wicked*, Beelzebub cackles, "If I turn him loose out of the skillet, he'll take over all Hell."

Charley Kinney has terrifying childhood recollections of hants. "I was in a house where somebody had died and come back, crashin' and clatterin' like a barrel of tin was bein' poured out overhead. Scared the pants off of me. I run out, straight into a thicket of briers. They jabbed me everywhere, turned me into a bloody mess." That experience is still stuck like a thorn in his memory. He has painted half a dozen versions of it.

Reading has never been one of Charley Kinney's favorite pastimes. He doesn't pore over his Bible like some in the hills. But he knows its more colorful characters from a thousand sermons—apocalyptic, pulpit-thumping, hoarse-voiced warnings of the fate that awaits those who defy the Lord. The passages Charley Kinney loves are the rip-roaring, thunder-and-lightning tales:

Now the Lord had prepared a great fish to swallow up
 Jonah. And Jonah was in the belly of the fish three days
 and three nights. Then Jonah prayed unto the Lord out
 of the fish's belly:
"I cried by reason of my affliction unto the Lord,
And he heard me; Out of the belly of hell cried I . . ."

Charley Kinney shakes his head in admiration. "God really laid it on that boy."

His memory of what happened a week or a month ago isn't too sharp, but Charley Kinney can recall in detail boyhood experiences. "I mostly went barefoot. Didn't bother me a bit. The bottoms of my feet were like saddle leather. I had a pair of wooden shoes I wore when I went out to hunt, so's the animals couldn't smell my tracks. Gun I had was a real old-timer, you had to put powder in the barrel and tamp it down. I carried powder and shot. Caps was hard to get, so I used the heads of matches. Worked just fine. In those days, there was so many squirrels they'd bend the branches. No tellin' how many you could kill, if you had a mind. We didn't have no deep-freeze to keep them in, you just killed what you could eat. Yes sir, in one tree I've counted as many as eighteen squirrels. You'll never see the likes of that around here again. To kill out the brush, the telephone and the power companies poison the ground where they string their lines. That's what's killing off the rabbits and squirrels."

Facing page above:
Charley Kinney: *Rattlesnake*

Facing page below:
Charley Kinney: *The Old Devil Burning the Wicked*

248

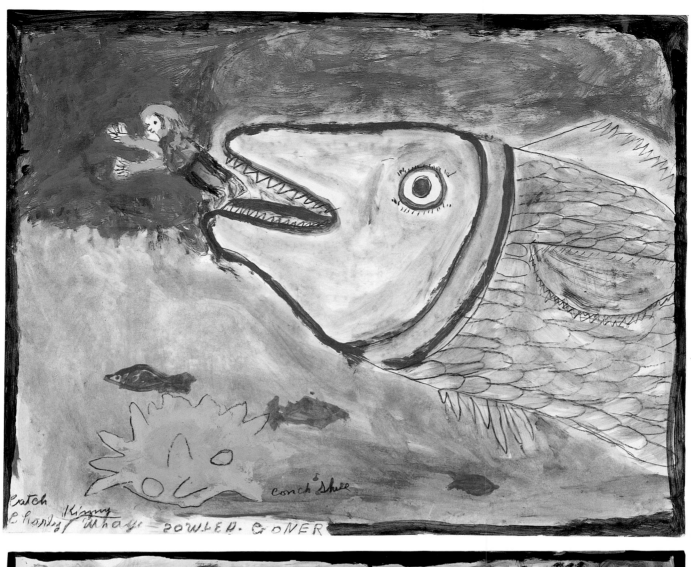

Catch
Charley Kinny Whale – SOWIER. GONER

conch Shell

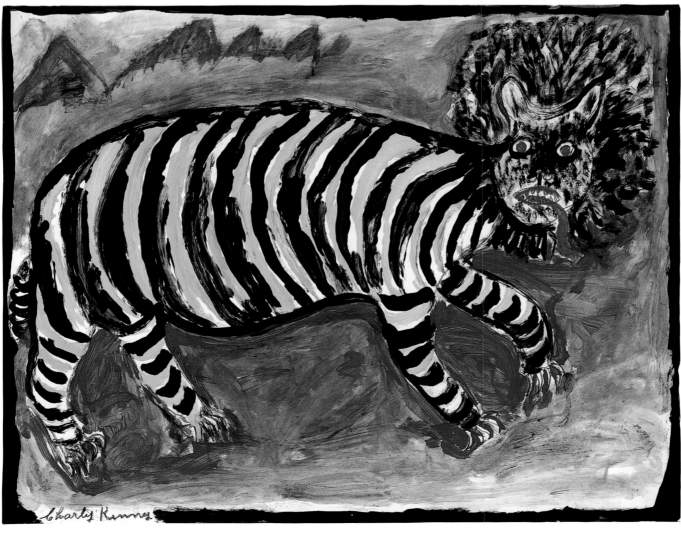

Charly Kinny

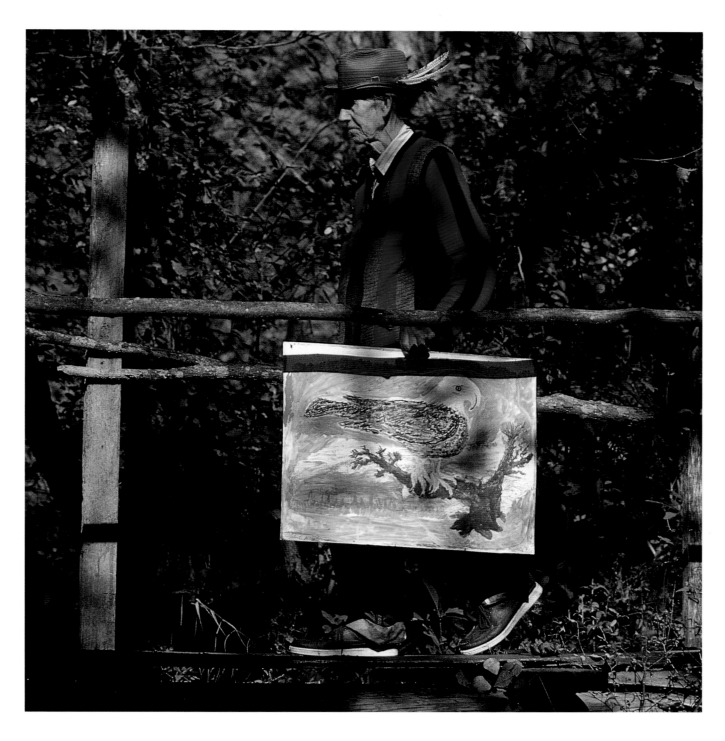

Noah Kinney raised his first tobacco crop when he was sixteen and didn't start carving until his farming days were done. Charley Kinney was an artist early on. "I was already picturin' when I went down to the schoolhouse. I wouldn't go to class. I'd rather spend my time in the woods tracking game. The teacher told me she'd just teach me how to spell my name and count money, in case I might get hold of some,

which wasn't too likely, considerin' the way I was startin' out."

Tramping across the worn plank bridge to the other side of the creek, Charley Kinney heads for his house. "You ever see a sawmill shanty? That's what this is. In the old days, the skinners that drove the ox-teams pullin' the timber wagons would sleep on the floor here, get up in the mornin' and be on their way."

Facing page above: Charley Kinney: *Jonah*
Facing page below: Charley Kinney: *Tiger*

He takes up his old single-barrel shotgun, cradling it in his arms as he stalks back across the creek to sit outside the barn. His keen, mountaineer's eyes scan the sky. "Pigeon flew in here yesterday. Red-tailed hawk almost got him. I'm watchin' for that hawk, aimin' to dust his tail feathers with a load of number 4 if he tries it again."

Charley Kinney taps time with his foot, a fiddle tune playing in his head:

Hey, black-eyed Susie,
Hey, pretty little black-eyed Susie. . . .

In his cluttered workshop, Noah Kinney finishes carving the tail of the lion. He inspects it with a critical gaze, decides it's fine, and starts to work on the beast's paws.

"Oh, it's changed, eastern Kentucky has. Most of the wildlife's gone. The water ain't fit to drink. Loggers and strip-mine operators has just about ruined a lot of these mountains and poisoned the creeks."

His knife hand poised, Noah Kinney's thoughts go to the ravaged hillsides that border his land. He shakes his head sadly. "Why couldn't they've left them woods alone?"

252

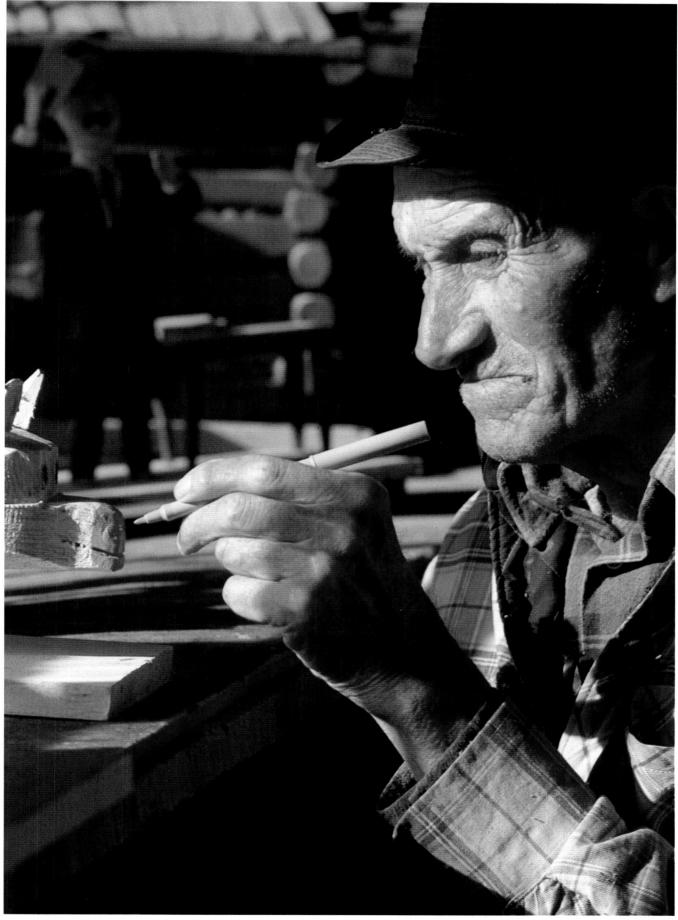

Noah Kinney

IN APPALACHIA, the summer sun ripens the blackberries in the greenbrier thickets. Tomatoes and corn come to their fullness. The ritual of canning vegetables and fruit begins.

Summer passes, autumn comes. The slopes are a wildfire of scarlet maple leaves, the golden leaves of the poplar trees, and the purple, star-shaped leaves of the sweet gum. The growl of chainsaws echoes in the woods. Kindling is split, logs are stacked.

Autumn gives way, retreating as winter marches across the hills. The rat-a-tat of a woodpecker rings in the crystal air. Deer, rabbits, and wild turkeys leave their tracks in the snow. In homes on the ridges, in homes in the hollows and bottoms, in homes along the ice-rimmed creeks needles flash as women stitch bear paw and double wedding ring patterns on their quilts.

Winter loosens its grip. Spring comes cautiously to the mountains. The white dogwood blossoms unfold. Jack-in-the-pulpit and trillium push their way up through the moist earth.

In the spring of 1988, while this book was taking shape, Dilmus Hall died. He was eighty-seven years old.

The seasons turn. Somewhere in West Virginia or perhaps Kentucky a retired coal miner comes home from a long walk in the woods. Filled with emotions he can't put into words, he takes a thick chunk of poplar off his woodpile and sets to work with his whittling knife. The skill he had as a boy and put aside all those years he labored underground now begins to return.

Somewhere in North Carolina or perhaps Tennessee a mountain woman takes up a brush and begins to paint a picture of something she saw in a dream. Somewhere in the Georgia hills a country preacher is filled with the urge to create an image of one of God's creatures. He carves an elegant, slim-legged horse.

Across Appalachia, new self-taught artists continue to be discovered. And others come into being as the seasons turn.

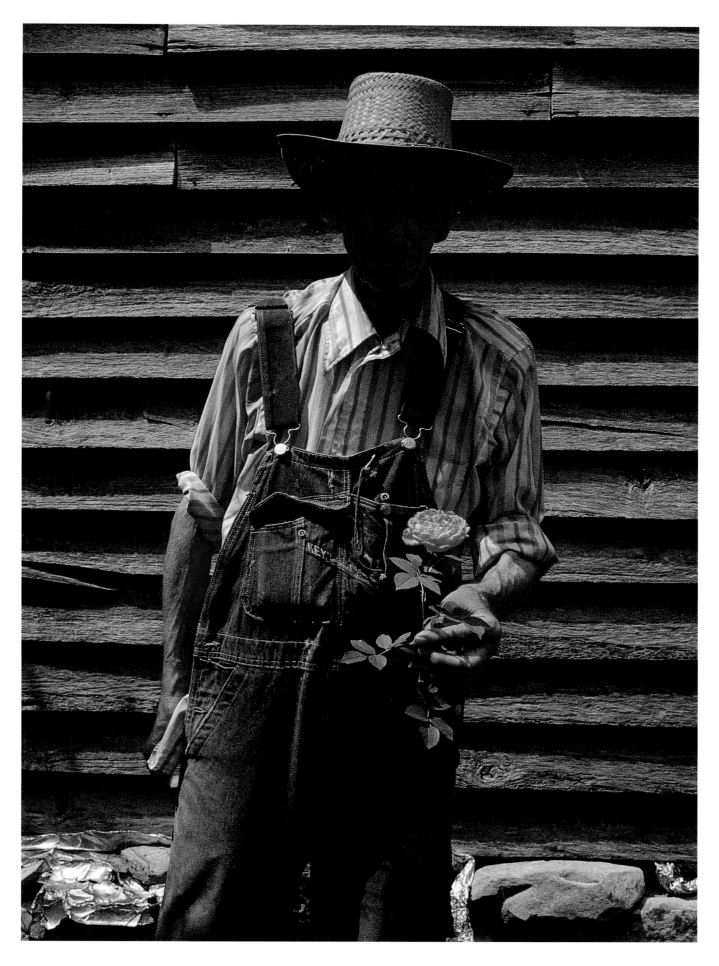

Special thanks are due to Robert Egelston for his unswerving commitment to the work that created this book. The authors are also deeply indebted to: Howard Borris, Stephanie and Scott Davis, Max Difray, Mollie Estep, Debbie and Robert Fisher, Richard Grant, Carol and Gerald Isenberg, Dan Lacy of the Ashland Oil Corporation, Roger and Cheryl Lerner, Patricia Maxwell, Mary Miller, and Sarah Lee Neal.

In the course of her search for self-taught Appalachian artists, Ramona Lampell was given generous assistance by: Jan Oliver Alms, McDowell Technical Community College, North Carolina; J. Roderick Moore, Director, Blue Ridge Institute, Ferrum College, Virginia; Rebecca Stelling, West Virginia Department of the Arts and Humanities; Tom Sternal and Adrian Swain, Morehead State University, Kentucky; Henry Willet, Southern Appalachian Regional Representative, National Endowment for the Arts and Humanities.

Works depicted in this book are from the collections of: Dr. Robert Burns, Max Chambers Davis, Robert Egelston, Elaine Garfinkle, Susan and Elliot Webb, and the authors.